Versailles: The Château of Louis XIV

ROBERT W. BERGER

Versailles
The Château of Louis XIV

Published for
THE COLLEGE ART ASSOCIATION OF AMERICA
by
THE PENNSYLVANIA STATE UNIVERSITY PRESS
UNIVERSITY PARK AND LONDON

1985

Monographs on the Fine Arts

sponsored by

THE COLLEGE ART ASSOCIATION OF AMERICA

XL

Editor, Carol F. Lewine

Library of Congress Cataloging in Publication Data

Berger, Robert W.
Versailles: the chateau of Louis XIV.

(Monographs on the fine arts; 40)
Includes bibliography and index.
1. Château de Versailles (Versailles, France)
2. Versailles (France)—Palaces.
I. College Art Association of America. II. Title. III. Series.
NA7736.V5B44 1985 725'.17'0944366 85-3668
ISBN 0-271-00412-6

Photographic Credits

Alinari/Art Resource, New York: 20, 25, 56, 58, 60, 63, 64, 84, 85, 97. Archives Nationales, Paris: 11. Author: 5, 8, 9, 19, 22, 23, 66, 68, 73, 75, 78–80. Bibliothèque Nationale, Paris: 1, 2, 4, 7, 24, 26–29, 90, 100. Giraudon/Art Resource, New York: 30–32, 86, 87, 94–96. Harvard Theatre Collection, Harvard University, Cambridge, Mass.: 81. Houghton Library, Harvard University, Cambridge, Mass.: 21. Istituto Centrale per il Catalogo e la Documentazione, Rome: 59. Marquand Library, Princeton University, Princeton, N.J.: 35–47. Musées Nationaux, Paris: 3, 6, 10, 34, 53, 61, 65, 67, 69–72, 74, 76, 77, 82, 83, 88, 89, 91–93, 98, 99. Nationalmuseum, Stockholm: 12–18, 33, 54, 55. Soprintendenza per i Beni Ambientali e Architettonici del Lazio, Rome: 57.

To My Mother

Contents

List of Illustrations

Preface

THE chapters of this book are detailed studies of Louis XIV's new Château of Versailles (the Enveloppe) and its major ceremonial spaces. All of these features are extant and very well preserved save for the Escalier des Ambassadeurs, destroyed not by war or revolution but by order of Louis XV in the mid-eighteenth century.

The early stages of research for this study were aided by residence as a visiting member at the Institute for Advanced Study, Princeton, and by a grant from the National Endowment for the Humanities (1977–78). I am particularly grateful to Professor Irving Lavin, who invited me to the Institute, and to Professor Hendrik J. Gerritsen of the Department of Physics, Brown University, for having critically read chapter V. I also wish to thank Professors Shirley Blum and Carol Lewine—two successive editors of the CAA Monograph Series—for their careful consideration of my manuscript and for suggestions for its improvement. Professor Lewine and Patricia Coryell, my copy editor, helped me to a smoother and clearer prose style.

All translations are by me unless otherwise noted. My translations are literal and do not attempt to add literary fluency to infelicities and awkwardness sometimes found in the documentary sources (particularly those quoted in chapter II). I have retained the original orthography and punctuation of the French passages reproduced in the notes.

It was necessary to print figures 35 to 47 from microfilm; every effort has been made to reproduce them as satisfactorily as possible.

French units of measure:
 1 *toise* = 1.949 m. = 6 *pieds*
 1 *pied* = 32.4 cm. = 12 *pouces*
 1 *pouce* = ca. 2.7 cm.

. . .le beau et le vilain furent cousus ensemble, le vaste et l'étranglé.
(. . .the beautiful and the ugly were sewn together, the vast and the constricted.)

The Duc de Saint-Simon, *Mémoires,* 1715

Introduction

VERSAILLES is the most famous palace in the world. Its name evokes, more than that of any other monument, the political institution of absolute monarchy and the aesthetic qualities of vast scale and bombastic display—features which are often evident in Baroque art. Louis XIV, whose ghost presides over Versailles, was primarily responsible for its creation and for its establishment (officially in 1682) as the main royal residence and governmental seat of France. It was at Versailles that many important decisions were made that affected the course of European history from the late seventeenth century on, and it was there that the Sun King died in 1715 after more than fifty years of personal rule. By that date the Château and its extensive gardens were virtually complete, having served as a gigantic *chantier-atelier* for several generations of French artists, working in many media. By 1715, Versailles was universally famous as one of the wonders of the modern world.

The art historian of today who undertakes a study of Versailles will find a wonderfully well-preserved and well-restored monument; an abundance of published sources and documents; and a large bibliography of modern art-historical studies, some written by such distinguished students of French art as Pierre de Nolhac, Fiske Kimball, and Alfred Marie. Despite numerous books and articles by these and other scholars, however, the investigator soon discovers that a number of basic art-historical problems are still in need of solution and that the richness of the material allows new and fruitful questions to be posed. As is the case with all great topics, the "definitive" study of Versailles has never been written and probably never will be.

The basis for modern art-historical studies of the Versailles of Louis XIV was established in the second half of the nineteenth century by the publication of the papers of Colbert by Pierre Clément (*Lettres, instructions et mémoires de Colbert,* Paris, 1861–70, 7 vols.) and of the docu-

ments of the Royal Building Administration by Jules Guiffrey (*Comptes des bâtiments du roi sous le règne de Louis XIV,* Paris, 1881–1901, 5 vols.). These fundamental corpora enabled Pierre de Nolhac to write *La création de Versailles* (Versailles, 1901), the first serious modern book devoted to the subject and a great milestone of French art-historical writing. In many other books and articles published during the first three decades of our century, Nolhac continued to draw upon primary published sources and upon unpublished documents available in French archives, which served as secure foundations for the expanding knowledge of Versailles.

A major step forward in scholarship was taken soon after World War II when Alfred Marie started exploring the important collections of French drawings preserved in the Nationalmuseum, Stockholm. Marie began to publish some of this material and shared his findings with the American scholar Fiske Kimball, who wrote several seminal studies on the Château, including articles on the Galerie des Glaces (1940), the Enveloppe (1949), and the Escalier des Ambassadeurs (1952). His remarkable *Creation of the Rococo* (Philadelphia, 1943) discusses many aspects of the art of Versailles under Louis XIV. In recent years Marie has published a multivolume encyclopedic survey of Versailles, with a rich corpus of illustrations (*Naissance de Versailles. Le château. Les jardins,* Paris, 1968, 2 vols.; *Mansart à Versailles,* Paris, 1972, 2 vols. [with Jeanne Marie]; and *Versailles au temps de Louis XIV,* Paris, 1976 [also with Jeanne Marie]). Mention should also be made here of Pierre Verlet's *Versailles* (Paris, 1961), a masterful synthesis.

This study of the architecture and decoration of the palace is founded upon the above-mentioned works as well as upon the efforts of many other students of Versailles, who are cited in the notes and bibliography. I have attempted to fully utilize archival materials, but have discovered that *published* sources of the late seventeenth century and the eighteenth century provide rich material that has at times been underutilized. After sifting through this abundant data, I find it possible to offer here new solutions to old problems (the chronology of the Enveloppe [chapter II]). In other cases, I attempt to explore new questions (the relationship of the royal planetary suites to seventeenth-century astronomy [chapter V]) or to discuss the artistic forms within a broader art-historical context than is encountered in past treatments (the àrchitecture of the Enveloppe [chapter III] and the vault paintings of the Escalier [chapter IV]). This book does not pretend to provide a comprehensive account of the palace. Rather, it deals essentially with the new Château of Louis XIV (the Enveloppe) and with the most important interior spaces. In chapter VII I have gathered together material that illustrates how the building was officially used under the Sun King. (It should be noted that the sequence of chapters IV–VI corresponds to the interior architectural and decorative sequence that was experienced by official visitors to Versailles after circa 1685: Escalier des Ambassadeurs—Planetary Rooms [king's side]—Galerie des Glaces; however, the paintings of the Planetary Rooms [1670/71–ca. 1681; chapter V] were begun slightly before the final decorations of the Escalier [1674–80; chapter IV].)

The reader may wonder how the present book attempts to alter current conceptions of the Château of Versailles. My main points are as follows: In 1668 Louis XIV decided to enlarge Versailles by preserving his father's building, the Petit Château, and by enclosing it in a new structure, Le Vau's Enveloppe. For a few months during the summer of 1669 the king changed his mind and wanted the old building torn down, but Colbert urged a return to the Enveloppe scheme. Louis accepted this advice, and work on the Enveloppe was resumed and brought to completion. The historical evidence thus essentially supports André Félibien and Charles Perrault, who insisted that the king wanted to retain the Petit Château for reasons of filial respect.

(Kimball, by contrast, had concluded in 1949 that Louis XIV at heart had always wanted his father's building to be razed.) The architect of the Enveloppe was Louis Le Vau (and not François d'Orbay, as maintained by Albert Laprade [1960]), who departed from his usual Italian Baroque sources to draw upon Italian High Renaissance models for the first (and last) time in his career.

As for the interiors, the Escalier des Ambassadeurs was indeed designed by d'Orbay after Le Vau's death in 1670 (Kimball, 1952), and is dependent on a slightly earlier project for a Louvre stair by Claude Perrault (Josephson, 1927). But the history of its frescoes (designed by Charles Le Brun) proves that decorative schemes at Versailles were especially susceptible to bearing imagery directly alluding to or representing contemporary events. Hence the original neutral scheme of decorative herms (begun in 1672) was suddenly replaced in 1674 by an elaborate program dealing with the then-raging Dutch War and the king's triumphant return from the conflict. Le Brun's vault paintings established a new degree of Baroque richness and complexity in French art, and d'Orbay's innovative skylight provided top-lighting, perhaps to symbolically suggest that celestial illumination guided the king. In chapter V, on the Planetary Rooms, Vitzthum's suggestion (1965) that the room sequences illustrated the new Copernican system is found to be erroneous, and Campbell's assertion (1977) that they referred to the old Ptolemaic scheme is upheld. But the dedications of rooms within the royal suites were affected by functional considerations, and it is unlikely that scientific advisers played any role. Rather, the planetary scheme, influenced by the Palazzo Pitti decorations of Pietro da Cortona and Cirro Ferri, probably owes much to ancient texts describing the Roman palaces on the Palatine Hill; in this way, the palace of Louis XIV could be viewed as a successor to the grandeur of imperial Rome. Finally, in the chapter on the Galerie des Glaces, attention is drawn to the intervention of the king's high council of ministers in the design process; this resulted in a direct depiction of Louis XIV's recent military triumphs of the 1670s on the painted vault, superseding allegorical cycles devoted to Apollo and Hercules that had been proposed earlier. The famous mirrors that give the gallery its name were intended to add luminosity to a room centering upon *le roi-soleil;* they were also perhaps meant to out-rival the mirrors in the Salon de los Espejos in the Alcázar of Madrid, the special audience hall of the Spanish Hapsburg foe.

Many changes in program and design were made in the planning of the Enveloppe (chapter II), the Escalier des Ambassadeurs (chapter IV), and the Galerie des Glaces (chapter VI) before the final results were achieved. At Versailles, however, even completed work might be swept away or significantly modified as the result of subsequent decisions; for example, the creation of the Galerie des Glaces radically altered the western range of the Enveloppe and the original sequence of the Planetary Rooms (chapters V and VI). The following chapters are intended not only to provide art-historical documentation, but also to permit the observation of artistic decision making at Versailles. Versailles as a whole—the gardens as well as the Château—was not carried forth in accordance with an unvarying master plan; indecision and changes of mind—very human phenomena—occurred throughout its genesis and development. These changes took place at Versailles because its functions were redefined at various stages in its history; because its development under Louis XIV witnessed changes in key personnel (particularly among the royal architects and the superintendents of the king's buildings)[1]; because artistic decisions at Versailles were particularly subject to the press of contemporary political and military events; and because the taste of Louis XIV himself underwent change. The study of Versailles serves to remind us that history is made not by impersonal forces but by real people acting in real situations.

II

The Enveloppe: Chronology

THE year 1668 is a key date in the history of Versailles: in that year Louis XIV decided to greatly expand the Château—a first step in the eventual transformation of Versailles into the seat of the court and government (officially proclaimed in 1682). Versailles in 1668—just before the new construction began—is vividly portrayed in Patel's bird's-eye view of that year (fig. 3). The ⊓-shaped building at the rear of the courtyard is the old Petit Château of Louis XIII, placed on a platform (*fausse braye*) within a dry moat (figs. 1, 2). Beginning in 1661, the king had made minor changes to this building, but without affecting its *retardataire,* brick-and-stone style. In 1662, two service blocks containing stables, kitchens, and servants' quarters were begun in materials and in a style matching the old building; they appear in Patel's view just before the Château, defining a wide court. Of about the same date was the oval entrance plaza with its obelisks and sentry booths, perhaps based on the approach to Vignola's Palazzo Farnese at Caprarola, begun in 1559. All of this new work at Versailles was designed by Louis Le Vau, first architect of the king since 1654.

Patel's painting also shows the extensive park, which André Le Nôtre had been transforming since the early 1660s. In the foreground we see the developing new town of Versailles, with its symmetrical pavilions for princes and courtiers (again in brick-and-stone with high slate roofs), and we note the beginnings of arterial systematization in the three converging tree-lined avenues that empty into a large *place* in front of the Château. A partial glimpse of the old village (a church and some houses) appears at the extreme left.

Before 1668, architectural activity at Versailles had been overshadowed by the complicated events concerning the Louvre, the king's palace in Paris. Here, the main issue was the completion of the all-important eastern (entrance) façade. Le Vau's design for this front, although already under construction, was suddenly halted on January 1, 1664, when Jean Baptiste Colbert replaced Antoine de Ratabon as superintendent of the king's buildings. The design of the

Louvre was then thrown open to French architects, and later in 1664 Colbert sought and obtained proposals from leading Italians, the most prominent of whom was Gianlorenzo Bernini, then considered Europe's greatest architect. The oft-told story of Bernini's sojourn in Paris in 1665 and the final formulation of his comprehensive Louvre scheme (fig. 21) need not be rehearsed here. Although the foundations of Bernini's Louvre were laid in 1665, the whole project was aborted in the following year, and in 1667 Colbert took the fateful step of appointing an entirely French committee of three (Le Vau, Charles Le Brun, and Claude Perrault), which formulated the Louvre Colonnade (fig. 22), begun in that year; the committee continued to meet into 1668, when it devised the new south façade (fig. 23).

With the question of the completion of the Louvre finally resolved, the king was free to focus on the Château at Versailles. Colbert had opposed its expansion even before he became superintendent and had urged that the Louvre remain the primary royal residence. But in 1668, with the new Louvre designs under construction, Louis XIV decided to enlarge Versailles. Reverting to traditional procedure, he ordered Le Vau, still the *premier architecte,* to design a new Château, but also to retain the Petit Château of Louis XIII. What follows is the abundant documentation for the development of the new building—known from its inception as the "Enveloppe"—with elevations facing the gardens (figs. 6–8) that are radically different from those of the Petit Château.

Beginning in October 1668, large payments appear in the *Comptes des bâtiments du roi* for earth removal and masonry work for "le nouveau bastiment" at Versailles; the contractor for the work was the architect Jacques IV Gabriel:

> [October 20–November 4, 1668]: to [Viart and Maron, excavators], for their final payment for the earth that they have removed from the old terraces of the château . . . 1424 *livres,* 10 *sols.*[1]
> [November 4, 1668]: to the said Maron, for the workers who have worked on the enclosure of the new workshop . . . 331 *livres,* 8 *sols.*[2]
> [November 22–December 3, 1668]: to Jacques Gabriel, for the masonry work which he has done for the new building . . . 21000 *livres.*[3]

Le Vau's design must have been devised before October 1668; as will be discussed later, his initial ideas were formulated earlier that year.

In 1668, apparently after the new work was begun in October, Colbert drew up a "Memoir concerning what there is to do for the buildings in the year 1669."[4] His notes on Versailles refer to new construction:

> Inspect the state of the plans of Versailles and what there is to do to finish the whole;
> The plans, drawings and elevations of the new buildings, to settle everything there is to do on this subject.
> Begin to make the drawings and resolve all the interiors, to give orders forthwith for the marbles and ornaments that will be necessary.[5]

As we have seen, Gabriel was paid for masonry work for the new building in late November and early December 1668, and another very large payment to him begins on January 25, 1669: "to Jacques Gabriel, entrepreneur of the new building of Versailles, for the masonry work that

he is doing for the said building."[6] These documents indicate that there was continuous construction, and this is confirmed by additional payments for work dated into June 1669:

[February 15, 1669]: to André Mazières and Anthoine Bergeron, for the masonry work done by them at the château of Versailles . . . 1500 *livres*.[7]

[February 15–March 28, 1669]: to Claude and Benjamin Guillot, and Nicolas Langlois, quarrymen of Meudon, for the remaining and final payment of 8200 *livres* to which amounts the seventeen large stones that they have furnished and conveyed to Versailles . . . 2500 *livres*.[8]

[March 19, 1669]: To [Boursault, excavator], for his reimbursement of what he has paid to the workers who have labored to remove the pavement of the *fausse braye* of the said location, and other expenses . . . 112 *livres, 17 sols*.[9]

[May 8–November 9, 1669]: to Cliquin and Charpentier, carpenters, for the carpentry-work of the new building of Versailles . . . 46000 *livres*.[10]

[June 2, 1669]: to [Boursault], for his reimbursement of what he has paid the workers who are demolishing the interiors of the two pavilions of the said château and who are making trenches to place the cast-iron pipes . . . 369 *livres, 12 sols*.[11]

On June 8, 1669, Louis Petit, the controller of the buildings of Versailles, wrote the following report to Colbert on the status of the new construction:

The façade wall on the side of the parterre of flowers is 19 feet 4 inches high. The one on the grotto side is 20 feet 4 inches. The hard stone arcaded wall which must carry the terrace between the two pavilions of the château on the side of the large parterre is 13 feet high. The aforesaid large walls with the exception of the last arcaded one are high enough to place the platforms on which the carpentry of the floors is to be placed; there only remains to place some stones and moldings behind the said windows. We have 566 workers who work here, namely 7 stone-markers, 8 stone-dressers, 142 stone-cutters, 118 stone-masons and 291 laborers. The reservoir is entirely repaired and very clean as much inside as outside; they would have been able to put the water in last Friday, if it hadn't been that it was necessary to first fill the two others. The King wishes that they level the avenues of the large park, particularly those that lead to St.-Antoine and to Trianon, to prevent the jolts of the carriages; it's where they are working with diligence. . . . The Sieurs Clicquin and Charpentier are preparing the roads in order to have quickly conveyed the wood for the first flooring of the building which they will begin to raise up next week.[12]

This important document informs us that the south façade of the new building ("The façade wall on the side of the parterre of flowers")[13] was more than 19 French feet high, and that the northern façade ("The one on the grotto side")[14] had reached a height of more than 20 French feet. These walls were almost high enough to be ready to receive the flooring of the *premier étage*. Most important, Petit specifically mentions the arcaded wall that was to support the terrace between the two pavilions on the western garden side ("the side of the large parterre"). These details clearly correspond to Le Vau's Enveloppe design as it is known from the architect's plans (figs. 10, 11) and contemporary depictions (figs. 6, 7). Begun in October 1668, the Enveloppe was considerably advanced by early June 1669, after more than seven months of uninterrupted activity.[15]

At this moment construction must have been temporarily halted, for on June 25 Charles Perrault, Colbert's first clerk in the Royal Building Administration, indicated to Colbert in a letter that six architects, including Louis Le Vau, were working "nuit et jour" on designs for Versailles.[16] Colbert's analyses of some of these designs indicate that they were for the Château itself; hence, it is apparent that a competition was now taking place, reminiscent of the competition for the Louvre earlier in the decade.

Perrault's letter of June 25 reveals that designs were anxiously awaited from Louis Le Vau, Antoine Le Pautre, Jacques IV Gabriel, Claude Perrault, Carlo Vigarani, and Thomas Gobert.[17] In such a situation we would expect that a list of specifications had been drawn up for the guidance of the architects, and indeed a "Memoir of what the King wants in his building at Versailles," undated, in Colbert's hand, corresponds to this expectation. This document, which probably dates from early June 1669,[18] indicates that the king had changed his mind, and now wanted his father's building—the Petit Château (figs. 1–3)—pulled down.[19] This can be deduced from the concordance of certain stipulations with Colbert's subsequent comments on a close variant of Le Vau's competition plan, which has survived (fig. 18): the elimination of the Petit Château is a major feature of this plan. Here is the text of Colbert's "Memoir"[20]:

> [M1] His Majesty wishes to make use of everything newly made.

This unequivocally indicates the royal desire to preserve the substantial work already accomplished on the Enveloppe. Judging from the "Memoir" and the responses to it, however, the competing architects were encouraged to make significant alterations and yet preserve the basic new fabric.

> [M2] Reduce the *avant-corps* by recutting the walls.

The west, south, and north façades of the Enveloppe feature *avant-corps,* that is, projecting sections of the ground floor which support an order at the level of the *premier étage* (figs. 6–8, 10–12). The king evidently wanted the degree of projection of the executed *avant-corps* to be reduced.

> [M3] Enlarge the arcades of the front side [i.e., the west façade].
> [M4] These two demolitions carry away the whole; so that, under the pretext of leaving what has been constructed, one remains constrained by the extent of the foundations, and thus one receives inconvenience from it without any advantage.

The "two demolitions" apparently refers to the operations requested in [M2] and [M3]. In [M4] we detect the viewpoint of Colbert, who seems to say that the cutting back of the *avant-corps* and the enlargement of the western arches ("the arcades of the front side") would be so extensive that a larger château could be erected, and that the king's insistence on keeping the Enveloppe (without the Petit Château) was a needless limitation in view of the amount of the fabric to be torn down. There is more than a pinch of sophistry here; the comment was probably intended for Colbert alone, not for the competing designers.

There follow three entries which concern foundations and cellars:

> [M5] Notice that while lowering the vault of the façade, it is necessary to redo the foundations of one of the walls.

[M6] Since the other vaults of the wings have neither air nor light, they will be cellars and holes filled with a thousand ordures, no matter what care is taken.

[M7] If it is necessary to give them air and light, it is necessary to transfer them either to the garden façade or to that of the court.

The remaining articles of the "Memoir" follow; many of these will be discussed in the analyses of Colbert's comments on the competitive designs.

[M8] The King wishes that the court be appropriate, that there be a fountain in the center, and that the coaches not enter;

[M9] That from the center of the court the four views be open:

[M10] The one of the entrance through the middle, which will be empty;

[M11] The one of the garden façade through the arcades of the lower gallery;

[M12] Those of the two wings through open vestibules.

[M13] The court façade, two large pavilions:

[M14] In the one to the right on entering, the main stair all of marble;

[M15] In the one to the left, the chapel and the stair.

[M16] The same symmetry for the two pavilions.

[M17] In the ground floor of the *corps-de-logis* to the right, the *appartement des bains,* composed of four rooms.

[M18] A small apartment on the court side.

[M19] On the staircase side, two small apartments.

[M20] In the main *corps-de-logis,* to the left, the apartments for the royal children, and two or three others.

[M21] Above, the *grand appartement* of the King, *salle, antichambre, grande chambre, grand cabinet.*

[M22] Another *cabinet.* [*In the margin:* That remains to be seen.]

[M23] On the court, a small apartment.

[M24] From the stair, it is necessary to enter into the two apartments, so that the large one will be always closed.

[M25] On the Queen's side, her large apartment overlooking the gardens, a *chambre* and *garde-robe* overlooking the court, for her *appartement de commodité.*

[M26] Remaining, an apartment for Monseigneur the Dauphin.

[M27] A square story in the attic, to make there a quantity of apartments, of which four to six must be composed of an *antichambre, chambre, garde-robe* and *cabinet,* and the others of a *chambre* and *cabinet* only.

[M28] Take care to place as many stairs as one can to service these apartments upstairs.

[M29] Take care that the King's apartments also have their stairs.

[M30] The gallery on the façade is to have a *salon* in the center, if possible.

[M31] Notice that, if one continues the wings up to the pavilions of the *basse-cour,* the centers will no longer exist by pulling down the *avant-corps,* and, by pulling them down, nothing more will remain.

[M32] Notice that in arriving from the gardens, the King will have to turn around in the *appartement des bains,* or from the other side, or traverse the whole court to find his stair.

[M33] The court will be 28 *toises* wide by 34 *toises* long.

[M34] The garden façade is 35 *toises*.
[M35] Up to the pavilion of the *basse-cour*, 7 *toises*.
[M36] In all, 42 *toises*.

	Toises.	Feet.
The *cabinet* on the façade is	5	1
The *grande chambre* is	5	2
The *antichambre* is	8	1
The *salle des festins* is	11	4
The thickness of the walls is	2	—
The two walls in front	2	—
Total	34	2
Remaining for the stair	7	4
Total	42	

[M37] Adding the 7 *toises*, the center will no longer exist in removing the *avant-corps*. By removing the *avant-corps*, it is necessary to demolish the walls behind and the arcades in front. That's to demolish the whole building.

Colbert here returns to the problem of the *avant-corps*, which he has commented on in [M4], above.

Perrault's letter of June 25 indicates that Le Vau had promised to submit his project the next day. After receiving designs from at least four of the competitors, Colbert drew up his "Observations on the plans presented by different architects for Versailles."[21] Only the minister's comments on the projects of Vigarani, Gabriel, Perrault, and Le Vau are preserved (see appendix II).

Colbert's remarks concerning Le Vau's design have been correctly correlated by Marie and Kimball with a plan in Stockholm (fig. 18). Marie claimed that this ground-floor plan precisely corresponds to Colbert's comments, and therefore must be Le Vau's competition design submitted on June 26;[22] Kimball, however, recognizing some divergences between Colbert's memorandum and the drawing, identified the Stockholm plan as a revision by Le Vau of a lost design of his that had already been commented upon by Colbert.[23] I shall proceed to an analysis of Colbert's critique of Le Vau's design, with special reference to the "Memoir" and to the Stockholm plan.[24] The critique is entitled "Observations on the design of the sieur Le Vau."[25]

[1] It preserves everything that was built.

Colbert's first note in the "Memoir"—[M1] "His Majesty wishes to make use of everything newly made"—while an explicit call for preserving the work already accomplished on the Enveloppe, can also be understood as implying the razing of the Petit Château. Thus, "everything that was built" should be understood to refer only to the new work; and, in fact, in the Stockholm plan (fig. 18), the Petit Château is entirely expunged. (I shall subsequently analyze in what way the Stockholm plan preserved the Enveloppe.)

[2] The pavilions and the entrances are as the King desires them.

In the "Memoir" we find:

[M13] The court façade, two large pavilions:
[M14] In the one to the right on entering, the main stair all of marble;
[M15] In the one to the left, the chapel and the stair.
[M16] The same symmetry for the two pavilions.

In the Stockholm plan, two symmetrical pavilions mark the beginnings of the wings. The chapel appears in the left-hand pavilion; vestibules for the two stairs (but not the stairs themselves) also appear in the pavilions.[26] For this reason, the Stockholm plan was perhaps not the precise project that Colbert had considered; on the other hand, the stair vestibules within the pavilions might have satisfied the demands expressed in [M14] and [M15].

[3] The entrance in the middle of the pavilion is not the entrance in the middle of the stair vestibule.

This criticism seems appropriate for the Stockholm drawing, where the central eastern entrances of the pavilions are not the median entrances of the stair vestibules. (In the south pavilion, the central eastern entrance leads directly into the chapel instead of into the vestibule.)

[4] The round shapes that he makes use of for vestibules and salons are not in good architectural taste, especially for the exteriors.

In the Stockholm plan, octagonal vestibules project forward on the court side; the rectilinear perimeter is broken at the western corners by two huge circular salons, encased in octagonal pavilions. Circle and octagon were apparently equivalent, interchangeable architectural shapes to Colbert.

[5] The vestibules composed of a large round room, of a small oval and of a large square will not be approved.

This objection corresponds exactly to the three-room sequences in the centers of the wings in the Stockholm plan, if we allow for Colbert calling an octagonal vestibule "round" and a rectangular room "square."

[6] The large stair preceded by a large vestibule will be fine.

This accords with the Stockholm plan.

[7] The return [of a wall?] that will have to be made in the *salle des gardes* needs a necessary reason to excuse it.
[8] The suite of the *grand appartement* of the King is beautiful and well-proportioned, except for the vestibule of the *grand salon,* which should be suppressed.

These two comments refer to the *premier étage,* which does not appear on the Stockholm plan.

[9] The small courts will be the receptacles of all the ordures.

Two small interior courts are indeed indicated on the Stockholm drawing at the junctions of the wings and the *corps-de-logis.* They are mentioned again in [12], below.

[10] The small apartments will not have any *enfilade*.

This could refer to the *premier étage* or to the *deuxième étage* (attic), specified in [M27]. In either case, the plans for these floors are lost.

[11] The stair of the vestibule will only have a blank window.

This probably refers to the *premier étage*.

[12] The two service stairs for ascending to the attic will only receive light from the small courts.

Here again, mention is made of the courts referred to in [9] of Colbert's "Observations." The small service stairs adjacent to the two small interior courts in the Stockholm plan doubtless continued up to the top story. Such stairs would have satisfied the requirement of [M28]: "Take care to place as many stairs as one can to service these apartments upstairs."

[13] On the Queen's side: the chapel of 13 *toises* will be too large.

In the Stockholm plan, the chapel in the southeast corner (Queen's side) is only about 8 *toises* long. Kimball, noting this disparity, wrote: "The plan, then, cannot be the competitive one submitted by Le Vau that June, but is, rather, a revision of it. Let us call it Le Vau's revised competitive plan."[27] Kimball's point will be returned to later.

[14] The tribune above will be too large.

This is probably a reference to the gallery of the chapel, perhaps indicated in plan by the curved recess on the western periphery of the room.

[15] If the coaches do not enter the court, it will be far to go to find the stair. To make a continuation of the *appartement belle,* there will only be one stair that ascends to the attic.

Colbert's first point about carriages not entering the court corresponds to [M8]: "The King wishes . . . that the coaches not enter [the court]." Nevertheless, it is difficult to reconcile the criticism expressed in the first sentence of "Observations" [15] with the Stockholm plan. In the drawing, the stairs of both wings are close to the eastern ends of the wings; the vestibule for the king's stair, the easternmost room of the north wing, is nearest to visitors arriving from the *avant-cour*. Colbert's last sentence in "Observations" [15] applies to the *premier étage,* as do the following criticisms:

[16] The Queen will not have any *appartement de commodité,* nor Monseigneur the Dauphin.
[17] There is no entrance from the *grand appartement* of the Queen to the small, beautiful, or commodious ones.

In [M25] an *appartement de commodité* for the queen was specifically requested.[28]

> [18] The advances of the two pavilions and vestibules in the wings will not be pleasing.

This clearly corresponds to what appears on the Stockholm plan.

> [19] The exterior ornaments of pilasters and columns are too common and ordinary. [20] The arrangement of the salon, which will be separated from the gallery, is a fault.

It is not clear whether this comment applies to the Stockholm drawing or to the lost plan of the *premier étage*.

> [21] The openings of the arcades will be 7 feet.

This final comment will be returned to later.

This analysis has revealed that a considerable number of Colbert's remarks seem to apply to the Stockholm plan (fig. 18). Furthermore, some details of the plan fulfill a number of additional demands of the "Memoir":

> [M8] The King wishes that the court be appropriate, that there be a fountain in the center, and that the coaches not enter;

A central fountain is indicated in the Stockholm plan.

> [M9] That from the center of the court the four views be open:
> [M10] The one of the entrance through the middle, which will be empty;
> [M11] The one of the garden façade through the arcades of the lower gallery;
> [M12] Those of the two wings through open vestibules.

The Stockholm plan would seem to satisfy these demands, although the views through the south and north wings would have been rather constricted; however, the view into the western garden would have been through a vestibule, not a gallery as requested in [M11].

> [M24] From the stair, it is necessary to enter into the two apartments, so that the large one will be always closed.

As Kimball noted,[29] this specification implies doubled ranges of rooms, features of the Stockholm plan.

> [M30] The gallery on the façade is to have a salon in the center, if possible.

This demand is fulfilled by the Stockholm drawing for the *rez-de-chaussée;*[30] a salon above the ground-floor vestibule, similarly flanked by galleries, may also have been projected for the *premier étage*.

[M31] Notice that, if one continues the wings up to the pavilions of the *basse-cour,* the centers will no longer exist by pulling down the *avant-corps,* and, by pulling them down, nothing more will remain.

Colbert here cautions the competing architects against continuing the newly constructed wings of the Enveloppe towards the east, where they would abut the service structures of 1662.[31] If this happened, the symmetry of the south and north garden elevations of the Enveloppe would be disturbed, unless the projecting *avant-corps* of the Enveloppe façades (which create the symmetry) were removed. But such a procedure would have been too destructive. In the Stockholm plan, the wings of the Château are not extended to meet the service blocks. In fact, Le Vau here proposed to eliminate them, for they are indicated by dots. It is evident that Le Vau made this suggestion because the service structures would have blocked views of, and access to, the ends of the Château wings.[32]

[M32] Notice that in arriving from the gardens, the King will have to turn around in the *appartement des bains,* or from the other side, or traverse the whole court to find his stair.

The four rooms of the *appartement des bains* on the ground floor that the king had requested in [M17] may well be the large ones located in the Stockholm drawing along the north range of the north wing; this corresponds roughly to their ultimate location in the final Enveloppe. In [M32] Colbert advised the architects that when the king arrived from the gardens, there were certain expected routes by which he would proceed to his stair in the north wing: through the *appartement des bains* or across the court coming from the western or southern ranges. The Stockholm plan satisfies these demands.[33]

[M33] The court will be 28 *toises* wide by 34 *toises* long.

Le Vau jotted down the dimensions of the courtyard on the Stockholm drawing: 33 *toises* long and 27 *toises* at the widest—very close indeed to the required measurements.[34]

[M34] The garden façade is 35 *toises.*

This is probably a reference to the western façade, which measures about 36 *toises* between the corner pavilions.

[M35] Up to the pavilion of the *basse-cour,* 7 *toises.*
[M36] In all, 42 *toises.*

	Toises.	Feet.
The *cabinet* of the façade is	5	1
The *grande chambre* is	5	2
The *antichambre* is	8	1
The *salle des festins* is	11	4
The thickness of the walls is	2	–
The two walls in front	2	–
Total	34	2
Remaining for the stair	7	4
Total	42	

[M37] Adding the 7 *toises,* the center will no longer exist by removing the *avant-corps.* By removing the *avant-corps,* it is necessary to demolish the walls behind and the arcades in front. That's to demolish the whole building.

Concerning [M35] through [M37], Kimball wrote: "Colbert adds an interesting calculation on the hypothesis that the wings might be brought eastward to the pavilions of the *basse-cour,* extending the enfilade of the apartments and devoting this space, in the suite of the Appartement du Roi, to the staircase. His discussion with the king must indeed have involved this hypothesis, with its supposed consequence that the several existing *avant-corps* must be removed to achieve symmetry in the extended façades."[35]

But [M37] is a restatement of [M31], and both passages indicate that the king and Colbert were opposed to this extension. Colbert's measurement of 42 *toises* for the length of a wing is very close to the measurement on the Stockholm plan (about 43 *toises*), and the 7 *toises* cited in [M35] more or less correspond to the distance from the ends of the wings to the service blocks of 1662, which are indicated by dots. The Stockholm plan preserves the existing *avant-corps* of the Enveloppe (cf. figs. 10–12) and does not extend the wings to the east. Kimball assumed that the rooms itemized in [M36] comprised the *grand appartement* of the king; this is indeed probable, and these rooms would correspond to the requirements described in [M21]: "Above, the *grand appartement* of the King, *salle, antichambre, grande chambre, grand cabinet.*" Colbert was obviously concerned about the lengths of these important rooms in their east-west extensions. The measurements stipulated in [M36] grant some idea of the dimensions of the rooms of the king's apartment, which undoubtedly stood above the main suite of rooms on the garden side of the north wing in the Stockholm drawing.

We can conclude, therefore, that the Stockholm plan (fig. 18), as Kimball determined, is Le Vau's "revised competitive plan" of 1669, even though it retains a number of features that Colbert had criticized in the first plan. It seems quite similar to the lost original competition plan of June, though it has a significantly smaller chapel. But it remains to analyze how this surviving plan and its lost predecessor preserved "everything that was built," that is, the Enveloppe as it existed at the beginning of June 1669.

We shall recall that Petit's report to Colbert of June 8, 1669, stated that the south façade had reached a height of over 19 French feet, that the north façade was over 20 French feet high, and that "The hard stone arcaded wall which must carry the terrace between the two pavilions of the château on the side of the large parterre is 13 feet high." We have previously noted that this sentence, with its mention of a terrace between pavilions, accords with the western elevation of the Enveloppe as originally built (figs. 6, 7), and there is no reason to believe that the new structure, begun in October 1668 and halted in June 1669, differed significantly in overall plan and massing at least, from the building as completed.

However, evidence for an alternative elevation of the Enveloppe is found in a longitudinal drawing in Stockholm (fig. 13), which conveniently depicts the junction of the Petit Château and the Enveloppe. The elevation of the Enveloppe shown here differs from Le Vau's final design. In figure 14 (detail of fig. 13) we see the western terrace and its ground floor supports; the wall above forms part of the Enveloppe façade overlooking the terrace. Moreover, in this drawing, a colossal order of Ionic pilasters embraces two floors: the lower story (*premier étage*) is pierced with long rectangular windows, the upper story with square ones; and the elevation is terminated by a full entablature, with tall vases on a low blocking course above the cornice. In the Enveloppe as executed (figs. 6, 7), however, the colossal order was not used: the Ionic

pilasters are confined to the *premier étage,* where they enclose rectangular windows and horizontal bas-relief panels; the *deuxième étage,* above the Ionic entablature, contains squarish windows placed between dwarf Corinthian pilasters, and the elevation is terminated by a full blocking course with balusters.

The longitudinal drawing from Stockholm (fig. 13) would seem to be a unique document of an alternative proposal for the elevation of Le Vau's Enveloppe. It is impossible to determine whether the Enveloppe, when it was begun in October 1668, utilized the colossal order of this drawing, or whether the latter merely constitutes a proposal. However that may be, the initial Enveloppe was probably like the final structure with respect to the lengths of the south, north, and west façades. The north and south façades of the Enveloppe, as built, are each about 33 *toises* long, and this is the length of the north and south wings in the "revised competitive plan" (fig. 18) if measured from the east to the *beginnings* of the proposed octagonal pavilions. We note that the north and south garden façades are articulated by three *avant-corps,* both in this plan (fig. 18) and in the Enveloppe (figs. 10–12), and that the widths of the outer ranges of rooms in the Stockholm plan (fig. 18) match the widths of the Enveloppe wings.[36] It follows from this, then, that in the competition scheme of the summer of 1669, Le Vau proposed that the western arches, then rising to support the terrace of the Enveloppe, be used instead to form the *rez-de-chaussée* of the court (!) elevation of a new *corps-de-logis* that would present a new entrance façade, due to the razing of the Petit Château. Thus, when Colbert wrote that Le Vau's competition plan "preserves everything that was built"—in reply to the king's demand "to make use of everything newly made"—he specifically meant that Le Vau had proposed to retain both the north and south wings, then rising, and the western arches "which must carry the terrace," all features reported by Petit on June 8, 1669. In his "revised competitive plan" (fig. 18), Le Vau, then, boldly designed a new, massive *corps-de-logis* much further to the west, a unit which was to have had an internal north-south enfilade in alignment with the north-south garden axis recently established by Le Nôtre.

The competition of the summer of 1669 was apparently won by the first architect, but if his winning design was begun, construction must have been limited in scope.[37] Probably in the late summer or fall of that year, Colbert expressed grave reservations about Le Vau's new project, and urged a return to the original Enveloppe scheme, which retained the Petit Château. All of this is contained in Colbert's undated document, the "Raisons générales."[38] This difficult document contains several obscurities; nevertheless, it seems to fit in most logically at this point in the chronology, and serves to explain the final decisions in the whole affair.

[1] Everything that they plan to do is only patch-work which will never be good.

By "patch-work" ("rapetasserie"), Colbert is evidently referring to Le Vau's proposed addition of a western *corps-de-logis* to the north and south wings of the Enveloppe and to the incorporation of the western arches of the terrace into the façade of the court.

[2] All beautiful houses should be elevated, and the maximum elevation is always best.
[3] That of Versailles is almost hidden [when seen] from the water basin at the farther end by the parterre in the form of an amphitheater.[39] Thus it would be more necessary to raise it.

"Raisons générales" [6], as we shall see, states that the court elevation (of the "revised competitive plan" [fig. 18]) is 60 French feet high. We can assume that the western garden

elevation was to be the same height, which is the height of the Enveloppe as executed. Colbert's observations in "Raisons générales" [2] and [3] are probably directed at both designs, which featured low, but very innovative, garden façades. By "the water basin at the farther end," mentioned in "Raisons générales" [3], Colbert refers to the Basin of Apollo; looking at the garden façade from this point in the park, he finds fault with its low profile, which the Fer-à-Cheval ("parterre in the form of an amphitheater") would further diminish. His criticism, which was probably based to some extent on the rising construction and also on perspective drawings, can be understood by referring to Silvestre's view of 1674 (fig. 7), which shows the completed Enveloppe.

> [4] It is necessary to ruin the beauty given by the elevation of the *avant-cour* and the court, because of the foundations of the new building.

This is a puzzling comment. Since the foundations are not visible, it is difficult to understand how they could have spoiled the views of the *avant-cour* (the space between the two structures indicated in wash in figure 18)[40] and the courtyard.

> [5] Whatever may be done, the windows and the arches will always be small, being able to have at the most only 6½ feet, and they should have 9 or 10.

In his design of the Enveloppe, which retained the Petit Château (figs. 10–12), Le Vau used the narrow openings of the old building to determine the widths of windows, portals, and arches in the new fabric.[41] These narrow openings were part of the first campaign of construction of the Enveloppe (October 1668–June 1669) and, of course, appear in the "revised competitive plan" (fig. 18), which incorporates the newly built parts of the Enveloppe. Colbert's remarks in "Raisons générales" [5] are directed at this situation, which appears in the wings and courtyard on the Stockholm plan (fig. 18), where Le Vau indicated wider openings for the proposed western elevation.

> [6] The elevation of the interior of the court will be 60 feet in height, and the court will only be 28 *toises* wide by 34 *toises* long.
> [7] There is no proportion observed in these measurements.
> [8] There will be only one sole court in that entire building[42] which will be much wider than long.

Kimball cited the three passages above[43] as evidence of an initial project by Le Vau for a new château in which, according to Kimball, the destruction of the Château of Louis XIII was envisaged, and the erection of a building around a single court, approximately 34 *toises* (about 204 French feet) wide was planned.[44] However, in "Raisons générales" [6] Colbert gives the *length* of the court under discussion as 34 *toises,* and 28 *toises* as its width. These measurements are identical to those called for in [33] of the "Memoir of what the King wants in his building at Versailles" (probably written early in June 1669), and they are very close to those marked by Le Vau on the Stockholm plan (fig. 18), which are 33 *toises* in length by 27 *toises* in width. A court elevation of 60 *pieds,* given by Colbert in "Raisons générales" [6], corresponds to the height of the Enveloppe. (Le Vau's competition project was probably of the same height.) In "Raisons générales" [7], however, Colbert judges the proposed length, width, and height of the courtyard to be proportionally unsatisfactory. "Raisons générales" [8], then, makes sense in relation

to the Stockholm plan only if "which" ("qui") is taken as referring to "building" ("maison"). In the Stockholm plan, the Château measures 56 *toises* in width (if measured between the outer walls of the western, octagonal pavilions) by 44 *toises* in length (including the pavilions); these measurements could cause the building to be characterized as "much wider than long."

> [9] The size of the rooms, which will be 6, 7, 8 and 10 *toises* by 5 *toises* and 5½ *toises* wide, will not be in any proportion to the smallness of the court and of the building in general.

These room measurements could apply to the Stockholm plan and/or to the lost *premier étage*. Colbert here pronounces the building and courtyard to be too small, a theme to which he will return.

> [10] Every person who has architectural taste, at present and in the future, will find that this château shall resemble a little man who would have large arms, a big head, that is to say a monster among buildings.

Colbert here seems to judge the wings too thick in relation to the building; "a big head" might be a way of indicating a high central pavilion, although this feature is not suggested by Colbert's comments in "Raisons générales" [2] and [3]. Colbert's anthropomorphic simile is one common in seventeenth-century architectural thought.

> [11] For these reasons, it seems that one would have to decide to raze and make a large building.

Colbert now embarks on a path of reasoning which proceeds from the conviction that the retention of the already-constructed parts of the Enveloppe ("everything newly made") will necessarily result in a château that is too small.

> [12] There are only 52 *toises* of width between the avenues of the two parterres, and 90 *toises* of length between the avenue of the large parterre in front and the entrance of the *demi-lune*.

The measurements refer to the width available between the east-west garden *allées* flanking the Château at north and south in the Stockholm drawing (fig. 18), and to the distance from the central steps of the west façade *eastwards* to the beginning of the oval entrance plaza (fig. 3); the plaza is indicated by dots in the Stockholm plan and was still extant in 1669. Judging these to be constraining limits, Colbert continues with "Raisons générales":

> [13] It is impossible to construct a large building in that space.
> [14] The land is limited not only by the parterres, but even by the village, the church, the pond. The large slope of the parterres and the avenues do not permit spreading out or occupying more land, without turning everything upside down and without making a prodigious expenditure.
> [15] It is true that the parterre of flowers [the south parterre] is at the level of the château, but the other [the north parterre] has a big slope, added that the château must have an even or level parterre, or a terrace, which would be impossible.

[16] There is no likelihood that the King will wish to occupy more land than that which this place can naturally offer, since to occupy more of it, it would be necessary to turn everything upside down, make a prodigious expenditure, which it will be more fitting or more glorious for the King to make at the Louvre or in some great works, and may the King restrain himself for a long time in the pleasure that he takes in this building.

[17] There is therefore no likelihood that His Majesty will adopt that resolution [i.e., to destroy everything and construct a large château].[45]

[18] It remains to consider whether it is necessary to raze everything or keep what was newly erected.

Having ruled out the possibility of destroying everything, both old and new, in order to erect a large palace, Colbert now considers whether the parts of the Enveloppe already constructed (between October 1668 and June 1669) should be pulled down or retained:

[19] In razing everything, it is certain that the incertitude, the perpetual changes and the great expenditure do not concur with all the great actions of the King. Besides which, by not being able to construct a large building, everything that will be done will have no proportion with the rest of the conduct of His Majesty.

[20] In keeping that which was erected, one falls into the inconveniences indicated above.

[21] There would be a third course, to keep to the resolution taken last year, to leave the Petit Château, and to build the Enveloppe following the design [already] begun.

Colbert here reveals that in 1668 the king had resolved to retain the Petit Château and to enclose it in the Enveloppe. Le Vau must have devised his design before October of that year when, as demonstrated previously, the construction began. Thus, in the late summer or fall of 1669, Colbert reached a point where he disapproved of Le Vau's "revised competitive plan" after all, and desired a return to the original Enveloppe scheme of 1668. The superintendent of the king's buildings then proceeds to a justification of the Enveloppe, a design that would not diminish the glory or reputation of his king:

[22] This course satisfies the reasonable opinion that the King do nothing during his reign that is not proportioned to his greatness, that is to say monstrous, but a well-arranged monster.

Colbert evidently regarded the combination of Petit Château and Enveloppe as a tolerable monster of an architectural composition.

[23] Everyone will see that the King had this little pleasure-house and added to it only buildings for his lodging and for the entire court. In one word, this building will not be considered to be a work of His Majesty alone. But it will be quite necessary to be careful not to attempt to join one room of the Petit Château to one of the large [Château], which would always be wrong, or to cover over or to join to the wall of the Petit [Château] within the court another wall adorned with columns and marbles, and erected to hide the roofs, since this Petit Château would then be imprisoned between a large wall and a large *corps-de-logis,* which could be censured more than anything else.

In this interesting passage, Colbert says that, above all, the Château of Louis XIII must not be covered over on the court side by any new construction, but must remain exposed so that all can see that the Château of Versailles in its entirety is not a work of Louis XIV alone. Furthermore, none of the rooms of the old Château is to be directly connected to those of the new Enveloppe. We find this stricture observed in the plans (figs. 10–12), where only small stairs and passageways link the two parts of the structure.

> [24] That which could be against that resolution is the great and public declaration that the King has made to raze the Petit Château, which gives a commitment such that it cannot be withdrawn.

The "résolution" referred to, already defined in "Raisons générales" [21], is the decision of 1668 to retain the Petit Château and to build the Enveloppe around it. The "grande et publique déclaration" of the king to pull down the old structure must have been made in June 1669; it was this that brought the construction of the Enveloppe to a halt and opened the way to the competition for a château that did not incorporate Louis XIII's old building. In "Raisons générales" [24], then, Colbert expresses his discomfort over the idea that the Petit Château would be retained in contradiction to a royal public statement.

In his analysis of the "Raisons générales," Kimball concluded that Louis XIV had always wanted his father's château demolished, and that Colbert had argued for its retention. This conclusion needs to be amended. According to Kimball, Charles Perrault's account of the king's insistence on keeping the old structure was a fabrication.[46] It is true that a number of statements by Perrault about the arts under Louis XIV have been rightly challenged by modern historians. In this case, however, Perrault is supported by André Félibien, the official historiographer of the royal buildings, in a statement about the old Château not mentioned by Kimball: " . . . since His Majesty has had this devotion for the memory of the late king his father not to pull down anything that he had had built, everything that has been added there does not prevent one from seeing the old palace as it formerly was. . . . "[47]

The preceding analyses have revealed that in 1668 the king had resolved to preserve his father's Château, which was to be enclosed on three sides by Le Vau's Enveloppe. In June of the following year, Louis XIV changed his mind, halted construction of the Enveloppe, and opened a competition for a new building that, while incorporating the work already done on the Enveloppe, would not link up with the Petit Château, which was to be pulled down. Then Colbert, in the late summer or fall of 1669, voiced dissatisfaction with Le Vau's "revised competitive plan" and urged a return to the Enveloppe design. This advice was accepted by the king. Thus, except during a few months in 1669, Louis XIV consistently favored retaining the Petit Château. Félibien and Perrault assert that the king wished to preserve the old building as a reminder of his father, Louis XIII, and this was certainly the attitude that the son mainly adhered to and that prevailed in the end. While Colbert argued in the "Raisons générales" for a return to the Enveloppe idea, the final points of his memorandum reveal that the superintendent was resigned to the scheme, which retained the Petit Château; but at heart he was unhappy about the entire matter, as is clear from "Raisons générales" [25] through [27]:

> [25] It will remain therefore to choose the course, either to do nothing worthwhile by keeping that which was built [i.e., the parts of the Enveloppe already standing, to be incorporated into Le Vau's "revised competitive plan"], or to do only something small by razing it [because the site could not accommodate a truly large château]. In

either case, the eternal memory which will remain of the King by this building will be pitiful.

[26] It is desirable that the building fall when the King's pleasure shall be satisfied.

[27] Choose the resolution of the King.

We can almost hear Colbert's deep sigh of resignation as he finished writing [27], a reference to [21] "There would be a third course, to keep to the resolution taken last year, to leave the Petit Château, and to build the Enveloppe following the design [already] begun."

Colbert's view of Versailles in 1669 as essentially a place designed for the king's pleasure but unrepresentative of his grandeur is thoroughly consistent with his famous letter of September 28, 1663 to Louis XIV.[48] There, Colbert declared that Versailles "concerns much more the pleasure and the diversion of Your Majesty than his glory . . . "; that

> during the time that [Your Majesty] has spent such large amounts for this building, [Your Majesty] has neglected the Louvre, which is assuredly the finest palace in the world and the most fitting for the grandeur of Your Majesty. . .;[49] Your Majesty knows that in lieu of magnificent acts of warfare, nothing betokens more the grandeur and the spirit of princes than buildings; and all of posterity measures them by the standard of these superb buildings that they have erected during their lives. O what a pity if the greatest king and the most virtuous—of the true virtue which creates the greatest princes—were measured by the standard of Versailles! And yet there is reason to fear this misfortune.[50]

In the second half of 1669 (or in early 1670 at the latest), the king, following the suggestion put forth by Colbert in the "Raisons générales," shelved Le Vau's competition scheme and returned to his Enveloppe and to the retention of the Petit Château. This constituted Louis' final decision in a process marked by royal vacillation about the fate of his father's Château.

The reasons for that vacillation are not difficult to fathom. Louis was torn between filial piety on the one hand and aesthetic considerations on the other. The old brick-and-stone structure of Philibert Le Roy (1631–34; figs. 1–3)[51] was démodé by the 1660s and too small for the court. But it was, after all, his father's building, and to destroy it might have seemed a disrespectful act. The king knew that the old Château would be out of scale with and entirely dissimilar in style to the new royal architecture that Le Vau was providing in the Enveloppe, but in the end Louis resigned himself to this lack of aesthetic unity. At least he could console himself with the fact that the new and old elevations could never be viewed simultaneously from the same fixed point.

Let us return to the building chronology. The *Comptes* for 1669 and 1670 do not distinguish between payments for the Enveloppe and payments for Le Vau's "revised competitive plan," so it is not possible to determine precisely when work on the latter was halted (if, indeed, it was ever begun).[52] The contractor Gabriel, described as the "entrepreneur du nouveau bastiment de Versailles," received the large sum of 335,000 *livres* for masonry work in eight payments between January 25, 1669, and January 1, 1670.[53] The sum for masonry work was greatly increased to 586,000 *livres* during 1670.[54]

Substantial carpentry work was also paid for during these crucial years.[55] In letters to the king, written in May 1670, Colbert refers to the Petit Château, clearly indicating that by that

date (and perhaps well before) Le Vau's Enveloppe scheme had been revived. The letters also attest to steady work and to the completion of the masonry work of the garden elevations:

> [May 5, 1670] For Versailles, the cornice of the façade on the parterre is entirely placed. They are proceeding with great diligence, and they are beginning to cut the wood for the roof; I am again increasing the number of workers for the pavilions of the large *avant-cour*.
>
> The coverings of the two wings and pavilions joined to the Petit Château are almost finished, and the stucco-workers will work on the interiors in the week that we are beginning.[56]
>
> [May 9, 1670] I was yesterday at Versailles and at Trianon,[57] where all the work progresses in such a way that I hope Your Majesty will be satisfied.
>
> With regard to Versailles, the cornice on the façade on the parterre will be finished tomorrow, and the attic in the following fifteen days. The carpenter is working at the same time to prepare the roof. . . .
>
> Sieur Le Vau persists in maintaining that it is necessary to close the two arcades of the vestibule, and I am also convinced of this necessity in order to make the Petit Château the more stable.[58]
>
> [May 22, 1670] For Versailles, there are two carpenters' workshops, of which one works during the day and the other at night.[59]

From at least May 1670, then, construction of the Enveloppe proceeded at full speed, along with the erection of the courtside structures (fig. 4);[60] the *Comptes* document this activity.[61] The Enveloppe and the court-side structures were essentially complete in 1673 when Félibien wrote the first "official" guidebook to palace and park, the *Description sommaire du chasteau de Versailles,* printed on December 30, 1673, and published in 1674. Silvestre's two views of Versailles (figs. 4, 7), both dated 1674, were perhaps made to celebrate the completion of the Enveloppe.

One important event of these years must not be overlooked: the death of Louis Le Vau in 1670. We have seen that the *premier architecte* was active at Versailles as late as May 8, 1670, when he advised Colbert of the need to close up arches in the vestibule of the Petit Château. He seems to have spent the summer and autumn of that year in his country house at Brévannes, apparently in ill-health,[62] and died in Paris on October 11.[63] After his death, the post of first architect of the king was left vacant by Colbert, but the responsibility for architectural activity and design at Versailles passed immediately to Le Vau's assistant, François d'Orbay, who remained in control until 1678, when he was superseded by the young and dynamic Jules Hardouin-Mansart.[64]

III

The Enveloppe: Style and Sources

THE Enveloppe (figs. 6, 7) was a revolutionary building within the context of French architecture. Its western elevation appeared as an Italianate villa of the variety with a recessed center between projecting pavilions.[1] This type of composition, rooted in classical antiquity,[2] opened up the traditional cubic massing of Italian architecture. In some Italian villas (cf. fig. 20), a terrace was introduced at first-floor level for viewing and taking the air. This is precisely what we find in Le Vau's Enveloppe. The Italian pedigree of the design is reinforced and confirmed by the straight roofline and the total lack of traditional French high roofing features.[3]

The Italianate quality of this architecture has long been recognized by modern scholars, who have sometimes suggested that it reflects the direct influence of Bernini's third Louvre design of 1665 (fig. 21). Although Le Vau's design may have been influenced in a vague way by Bernini's project, the latter is not of the villa type with a recessed center. Furthermore, it is doubtful that the Enveloppe was ever intended to consciously recall Bernini's Louvre design, for that had recently been rejected and replaced by the new French-designed east and south façades of 1667 and 1668 (figs. 22, 23)—a process influenced certainly by French national pride.

Le Vau's early ideas about the elevation of the Enveloppe are recorded in a drawing of 1668 in Stockholm (fig. 13), and have already been discussed in chapter II. The Enveloppe elevation overlooking the garden terrace appears at the extreme right of this drawing (fig. 14). Here we find an attenuated colossal Ionic pilaster order on high pedestals, carrying a full entablature with a low blocking-course surmounted by tall vases. The colossal pilaster order—Le Vau's favorite motif for the articulation of château façades—is already evident in his first château, Le Raincy (early 1640s, destroyed), and it was later used on the king's and queen's pavilions at Vincennes (1654–61), at Vaux-le-Vicomte (1656–61), and in his Louvre designs (1659–64).

Colossal pilasters also appear in at least two of Le Vau's Parisian houses, the Hôtel Lambert (1640–44) and the Hôtel de Lionne (1662–64; fig. 26).[4]

The significance of Le Vau's use of the colossal order throughout his career was his recognition of its effectiveness from the distant view. Such views were assured, of course, for the châteaux and also for the Louvre façades.[5] When designing urban *hôtels* on cramped city streets, Le Vau employed the colossal order only when it could be seen from some distance, as on the garden façades of the Hôtels Lambert and de Lionne (fig. 26); he never used the orders in any form on street façades or in courtyards.

Thus, the projected use of the colossal order on the garden façades of the Enveloppe, as recorded in figures 13 and 14, is perfectly consistent with Le Vau's entire architectural career and may be regarded as his initial, almost intuitive, response to the architectural problem. The pilasters are extremely elongated and are very similar to those of the Hôtel de Lionne, as recorded by Marot (fig. 26).

In the Enveloppe design as executed, however, the colossal order was rejected (figs. 6–9). Instead, the *bel étage* received its own Ionic order, and the windows of the *deuxième étage* (now in the form of an attic) were framed by dwarf pilasters with modified Corinthian capitals. Two drawings in Stockholm (figs. 15, 16), which appear to be working drawings from Le Vau's office for the revised Enveloppe elevations,[6] correspond in all details to the executed architecture, except that the sculptural details of keystones and rectangular panels are not delineated on the drawings. Figure 15 depicts the wall at the rear of the terrace that abutted the Petit Château; here the draughtsman has recorded the smaller windows of the old building, indicating by parallel shading the difference in size between the openings of the old and new construction. Drawings like these were probably sent from Le Vau's office to the contractor, Jacques IV Gabriel, to guide the masons.

The change from the projected elevation with a colossal order to the executed elevation with a one-story order was probably due to a decision made in 1668 to embellish the Enveloppe façades with an elaborate program of sculptural decoration.[7] The main features of this decoration are the monumental statues placed upon the entablatures of the free-standing columns of the *avant-corps* (figs. 6–8).[8] Such *avant-corps* are not indicated in Le Vau's initial project, which still employs the colossal order (fig. 14). Locating the statues on an *avant-corps* meant that they would be placed on a level closer to the spectator than their positioning above the top floor would have allowed. (Conventional vases and trophies appear in the latter location.) The result is two levels of façade sculpture, one above the *premier étage,* which is decorated with statues whose attributes allow for specific identification, and a second above the attic, which is decorated with vases and trophies.

Just as Le Vau's overall massing was derived from Italian ⊓-plan villas, so the articulation of his elevations was based on Italian prototypes, specifically on the architecture of the Roman High Renaissance. Blunt has rightly invoked the name of Bramante,[9] and this suggests a comparison with Bramante's Palazzo Caprini, begun ca. 1501 and now destroyed (fig. 24) and, especially, with the Raphaelesque Palazzo Caffarelli-Vidoni by Lorenzo Lorenzetti, begun ca. 1524 (fig. 25), which was in turn based on Bramante's building.[10] The Palazzo Caffarelli-Vidoni, in its present enlarged form with a third story that was added sometime between 1560 and 1625,[11] comes closest to the façade articulation of Le Vau's Enveloppe. The rectangular windows on the first floor of this *palazzo,* with rectangular panels above them, correspond to the windows topped by sculptured panels in Le Vau's *premier étage.*[12] Both Roman *palazzi* feature a rusticated ground floor, balconies with balusters in front of each window of the main story, and a full entablature crowning the first floor—all features found at Versailles. And at the

Palazzo Caffarelli-Vidoni in its expanded form a flatly articulated attic story appears, as in the Enveloppe.[13]

A major difference, however, is Le Vau's use of projecting columnar *avant-corps* of paired columns, with the wall of the *premier étage* articulated with pilasters; in the two Roman *palazzi,* engaged columns in one plane appear throughout. Despite this difference, it is evident that the primary sources for the Enveloppe were Italian ⊓-plan villas (with terrace) and Roman High Renaissance palaces, particularly the Palazzo Caffarelli-Vidoni.[14] Italian influences have been noted in Le Vau's earlier buildings, but these influences come from contemporary Baroque architecture.[15] The harkening back to the High Renaissance in the façade design of the Enveloppe marks an entirely new development in Le Vau's career, as does the general style of the edifice. Gone are his characteristic high, complex roofing forms and curving projections of volumes. Despite the trophies and vases that enliven the roofline, the building stresses severe cubic massing and a low, rectangular profile to a degree unusual in France. The result is an *avant-garde* design, as unconventional as the recently begun Louvre Colonnade (fig. 22), the other new architectural expression of the French monarchy.

In contrast to the Enveloppe, Le Vau's revised competition scheme of the summer of 1669 (fig. 18) can readily be understood as an outgrowth of his characteristic style.[16] The central-plan salons of the *corps-de-logis* and the central pavilions of the wings facing the court would have produced Le Vau's typical bulging walls, expressive of interior volumes. The court pavilions in particular have forerunners in Le Vau's superposed Louvre rotundas of Mars and Apollo, 1655–58 (fig. 19).[17] Marie has compared the large central-plan salons to the semimedieval towers of French Renaissance châteaux.[18] In introducing this motif at the corners of the main garden façade, Le Vau may well have been influenced by Claude Perrault's Observatoire in Paris (1667–71), then rising, even though the motif was *retardataire.*

Many of the planning features of the Stockholm drawing (fig. 18) are typical of Le Vau. The use of double files of rooms in all three ranges is to be expected from his earlier work, such as the Hôtel Hesselin, Paris (ca. 1640–ca. 1644), and Vaux-le-Vicomte (1656–61). The columnar vestibule of the *corps-de-logis* is a favorite motif of his for châteaux, beginning with Le Raincy (early 1640s),[19] and the free-standing columns placed well within the vestibule are also features of the latter building. Finally, we find enfilades in all three ranges, as in Le Vau's other châteaux. It is important to notice that the enfilade of the *corps-de-logis* was precisely coordinated with Le Nôtre's new north-south garden axis,[20] so that a view along that axis would have been possible from *within* the Château; this is in contrast to the eventual decision, in which the garden axis passes in front of the western façade, not through it.

The abandonment of Le Vau's revised competition scheme in 1669 was principally due to the king's final decision to retain the Petit Château.[21] It is evident from Colbert's comments that the minister, at least, was aesthetically repelled by the protruding forms on garden façade and courtyard, for he wrote: "The round shapes that he makes use of for vestibules and salons are not in good architectural taste, especially for the exteriors."[22] This comment alone helps to explain why Colbert halted Le Vau's Louvre project in 1664, and why the superintendent was in general antipathetic to Le Vau's usual style: it was too Baroque in the sense that it frequently featured movemented, protruding pavilions, which relate his buildings to contemporary Italian experiments with the curving wall.[23]

Whereas Le Vau's competition design can be readily related to his on-going idiom, the façades of the Enveloppe, whether in their initial version (fig. 14) or their final version (figs. 6, 7), are

difficult to understand in the context of Le Vau's style. He had never previously turned to the Roman High Renaissance for sources for his elevations; in no other place in his *oeuvre* do we find a rusticated *rez-de-chaussée* serving as a podium for more lightly articulated stories above. The projecting, free-standing columnar frontispieces of the Enveloppe are without precedent in his work. In addition, an uncharacteristic detail occurs in the treatment of the orders of the Enveloppe: in both the Stockholm drawing (fig. 14) and in the executed building (fig. 9), the edges of the corner pilasters meet at the salient edges of the building. In all of his previous designs, without exception, Le Vau had slightly set back his terminal pilasters from the corners.[24] It could be argued that the architect departed from his customary handling in order to harmonize the corner treatment of the Enveloppe with the corners of the Petit Château, where the pilasters meet (figs. 4, 5), but this is doubtful. It is more likely that this detail confirms observations about the Enveloppe as a whole: that it stands apart from Le Vau's *oeuvre* in a marked way, so that it is difficult to understand as an organic outgrowth of his evolving style. One is therefore forced to reconsider Laprade's controversial thesis that François d'Orbay—Le Vau's chief assistant—was the real designer of the Enveloppe.[25]

Laprade's attribution of the Enveloppe to d'Orbay is part of a far more sweeping theory that maintains that d'Orbay designed virtually all of Le Vau's major projects from the early 1660s to 1670 (the year of Le Vau's death), as well as those of Jules Hardouin-Mansart from 1678 until d'Orbay's demise in 1697. During these years, d'Orbay was the chief draughtsman to these royal architects, but Laprade argues that he was the real designer and, hence, the sole, true creator of the royal architectural style of the Louis XIV period. Much of the evidence marshaled by Laprade in support of his extraordinary claim is fragile and conjectural, and his book predictably elicited much adverse criticism.[26] But in the case of the Enveloppe of Versailles, Laprade's attribution cannot be dismissed out-of-hand because the style of the building is anomalous in relation to Le Vau's idiom, as analyzed above. Was the *premier architecte* capable at the close of his career of a startling stylistic change, or did he leave the design to someone else (that is, d'Orbay, his chief assistant)?

Posing the question in this manner may oversimplify the problem. Let us return to the precious drawing of 1668 in Stockholm (figs. 13, 14), which depicts the Enveloppe elevation with a colossal Ionic order. The extremely elongated Ionic pilasters in this drawing are typical of Le Vau: they are found at Le Raincy, Vaux-le-Vicomte, and the Hôtel de Lionne. In a garden elevation of the Hôtel (fig. 26), we find a composition closely related to the upper two floors of the proposed Enveloppe elevation.[27] But the colossal pilasters of the Hôtel were set back from the corners, in typical Le Vau fashion. In the Stockholm drawing (fig. 14), the pilasters, as previously remarked, are flush with the corners, and the two upper stories rest on a podium that is undoubtedly rusticated as in the final design—features which are not typical of Le Vau. Therefore, the Stockholm drawing, although closely related to one of Le Vau's later works, contains elements that suggest a shift in style or the intervention of a new personality, who would logically have been d'Orbay.

In the new Louvre façades of 1667 and 1668 (figs. 22, 23), colossal Corinthian pilasters meet at the corners of the structure. Those who maintain that Le Vau was the principal designer of these elevations must concede that here, too, is found a feature uncharacteristic of the *premier architecte*. However, the authorship of these Louvre façades is still an unresolved question; Le Vau's responsibility is moot, and therefore these majestic elevations cannot yet be used as evidence of a change in Le Vau's personal style in the 1660s. At present, the only certain observation that can be made is that the Stockholm drawing (figs. 13, 14) follows organically from the garden façade of the Hôtel de Lionne of 1662–64 (fig. 26), except for the treatment of

the corner pilasters and the use of a rusticated podium—elements that suggest either an internal stylistic shift or the influence of a collaborator (presumably d'Orbay). But the Enveloppe façades as built (figs. 6–8)—which retain the features of the Stockholm drawing that are uncharacteristic of Le Vau—depart entirely from Le Vau's established *oeuvre* in the ways analyzed above. Whether these façades should be ascribed to Le Vau or to d'Orbay depends in part on one's sense of the degree of an artist's potential for stylistic change in a given context. Laprade believed that Louis Le Vau could never have so drastically modified his style as to produce the Enveloppe elevations; others feel that such a stylistic change is possible, without assuming any active collaborator.

At this point it is useful to survey d'Orbay's independent designs before 1670 for clues to his personal style. Such designs are very few. The earliest is the project for a monumental stairway below S. Trinità dei Monti in Rome (fig. 27), executed in 1660 while he was in the Eternal City.[28] But d'Orbay avoided using the orders in this project—corner articulation is by means of quoining strips—and there is no rusticated *rez-de-chaussée* for the flanking buildings. D'Orbay's treatment of these structures is decidedly complex and Mannerist, with pediments-within-pediments, pediments broken by decorative intrusions, framing bands, and fussy, small-scale decorative motifs. The design hardly seems to indicate a future classicist.

After his return to Paris in 1660, d'Orbay resumed working for Le Vau as an assistant, but also undertook minor independent commissions. In 1662–63 he built the convent of the Prémontrés. There, the chapel façade (fig. 28) continues the taste for decorative richness found in the Roman staircase design, with a portal flanked by Tuscan pilasters in two planes; again, the corners are articulated with quoining strips. No other independent projects of the 1660s by d'Orbay are known. In 1671 he built the façade of the Chapelle de la Trinité in Paris. Marot's engraving (fig. 29) shows a more sober approach and a more pronounced use of the orders, but also corner pilasters *set back* in the Le Vau tradition!

Thus, none of d'Orbay's known personal creations of 1660–71 (a monumental staircase project and two chapel façades) can be compared to the Enveloppe façades, and in the one instance where he used corner pilasters, d'Orbay treated them in a manner unlike Versailles.[29] Thus, the available evidence in no way suggests that d'Orbay could have designed the new Versailles elevations. The conclusion must be that Le Vau himself profoundly revised his style at the end of his career (in 1668 he was fifty-six years old).[30]

This conclusion is reinforced by the important testimony of none other than Charles Perrault, who in 1693 categorically attributed the Enveloppe to Le Vau: "They afterwards constructed the three great *corps-de-logis* which surround the Petit Château and which have their façades turned to the gardens. . . . these three *corps-de-logis* . . . are of the design of M. Le Vau. . . ."[31] And Perrault added that the new structures were "beaux et magnifiques."

It is well known that Perrault was no champion of Le Vau's reputation. Throughout his long life, Perrault maintained that the Louvre Colonnade (fig. 22) had been designed by his brother, Claude, and he argued against those who attributed it to Le Vau (and d'Orbay).[32] If Perrault believed that the assistant was the true author of the Enveloppe, he would certainly have said so. Furthermore, Perrault was in a position to know what had really happened at Versailles.[33] His attribution of the Enveloppe to the *premier architecte* is formal and unqualified, and it harmonizes with the conclusions reached above—namely, that the new Château cannot be related stylistically to any of d'Orbay's independent creations of 1660 through 1671, and that at least some features of its elevations can be related to Le Vau's earlier Hôtel de Lionne. These circumstances lead us to conclude that Le Vau did indeed revolutionize his style at Versailles, and that his new architectural imagery for the French king drew, somewhat ironically, upon

Italian sources for the massing and elevations of the new fabric. Yet it seems that these sources were never remarked upon by contemporaries. Félibien's encomium of 1674 characterizes the tone of response to the Enveloppe throughout the reign of Louis XIV: "That great façade which faces the Parterre d'Eau, and the two wings which form the perimeter of the Château well deserve to be examined as much for the majestic grandeur of the entire mass, as for the beauty of the stones with which it is built, the care that was taken to cut them well, and the choice that was made of the statues and ornaments which decorate it."[34]

Despite its Italianisms, the Enveloppe bears the Gallic stamp with its open upper stories (even in its original condition with Le Vau's rectangular windows; see figs. 6, 7), the very smoothly rusticated ground floor, and the decorative emphasis given by the two ranges of sculptural adornments.

What is at first surprising about Le Vau's Enveloppe in comparison to the contemporaneous Louvre Colonnade (fig. 22) is its un-antique flavor. The Colonnade projects the image and aura of classical antiquity, with ranges of free-standing columns, a central pediment, and ornamental detailing that are reminiscent of an ancient temple. The Enveloppe has no such pretensions, despite its apparatus of the classical orders. That is because it was designed as the park façade of a château that in the late 1660s was still intended as a place for royal recreation and informality, not for official, governmental functions and display. In this it differed from the urban Louvre, which Colbert had always fostered as the main seat of the Crown. Thus, the architectural distinctions between the Colonnade and the Enveloppe reflected Colbert's attitudes toward the two buildings. Not until 1682 did Versailles become the official royal residence.

IV

Escalier des Ambassadeurs

THE use of elaborate staircases in residences to create visual monumentality and to induce a dramatic, suspenseful mood in the visitor is characteristic of Baroque art, and the Enveloppe was predictably equipped with such a feature—the Escalier des Ambassadeurs. The history of its design and decoration—marked, like the history of the Enveloppe, by changes of mind—can be closely documented and allows insight into motivating factors at work at Versailles.

In Louis XIII's hunting lodge of 1623–24 at Versailles, a wooden stair occupied the center of the *corps-de-logis*.[1] This location was traditional for a stair, and the form of the stair at Versailles was then in current use: three straight flights with two landings, rising from the ground floor through the first floor to the second floor dormer level by means of right-angle turns around an open well. When the building was transformed by Philibert Le Roy in 1631–34,[2] the location and general form of the stair remained unchanged, but it was probably enlarged and the first flight was rebuilt in stone.

This arrangement was totally altered by Louis XIV in the early 1660s. The king started work at Versailles in 1661,[3] and in a plan perhaps dating from a year later (fig. 1) the stair no longer occupies the center of the *corps-de-logis,* which is now a vestibule permitting free circulation from court to garden and completes the enfilade through this part of the Château. Instead, stairs now appear at the center of each wing. Of identical form and dimension, they are of the same type as Louis XIII's stair. In this plan of ca. 1662 (fig. 1), the initial treads are depicted as curving around the newel post, and this graceful detail reappears in plans for the Enveloppe from Le Vau's office (figs. 10, 11).[4] These stairs were described in 1669 by Madeleine de Scudéry:

> . . . I brought the beautiful stranger out of that lower apartment, and I led her by the stair which is in the wing on that side [the left-hand wing], which she found very

pleasant; in effect, the steps of it are of a jasper marble, the balustrade is of gilt bronze of very beautiful work, all the sides are painted in gilt bas-reliefs, it is very well lit, and although not extremely large it is noble and commodious. There is one just like it in the opposite wing, in which the cupola seems to be an open sky.[5]

This last detail is of interest because the idea of lighting a staircage from above was to become a principal feature of the Escalier des Ambassadeurs.[6]

Le Vau's initial ideas for the stairs of the Enveloppe appear in the two plans previously referred to (figs. 10, 11), which date from 1668. Here the stairs are strongly differentiated: the stair for the south wing (the Escalier de la Reine) consists of a narrow straight flight, similar to the matching stairs of the competition design of summer 1669 (fig. 18) but commencing with a shorter introductory flight (only in fig. 11). The Escalier du Roi, by contrast, is introduced by a large rectangular stepped podium, like the one which Le Vau had used at the Château du Raincy many years before.[7] As in the latter building, one straight flight ascends to the left from the landing at the top of the podium. The staircages for both the king's and queen's stairs were to be located between the ends of the wings of the Enveloppe and the two new short wings in brick-and-stone that were attached to the *pavillons décrochés* of the Petit Château. The three central bays of these short wings formed vestibules of approach for the stairs,[8] but only the westernmost portals were directly aligned with the stairs—an awkward arrangement.

No work on these proposed stairs had been begun by the time Le Vau died in October 1670. A sectional drawing for a new Escalier du Roi (fig. 31), composed by Le Vau's successor, François d'Orbay, indicates a change in design.[9] The drawing is a north-south section through the short northern wing and the end of the northern Enveloppe wing; thus, in viewing the drawing, one looks towards the west (the pavilion at the left is the end of the north wing of the Petit Château). An inscription on the verso reads: "Escalier a deux rampes au côté de la cour et du jardin" ("Stair of two flights on the court and garden sides"). This important indication reveals that the stair was double-branched,[10] with the two flights arising from a podium that is indicated in the drawing by a section of masonry at the base of the stairs (curiously, no steps leading to the top of the podium are shown). The walls of the staircage at the first floor level were to be decorated with sculpture, consisting of circular medallions, trophies, and herms, the latter supporting an unbroken Ionic entablature.[11] A wooden vault is indicated, set within the high-pitched exterior roof, and the cupola is decorated with two bands of rosettes and trophies. A striking feature is the top-light, provided by a skylight, apparently of circular or oval form.

Top-lighting was already provided for the right-hand stair of the Petit Château as we have noted, but the precise form used there is unknown. In earlier French architecture, such lighting for staircages was sometimes used, but in the form of a cupola and lantern, as in François Mansart's Château de Maisons (1642–51),[12] where the light enters the glazed *sides* of the lantern. In d'Orbay's sectional drawing, by contrast, a low lantern surmounts the dome, but the *top* of the lantern is glazed, thus forming a true skylight on the roof of the pavilion, perhaps the first skylight in French architecture.

The drawing also shows a proposal for the decoration of a room of the king's suite in the north wing of the Enveloppe, a room that was eventually to be the second Salon de Vénus (fig. 65). Here we find a simple repetition of the decorative motifs of the staircage, and a closed vault set within the roof. The herm figures appear to be male in this drawing, but in another sectional drawing by d'Orbay, which shows the entire north wing of the Enveloppe (fig. 32), the herms are female, although the room is simply designated as "Grand Pallier du Grand Escallier." Beneath this room, on the *rez-de-chaussée,* an articulation is developed for a room

that in another of the sectional drawings (fig. 31) is totally bare. This room, directly behind the stair, is labeled "Vestibulle d'Entrée," and is the present Salle des Ambassadeurs (or Salle des Hocquetons), which has been restored.[13] Here we find the system of squat piers, decorated with trophies, carrying arches with relief medallions in the spandrels.

It should be noted that d'Orbay's first proposal for the king's stair was an alternative to a design for a large salon or gallery (fig. 30), with the inscription "Profil du Sallon en sa longueur"; the project for a staircase with a separate room of the king's suite to the north (fig. 31) is drawn on flaps of paper that can be turned down over the salon or gallery as well as one of the rooms beneath.[14] The salon/gallery idea, although worked out in considerable detail with respect to its decorations, was soon rejected in favor of the double-branched staircase previously analyzed, which was to develop Le Vau's intention to locate the principal ceremonial staircase in this part of the building.

Payments in the *Comptes* indicate that this stair with its herm decoration was in construction from 1671 until early 1674; d'Orbay's sectional drawings (figs. 31, 32) probably date from late 1670 or early 1671. In January 1671, funds were provided for the continuation of work at Versailles, and this included "les grand et petit escalliers."[15] Payments for steps and stones were made in April and July,[16] and in December mention was made of a model.[17] In January 1672, 19,000 *livres* were provided to finish "le grand escallier," and 75,000 *livres* "For the marble, herms, balustrades and stuccoes of the vault and cornice of the said stair."[18] The mention of herms ("termes") for the decorative scheme would seem to indicate that d'Orbay's design was the one in question. Payments were then made through 1672 for the stair, including the roofing.[19] On July 17, 1672, Colbert wrote to Louis XIV that "The roof of the stair is also almost all cut and they are beginning to put it in place,"[20] and on September 30 the minister wrote the following command: "Ask Sieur d'Orbay for the specifications of everything that remains to be done for the great staircase of the King."[21] Payments for marble work were made from November 1672 to March 1673,[22] and the stair was described in 1673 by Félibien as having ". . . two ramps, one on the right and the other on the left, and when one has arrived by the first onto the large landing, one enters into seven other rooms [the king's apartment]. . . ."[23]

The stair which Félibien so laconically described was not yet complete in 1673, as indicated by the specifications for the work at the beginning of 1674; the mention of "les figures captives" is confirmation that the same scheme was being continued:

> For the marble incrustation of different colors in the walls of the great stair and of the room above which serves it as a landing, with the door-frames and pedestals to carry the captive figures . . . 30,000 *livres*.
> For placing the steps of lias of Senlis of the said stair . . . 3,000 *livres*.
> For placing the marble balustrade of which the socle and banister are of white and black marble, and the balusters of white and red marble . . . 9,000 *livres*.
> For making a fountain in the niche which is on the landing of the stair and for placing there a gilt bronze figure . . . 3,000 *livres*.
> For the pavement of the bottom of the stair and of the great landing and of the five small ones . . . 22,000 *livres*.
> For all the work and ornaments in stucco of the said stair . . . 25,000 *livres*.[24]

Payments for work on the stair are documented throughout 1674,[25] but on June 8, mention is made of a model of the "grand escallier" for which the woodworker Jacques Prou and the

sculptor Michel Anguier were paid.[26] Since a model already existed in December 1671 (see above), it is apparent that a new one had been prepared in 1674, during the first half of the year, thus indicating a change in design.[27] On July 6 a payment was made "to Rossignol, for the workers who have rough-cast, coated, and painted in fresco the great stair,"[28] thus confirming the design change, for a program of fresco paintings—not envisaged in d'Orbay's project (fig. 31)—was to characterize the final, executed Escalier des Ambassadeurs, which was carried out in all details from 1674 to 1680.[29]

The Escalier des Ambassadeurs was destroyed in 1752 at the command of Louis XV in order to accommodate a cluster of domestic rooms and an interior court; however, Louis XV's intention to create a new monumental stair was never realized.[30] Of all the parts of the Château of Louis XIV that no longer exist, this is the most serious loss. But the appearance of the Escalier is vividly known, thanks to early detailed descriptions, excellent engravings (figs. 35–39, 48), and a modern model (fig. 34) based upon them.[31]

The Escalier des Ambassadeurs was the official grand entrance into the Château, specifically intended to astonish and impress foreign dignitaries.[32] It was entered from the courtyard through three arches with grilles that led into a low vaulted vestibule (fig. 36), featuring arches on squat, heavy piers and pronounced architectonic articulation barely relieved by reliefs of rosettes and military trophies. Three low steps led directly from this somewhat shadowed and constricted space to the high, expansive staircage (figs. 37–39), lit by a large skylight in its vault (fig. 48), which was covered with a wealth of painted decoration. In this sequence from low severe vestibule to high festive room, d'Orbay adapted the effect of the *salon à l'italienne* of mid-century châteaux architecture to the special case of a monumental entrance stair.[33]

The stair itself consisted of a large five-sided stepped podium leading to a central, initial landing (fig. 34)—a development of the podium idea indicated by Le Vau in his Enveloppe designs of 1668 (figs. 10, 11) and present in identical form in two of his earlier stairs.[34] From this landing two long flights diverged, rising along the rear wall to landings above with doors leading into important ceremonial rooms.[35] This double-branched stair preserved the formula of its immediate predecessor. The entire arrangement corresponded to the open staircage type: all the flights were enclosed within a single structure and all were visible at the same time.[36]

Although the idea of a double-branched staircase for Versailles first appears on a drawing by d'Orbay (fig. 31), it is clear, as first noted by Josephson (1927), that the final form of the Escalier des Ambassadeurs was directly based on a design by Claude Perrault for a grand stair for the Louvre, dating ca. 1667–69 (fig. 33).[37] A comparison between Perrault's project and the executed Escalier reveals startling similarities. In common are the massive initial stepped podiums; the long diverging flights of the T-scheme; the seven-bay pilaster articulation of the wall above the stairs, with its unbroken entablature; and the doubling of the pilasters enframing the central bay. The painted decoration of the Escalier des Ambassadeurs will be discussed in detail below, but it is immediately apparent that Le Brun's simulated perspective loggie derive their inspiration from the real loggie of Perrault's drawing. Although the architectural system of the Escalier is adumbrated in several designs by Le Vau,[38] there can be no doubt that d'Orbay reverted directly to Claude Perrault's drawing when he prepared the new stair of 1674.[39]

The painted fresco decoration of the Escalier was its most famous feature, and was the earliest extensive undertaking within the Château by Le Brun and his assistants, along with the contemporaneous decorations of the *grands appartements* (see chapter V).[40] The theme and spirit of the decor of the stair were explicitly stated in the *Mercure galant* of 1680:

This location is embellished in this way, in order to depict a festival day, when the divinities of Parnassus have assembled to receive the King upon his return from the war. Thus a part of the subjects are painted as pictures and in fictive tapestries. It is imagined that everything has been [painted] by those spirits who appear in the air, still adorning the vault with festoons of flowers, after having placed some in several places along the cornice and in the large baskets or vases which are above the herms and the pilasters.

His Majesty is placed in the center [that is, the sculptured bust above the first landing (fig. 37)], in order to indicate that it is for Him that this festival is held.[41]

In his biography of Le Brun of ca. 1700, Nivelon wrote: "The subject in general is based on that which occurred at that time, which is the famous naval battle held near Messina by the French against the naval forces of Spain and Holland, where the great admiral Ruyter gloriously ended his life, and everything appears there like a festival or public celebration."[42] The French naval victory alluded to by Nivelon took place in 1676,[43] and Le Brun's biographer immediately goes on to describe the poops of the large ships in the corners of the vault (fig. 48), implying that they are references to these triumphs. But the *Mercure* of 1680—appearing soon after the unveiling of the completed staircage in 1679—simply refers to the return of the king from "la guerre," a generalized reference to the Dutch War of 1672—78, of which the Sicilian operations of 1676 were a part, and describes the poops as symbols of Louis' governance of the State.[44] The main point is that the decoration, although permanent, was meant to suggest the architecture and decoration appropriate for a temporary public celebration, a holiday pageant in honor of the returning hero.

The common characteristic of public pageantry in all ages is the mingling of artistic and living elements, the merging of art and life. In this context, the illusionistic loggie (figs. 37, 38), which expand the space of the room, are perfectly appropriate: First, they contain groups of spectators representing the Four Parts of the World, who could be perceived as blending with the real people ascending or descending the stairs, just as simulated and real figures are often juxtaposed in public pageants. Thus Nivelon wrote:

> [These figures] seem to come and go in the prince's apartments, conversing mostly together or looking at the vault of this locale according to their spirit, which creates a very pleasant, natural variety, and one can say that when that great King descends by this stair in the center and [is] followed by all the princes and princesses, all that creates a spectacle so great and so superb that one would believe that all these people have gone as a crowd to this place to honor his passage and to see the most beautiful court on earth in such a way that these subjects are so artistically mixed together, the living with that which is simulated.[45]

Second, the prominent carpets that hang over the parapets in these loggie are not only artistic devices linking the painted image with real space; they are also specific indications of the holiday event, for it was a contemporary custom to hang carpets from balconies and windows on such occasions.[46] The simulated tapestries depicting the king's military victories that adjoin the loggie (figs. 44–47)[47] and the painted festoons and vases of the vault (figs. 48–50)—features specifically cited in the *Mercure* of 1680—are also painted representations of traditional festival motifs that were often set up in real life.[48]

Returning to the chronology of the stair, we can now understand that the original, icono-

graphically neutral, decorative scheme of sculptural herms, trophies, and medallions—which we know from the drawing of 1670/71 (fig. 31) and which was being executed from 1671 until early 1674—was aborted because of the impact of the Dutch War, which began in 1672. Clearly, the new model of 1674 embodied complex fresco decoration directly related to that war, which was then raging. A decision had evidently been reached before June 1674 to utilize explicit, panegyrical imagery in the staircage, along with three scenes from the war: the king's Ordering of Sieges of Dutch Towns (1672); the Crossing of the Rhine (1672; fig. 51, center); and the Second Conquest of Franche-Comté (1674; fig. 52, center). These subjects were painted on the vault (fig. 48); eventually, four victories of 1677 were depicted on the simulated tapestries adjacent to the illusionistic loggie (figs. 44–47).[49]

A major innovation of the Escalier des Ambassadeurs was the skylight that provided the sole means of illumination (fig. 48). We have seen that a skylight, apparently of circular or oval shape, was intended for the stair with herm decoration of 1671–74 (fig. 31). In this drawing, the oval shape surely cannot be read as a cross-section of the glass; it must represent a circular or oval plan, depicted in a perspective view at variance with the sectional representation of the entire drawing. Thus, this first, relatively small skylight was to have covered only the median point of the vault over the cage. In the Escalier des Ambassadeurs, by contrast, the skylight was a long rectangle that extended over most of the width of the staircage. The glass sections were in the form of a pitched roof.[50] This apparently innovative feature, which provided abundant and effective light for the illumination of the frescoes,[51] may also have played a symbolic role in connection with the scenes of the king's heroism depicted by Le Brun. In a sumptuous monograph on the Escalier, published in Paris in 1725, L.C. Le Fevre wrote:

> THE GREAT FRAMEWORK in the form of a parallelogram that one sees at the summit of the ceiling and which is adorned all around in its lower part by a cordon of flowers and fruits in sculpture, is the only channel by which light passes to illuminate this great machine. The consoles which appear on this framework are directly over the columns and pilasters below, and support as a crowning feature a cornice on which is placed, in the form of a roof, a panel of glass which closes the opening and prevents the rain from penetrating into the interior. The impossibility which one faced of introducing light at other points except by the center of the vault has produced a marvellous effect; the lower part of the structure is not interrupted by windows, whose too strong lights shimmer and adversely affect the eyes of the viewers. There appears greater harmony in the paintings, the light becomes majestic, and if one pays attention to the allegory of the whole work, one can grasp the arrangement of this light as a symbol of that celestial illumination which guides the true heroes in all their actions, and which shall crown them in eternity.[52]

Here Le Fevre waxes enthusiastic over the way the frescoes appear in the top illumination, but that light from above is also seen as a symbol of the celestial light that guides heroes and crowns them in eternity. This interpretation of the top lighting, while assuredly not contemporary with the creation of the stair, at least raises the possibility that the unprecedented form of the skylight and its abundant illumination were conceived of by the designers (d'Orbay and Le Brun) in this symbolic spirit.[53]

The festival theme of the Escalier des Ambassadeurs provided Le Brun with a license to create a decorative scheme that was (for France) of unprecedented richness and complexity.[54] In the

extensive fresco decorations, Le Brun emphasized the architectural articulation, which he extended fictively into depth by means of *quadratura* devices. On the two long walls (figs. 37, 38), at the level of the *premier étage,* Le Brun transformed four of the bays between the real pilasters into illusionistic loggie, open at the rear to the sky; groups of figures, each representing the nations of the Four Parts of the World (Europe, Asia, Africa, and America), crowd behind balustrades covered with carpets and gaze out at the spectators and the artistic spectacle of the staircage itself.[55] Above the continuous Ionic entablature, Le Brun created an illusionistic architectural framework whose solids continue the structural supports below (fig. 48). Vertical supports appear either in the form of deep piers or as a series of columns in depth, with twelve herms representing the months of the year articulating the supports along the two long sides.[56] These squat, heavy supports uphold a deep, coffered lintel. The bays above the painted loggie of the *premier étage* are illusionistically opened with balustrades, on which rare birds appear;[57] beyond the balustrades are glimpses of coffered arches and sky. The same architectural vistas appear near the corners.

Le Brun's system of painted *quadratura* architecture on the walls and the lower part of the vault was a marked departure from his previous decorative enterprises. Nothing like it can be found in his earlier ceilings,[58] and it was undoubtedly suggested by the real architecture of the staircage. But illusionistic balconies, in one instance peopled with spectators, also appear in two rooms of the *grands appartements,* decorated by painters working under Le Brun during the 1670s, a campaign exactly contemporary with the work in the Escalier (see chapter V). In the present Salle des Gardes de la Reine—the decoration of which originally adorned the Grand Cabinet, or Salon de Jupiter, of the king's suite (the later Salon de la Guerre [fig. 86])—the four corners of the vault feature balustrades overhung with draperies from behind which spectators peer down at the visitors below (figs. 77, 78).[59] And in the Salon de la Reine (fig. 80), painted balustrates again appear in the corners of the ceiling, but instead of human spectators, gilded stucco putti appear in front of the balustrade and allegorical figures are set against the sky beyond.[60]

Le Brun's recourse to *quadratura* devices in the Escalier and in these rooms of the royal suites must have been stimulated by the presence in France during 1671 and 1672 of Angelo Michele Colonna, the famous Bolognese *quadratura* virtuoso.[61] Colonna was called to France in 1671 by Hugues de Lionne to decorate his Parisian *hôtel,* and in 1672 was paid for a fresco in a room of the *appartement des bains* at Versailles.[62] All of his work featured *quadratura,* which was executed by Colonna's new assistant, Giacomo Alboresi, who had succeeded Agostino Mitelli.[63] Colonna and Alboresi left France precipitously in 1672 as a result of a dispute between them,[64] but there remained behind examples of their work. They must have been personally in contact with Le Brun at Versailles, where the *premier peintre* was the overseer of all decoration. The activity of Colonna and Alboresi in Paris and Versailles during these crucial years when the interior decoration of the Enveloppe was in its planning or initial stages suggests that they inspired in Le Brun an approach that differed from the French artist's prior decorative methods, which had made virtually no use of *quadratura.*

Colonna's French decorations have not survived, and only the ceiling in the Hôtel de Lionne can be vaguely surmised by means of a written description.[65] This work does not appear to have resembled the frescoes of the Escalier des Ambassadeurs. But one of Colonna's and Mitelli's earlier collaborations, the Third Room of the Museo degli Argenti in the Palazzo Pitti, Florence (1641; fig. 56), contains the essential motifs of the Escalier: spectators on balconies, atlas figures (though not herms), and views into architectural spaces. This Florentine decoration was finished just before Le Brun's arrival in Italy in 1642, and it is commonly assumed that he

visited Florence and viewed Pietro da Cortona's frescoes in the Palazzo Pitti before he left for France at the end of 1645.[66] He therefore surely would have seen the frescoes of the Museo degli Argenti as well. Although Colonna's Third Room of the Museo contains the basic elements, the overall composition of the Escalier follows other Italian models.

The fictive columnar loggie of the walls with their spectators (figs. 40–43) were probably directly inspired (as Marie has suggested[67]) by the upper frieze of the Sala Regia (Sala dei Corazzieri) of the Palazzo Quirinale in Rome (fig. 57), the joint production of Tassi, Lanfranco, and Saraceni (1616–17),[68] which Le Brun could have seen while in Rome. Here we find illusionistic *quadratura* loggie with richly decorated cross-vaults and sky beyond. The balustrades are almost completely covered by carpets, and crowded behind them appear a varied array of spectators who peer down and converse among themselves. The variety of physiognomies and costumes suggests the theme of the Nations of the Four Parts of the World. Le Brun replaced the crowded and contorted throngs of the Quirinal frieze with more decorous groups, less crowded and lacking the almost caricatured faces of the Italian work; moreover, the illusionistic architecture was redesigned at Versailles to match the real trabeated Ionic system of the staircage. But Le Brun's main innovation appears to have been the depiction of illusionistic balconies with spectators in a staircage, and the placement of the *Nations of America* and the *Nations of Europe* above the steps themselves (fig. 37), a device that assured close physical proximity between the painted images and the people using the stairs.

Such illusionistic loggie had not previously been used in French painting.[69] Figures behind a balustrade had been painted by Le Brun's master, Simon Vouet, in the ceiling of the chapel in the Hôtel Séguier, Paris (before 1638),[70] but these were actors in a religious narrative who were not turned towards the spectators' space. Moreover, these figures appeared against a landscape setting with architectural fragments, and were not enclosed within architecture as in the Quirinal frieze (fig. 57).

In the painted *quadratura* zone above the Ionic entablature of the Escalier des Ambassadeurs (figs. 49, 50), the architectural vistas, as previously noted, are similar to Colonna's and Mitelli's work at the Palazzo Pitti (fig. 56). But, again, they can be compared to features in the Quirinal frieze—namely, to the painted cross-vaults without figures that appear in the square fields corresponding to the real windows on the opposite side of the room.[71] However, Le Brun's continuous architectural framework, in its clarity and measured order, is also reminiscent of Michelangelo's Sistine Ceiling (fig. 58), with Le Brun's allegorical figures (figs. 49, 50) corresponding to Michelangelo's Prophets and Sibyls. Le Brun's atlas herms, on the other hand, surely reveal the impact of Annibale Carracci's Farnese Gallery (fig. 59), a work studied by the French artist during his Roman stay.[72] It is significant that Le Brun did not adopt Carracci's complex system of overlapping panels, which obscure the simulated architectural skeleton; instead, the Frenchman, although appropriating Carracci's varied, expressive herms, returned directly to the Sistine Ceiling with its pronounced architectonic emphasis.[73]

In the four corners of this decorative level, however, Le Brun introduced a more complex, space-filling motif, designed to resolve the junction of forms at the corners and to link this zone with a higher zone of simulated bas-reliefs on the curve of the vault around the skylight.

Le Brun's densely piled-up compositions, which build diagonally from the corners up to an octagonal relief medallion (figs. 49, 50), are ultimately based on the corner motifs of Pietro da Cortona's Barberini Ceiling (1633–39; fig. 60), where they function in an analogous manner in the overall scheme.[74] Earlier in his career Le Brun had designed similar corner-fillers for ceilings composed of some of the same motifs that reappear in the Escalier. In a study for the Chambre du Conseil of the Louvre (fig. 61),[75] circa 1653, we find recumbent, symmetrical prisoners as

well as military trophies and shields. In both this drawing and the painted vault of the staircage of Versailles, the captives were depicted as simulated sculptures. The Chambre du Conseil project was never executed, but in 1659 Le Brun did realize the ceiling of another room in the Louvre, the Salon du Dôme (Rotonde d'Apollon), no longer extant but recorded in an engraving (fig. 62).[76] Here, in addition to prisoners and trophies, there were pairs of winged female figures of Fame at the tops of the groupings; Le Brun directly appropriated these motifs for the Escalier in the same parts of the composition. Furthermore, the captives in the Salon du Dôme reclined on decorative scrolls, harbingers of the cornucopias of the later decoration at Versailles.

Once again, Le Brun's sources for these motifs can be found in the exuberant world of forms of Cortona's Palazzo Pitti decorations. In the Sala di Marte (fig. 63) the corners are filled by real stucco captives, back-to-back at the base of a decorative build-up of trophies extending diagonally into the vault;[77] and in the Sala di Giove (fig. 64) the corner spandrels contain pairs of stucco females, similar to Le Brun's painted Victories, although not winged.[78] As noted previously, the poops of naval vessels that appear between Le Brun's paired prisoners were introduced as allusions to Louis XIV's government and to French naval victories in the Dutch War. It is thus interesting to note (in the context of influences from the Palazzo Pitti) that ships' prows also figure prominently in the Sala di Marte and Sala di Giove frescoes.[79]

Above this zone of the decoration, on the cove of the vault, Le Brun abruptly introduced an assemblage of simulated bas-relief panels, treated as *quadri riportati,* with no illusionism or foreshortening (figs. 48–52). The early descriptions inform us that the panels presented bluish or yellowish figures set against gold backgrounds—a coloristic treatment found in similar simulated reliefs in surviving rooms at Versailles.[80] Fictive sculptural motifs were present in the lower, illusionistic zone (figs. 48–50), which contained "bronze" atlas herms, white "stucco" or "marble" captives, and "bronze" shells beneath the cornucopias. But these were occasional sculptural references within a fully polychromatic illusionism. In the coved zone, an entirely different decorative mode suddenly appears. The basic source is again probably the Farnese Gallery (fig. 59), where simulated bronze reliefs and *quadri riportati* appear. But once again Le Brun's overall arrangement is much simpler than Carracci's: In the French scheme there are side-by-side placements of panels of uniform size and an avoidance of overlapping, except where the colored corner motifs rise up towards the octagonal medallions.[81]

This mixture of perspectival modes in ceiling decoration is not unheralded in Le Brun's earlier *oeuvre,* and it is, in principle, typical of the ceilings executed under his direction in the *grands appartements* (see chapter V). In the painter's first major ceiling commission, the Galerie d'Hercule in the Hôtel Lambert, Paris (ca. 1650–ca. 1662), he combined areas seen *di sotto in su* (with some steeply foreshortened figures spilling over the frames) with two central areas treated as *quadri riportati* in the form of simulated tapestries.[82] In the Salon du Dôme in the Louvre of 1659 (fig. 62), the *di sotto in su* perspective of the central panel differed from the representations of the Four Ages of Man around the perimeter, which were treated as *quadri riportati*. The latter solution was the basic formula used for all the rooms of the king's and queen's suites (figs. 66, 68, 70, 73, 75, 78, 80), executed during the 1670s; in them a central painting, seen in modified *di sotto in su,* is accompanied by *quadri riportati*. But in the Escalier des Ambassadeurs, unlike his earlier work, Le Brun created a zone of bichromatic simulated bas-reliefs. The only parallel for this is the long rectangular cove paintings in the Antichambre de la Reine (fig. 79), executed by Claude François Vignon and Antoine Paillet, working under Le Brun.[83] Here, however, rectangular panels alternate with colored roundels and gilded stucco sculpture in the corners. The coved zone of this room, which is contemporary with the Escalier, is an echo of the topmost zone of Le Brun's staircage, and it should be noted that both rooms are long and rectangular in shape.

We turn now to the iconography of the ceiling of the Escalier des Ambassadeurs.[84] In the zone above the Ionic entablature, the theme of the Four Continents of the World is repeated in the guise of seated figures (identified by conventional attributes borrowed directly from Ripa),[85] who are placed in propinquity to the corresponding loggie below. The Twelve Months of the Year, each represented by an atlas herm with the appropriate zodiacal sign on its shaft, contribute to the theme of universal space and time. But the four large, multifigured groups in the centers of the four sides introduce themes that relate specifically to Louis XIV. In the group above the king's marble bust (discussed below), the Muses Clio and Polyhymnia (fig. 51), denoting History and Eloquence,[86] ensure the recording of the king's deeds, embodied by Hercules.[87] Both Hercules and Minerva (Wisdom who guides Louis' actions), appear behind Clio and Polyhymnia, flanking Hercules' chariot,[88] which is filled with the shields and booty of Spain, Germany, and Holland—the Triple Alliance, symbolized by a three-headed dragon that lies crushed beneath the chariot. The latter is surmounted by a globe with fleurs-de-lys and the French royal crown.[89]

The corresponding group on the other side of the vault (fig. 52) features the Muse Calliope (Epic Poetry) who, having a "large part in reciting actions of all the great men,"[90] is therefore accompanied by Melpomene (Tragedy).[91] Another Muse, Thalia (Comedy), stands behind Melpomene, and behind Calliope appears Apollo—the central mythological deity in the iconography of the king—leaning against his tripod, at the foot of which lies the slain Python. The *Mercure galant* explains this imagery thus:

> [His Majesty] has ended the civil wars, and prevented the secret rebellions which enemies have wanted to engender in France. These rebellions are depicted by the serpent Python . . . because he took his origin only from the gross impurities of the earth, and was pierced almost at birth by the arrows of Apollo, who represents the person of the King in this subject-matter. . . .[92]

From the 1650s on, the Python of Greek mythology had been adopted as the symbol of the Fronde, the mid-century civil rebellions in France. Although this serpent was depicted in the Petit Parc in the Dragon Fountain and in unexecuted projects for the Fer-à-Cheval, the Python in the Escalier des Ambassadeurs constituted a rare appearance of this political theme within the Château.[93]

The array of Muses is added to at the center of one of the short sides of the *quadratura* zone (fig. 50), where Urania (Astronomy) is paired with Euterpe (Music);[94] but instead of representing Terpsichore (Dancing and Song) and Erato (Lyric and Love Poetry), the painter completed the groupings at the opposite side with personifications of Painting and Sculpture (fig. 49),[95] who are more appropriate for the Escalier, where the visual arts record the glories of the king.[96]

We have already discussed the iconography of the ships' poops in the corners, noting that they refer to the king's governance of the state as well as to French naval victories during the Dutch War of 1672–78. But the *Mercure galant* points out that the trophies above the poops were varied to correspond to the Four Parts of the World,[97] the unifying theme of the Escalier, which the *Mercure* also explains as being particularly suitable to Versailles, which is an anthology of the rare wonders of the world: "The Four Parts of the World are represented in this charming place, to show that the King, in order to adorn it, has had searches made for that which is the rarest in the whole world, as much for furnishings as for plants, animals, and other things; which makes this magnificent palace so notable, that it seems to excite curiosity in everyone, in attracting a part of the most distant nations."[98]

The allegorical mode was continued in the zone of simulated bas-reliefs, with depictions of Fame and Mercury with Pegasus in the end roundels, and Painting, Sculpture, Poetry, and History above the open vistas of the *quadratura* level.[99] Personifications of Magnificence, Authority, Strength, and Vigilance occupy the corner octagons.[100] Around the opening of the skylight, however, Le Brun also depicted, for the first time at Versailles, several events from contemporary history involving Louis XIV: the Crossing of the Rhine (1672; fig. 51, center), the Ordering of Sieges of Dutch Towns (1672), the Second Conquest of Franche-Comté (1674; fig. 52, center). There are also three scenes of a more generalized sort: the King Dispensing Laws and Justice, Satisfaction Granted Louis XIV by the Spanish Ambassador, and the King Receiving Ambassadors.[101] In addition, scenes of the Re-establishment of Commerce and the King Distributing Titles and Honors appear above the central figural groups on the shorter ends (figs. 49, 50).[102] The military scenes relate thematically to the four simulated tapestries of the lower walls, which depict three sieges and one battle of 1677.[103] In the "tapestries" (figs. 44–47) Le Brun treated historical events as unadorned narratives, but in the scenes of contemporary history around the skylight, he mixed historical figures with personifications (figs. 51, 52), thus establishing a hybrid mode of representation to be used later in dramatic fashion in the Galerie des Glaces (chapter VI).

All of this panegyrical imagery swirled, so to speak, around the central cult image, the king's sculptured bust (fig. 53). This work by Jean Warin was created in 1665–66 to rival Bernini's bust of 1665 (fig. 67). Warin's bust was kept next to Bernini's in the Louvre and later in the Palais des Tuileries until its transfer to the Escalier around 1679.[104] (It was later replaced by a bust by Coysevox.[105]) Warin's bust, along with Le Brun's vault paintings in the Escalier of specific deeds of the king, signaled the first direct portrayals of the monarch at Versailles; in all of the other interior decoration until the unveiling of the stair in 1679, and in the sculptural adornment of the park of the Château, references to the Sun King had been allegorical, by means of mythological or historical subject matter. This latter principle was to be respected in the park (with few exceptions),[106] but not within the Château, where depictions of Louis XIV were to abound from the 1680s on in the Galerie des Glaces, in the Salon de la Guerre, and in other locations.

V

The Planetary Rooms

T HE *premier étage* of the Enveloppe contains two royal suites, the *grand appartement du roi* and the *grand appartement de la reine,* the former occupying the north block, the latter, the south. In the original arrangement of the Enveloppe—before the modifications of Jules Hardouin-Mansart, which began in 1678—each of these suites consisted of seven rooms, five along the northern and southern ranges, with two additional rooms in the western block, between the corner rooms and the central terrace (fig. 12). The rooms were named after heavenly bodies; in each suite a room dedicated to Apollo (the Sun) was preceded and followed by three rooms dedicated to the planets and the Moon (fig. A).

In his guidebook of 1674, Félibien became the first writer to allude to the planetary dedications:

> [*Grand appartement du roi*]:
> And since the Sun is the emblem of the King, they have taken the seven planets to serve as the subjects of the paintings in the seven rooms of that apartment. So that in each they must depict the actions of heroes of Antiquity, which shall relate to each of the planets and to the actions of His Majesty.[1]
> [*Grand appartement de la reine*]:
> And the paintings which adorn the ceilings must also represent the actions of heroines of Antiquity, in relation to the seven planets.[2]

Félibien proceeded to identify the dedications (and functions) of each of the rooms of the king's suite in the original Enveloppe (fig. A).[3] The rooms of the queen's suite, on the other side of the Enveloppe, were apparently dedicated in the identical sequence in the original layout (fig. A).[4]

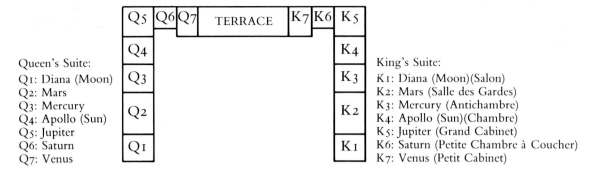

Queen's Suite:
Q1: Diana (Moon)
Q2: Mars
Q3: Mercury
Q4: Apollo (Sun)
Q5: Jupiter
Q6: Saturn
Q7: Venus

King's Suite:
K1: Diana (Moon)(Salon)
K2: Mars (Salle des Gardes)
K3: Mercury (Antichambre)
K4: Apollo (Sun)(Chambre)
K5: Jupiter (Grand Cabinet)
K6: Saturn (Petite Chambre à Coucher)
K7: Venus (Petit Cabinet)

FIG. A. Planetary Rooms, King's and Queen's Suites, Versailles (original arrangement)

It has long been recognized that the suite of planetary rooms at Versailles had a forerunner in the Palazzo Pitti in Florence. There, between 1641 and 1665, Pietro da Cortona and Ciro Ferri decorated a linear suite with rooms dedicated to Venus, Apollo, Mars, Jupiter, and Saturn (fig. B).[5]

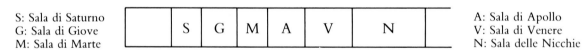

S: Sala di Saturno
G: Sala di Giove
M: Sala di Marte

A: Sala di Apollo
V: Sala di Venere
N: Sala delle Nicchie

FIG. B. Planetary Rooms, Palazzo Pitti, Florence

The first scholar to consider—however briefly—the implications of different planetary sequences in Florence and Versailles in the context of seventeenth-century astronomical thought was the late Walter Vitzthum. In his preface to a picturebook on Le Brun's decorations in the Galerie des Glaces,[6] Vitzthum claimed that the Florentine decorations followed the old Ptolemaic cosmology, whereas those at Versailles were in accordance with the new Copernican system:

> . . . the Medici of Florence, as despotic as they could be in action and thought, when called upon to illustrate their deeds, did so in a language such as was in least possible contrast with tradition. Let us consider the iconographic detail which is most striking: the seven [actually five; see fig. B] planets of the Palazzo Pitti are arranged according to the old Ptolemaic system. At Versailles the same planets are arranged so that the Sun, that is, Louis XIV, became the center of the system; thus the decoration of Versailles coincides with the new Copernican system.[7]

In attempting to correlate a linear sequence of rooms with a planetary system, it is of crucial importance to realize that the latter can be schematized in two ways: as a sequence of the names of the heavenly bodies or as a diagram of concentric orbits drawn around a central, stationary body. In a sequence of names, the first is normally the fixed, central planet or Sun around which the other bodies move. Thus, the Ptolemaic system[8] is normally indicated as: Earth–

Moon–Mercury–Venus–Sun–Mars–Jupiter–Saturn. The Copernican model is usually written: Sun–Mercury–Venus–Earth (with Moon)–Mars–Jupiter–Saturn. Figure C shows the familiar diagrams of concentric orbits.

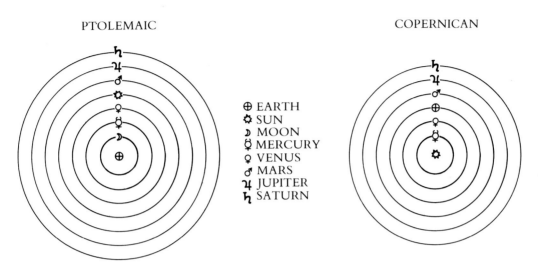

<div align="center">PTOLEMAIC COPERNICAN</div>

⊕ EARTH
✿ SUN
☽ MOON
☿ MERCURY
♀ VENUS
♂ MARS
♃ JUPITER
♄ SATURN

<div align="center">Fig. C. Ptolemaic and Copernican Systems</div>

The planetary rooms of the Palazzo Pitti have most recently been studied by Malcolm Campbell.[9] Following Vitzthum, he identifies the sequence as Ptolemaic—though with the omission of Earth, Moon, and Mercury, which should precede the first room, the Sala di Venere (fig. B, "V"). Campbell notes that a seven-room sequence, beginning with the Moon (Diana) and Mercury, may have been intended between 1638 and 1641, but was abandoned for practical, architectural reasons.[10]

The identification of a Ptolemaic system in the Pitti suite would seem to be correct if we assume, along with Vitzthum and Campbell, that its designers thought of this system as a linear sequence of the names of planets. At Versailles, however, as Vitzthum has noted, the room dedicated to the Sun, the Salon d'Apollon, was preceded by three planetary rooms and followed by three others (fig. A). He thus concluded that this arrangement was heliocentric, coinciding with the Copernican system. But here Vitzthum committed an error in logic, because he compared a centralized, concentric schema (Versailles) with a linear, sequential one (Pitti), an unacceptable comparison of "apples and oranges." In accordance with basic logic, if the Pitti suite is thought of as analogous to a sequential cosmological series, then the Versailles *appartements* must also be thought of in this way. It will then be apparent that the Versailles scheme is basically Ptolemaic (with some aberrations); a linear Copernican schema would have *begun* with a room dedicated to the Sun:

Ptolemaic: Earth–Moon–Mercury–Venus–Sun–Mars–Jupiter–Saturn
Pitti: Venus–Sun–Mars–Jupiter–Saturn
Versailles: Moon–Mars–Mercury–Sun–Jupiter–Saturn–Venus
Copernican: Sun–Mercury–Venus–Earth (with Moon)–Mars–Jupiter–Saturn

Campbell would appear to be correct, therefore, in describing the original *grands appartements* at Versailles (fig. A) as "a freely redistributed Ptolemaic solar system."[11] For in the Ptolemaic order, when described as a linear sequence, the Sun is a "central" planet preceded and followed by other astronomical bodies. This arrangement harmonized perfectly with the Apollonian and solar imagery associated with Louis XIV.

If, on the other hand, we assume that the designers at the Palazzo Pitti and at Versailles conceived their room sequences in accordance with centralized diagrams of concentric orbits, both sequences would then have been heliocentric, with the Sala di Apollo and the Salon d'Apollon as the fixed centers around which the other rooms "revolved." At the Palazzo Pitti, the planets would be in the alignment around the Sun that is shown in figure D.

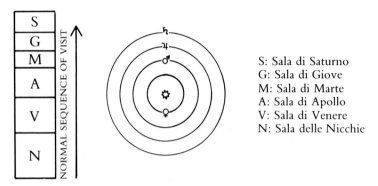

S: Sala di Saturno
G: Sala di Giove
M: Sala di Marte
A: Sala di Apollo
V: Sala di Venere
N: Sala delle Nicchie

Fig. D. Palazzo Pitti Rooms and Planetary Diagram

If the Copernican system was the model, then Mercury (closest to the Sun) and the Earth with its Moon (between the orbits of Venus and Mars) would be missing. If the Tychonic system was used, the same diagram and planetary positions (and omissions) would be in force.[12] But the absence of a room dedicated to the Earth is probably the strongest piece of evidence against the notion that a Copernican model underlies the Pitti suite, for the concept of the Earth as a moving planet was one of the most conspicuous features of Copernican thought.[13] This fact, along with the dangers of expressing pro-Copernican ideas so soon after the trial of Galileo (1633), confirms Vitzthum's and Campbell's assertions that a Ptolemaic model underlies the Pitti rooms and that, as a consequence, the schema of that cosmological system in the minds of the planners was linear and sequential, like the architectural arrangement itself.

If the schema of the Copernican system as a centralized orbital diagram is applied at Versailles, it is possible to place most (but not all) of the planets in a pattern corresponding to the room sequence (fig. E). With the planets so arranged, the sequence from bottom to top—Mars–Mercury–Sun(Apollo)–Jupiter–Saturn—precisely corresponds to the sequence of the five inner rooms. The anomalies consist in the placement of Venus as an outermost planet, beyond distant Saturn, and the positioning of the Moon (Diana), Earth's satellite, further away from the Sun than Mars. Clearly, there is a lack of scientific rigor in the dedications of the rooms, if we assume that the Copernican model was consciously used in this manner. If the Tychonic model is followed, then the same five heavenly bodies—Mars–Mercury–Sun–Jupiter–Saturn—can be arranged to match the room se-

quence at Versailles,[14] and the same anomalies in the positions of Venus and the Moon persist. As in the Palazzo Pitti, however, the omission of a room dedicated to Earth, the "new planet" of the Copernicans, strongly suggests that the Copernican model was not in the minds of the designers at Versailles. (I shall discuss the status of Copernican thought in France around 1670 a bit later.) The Versailles arrangement seems to indeed have been "a freely redistributed Ptolemaic solar system," thought of as a linear sequence of the names of heavenly bodies matching the linear sequence of rooms, as at the Palazzo Pitti.

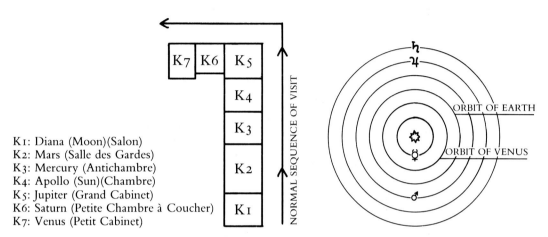

K1: Diana (Moon)(Salon)
K2: Mars (Salle des Gardes)
K3: Mercury (Antichambre)
K4: Apollo (Sun)(Chambre)
K5: Jupiter (Grand Cabinet)
K6: Saturn (Petite Chambre à Coucher)
K7: Venus (Petit Cabinet)

Fig. E. Versailles Rooms and Planetary Diagram

Whether thought of, then, as based on the Ptolemaic, Copernican, or Tychonic model, the Versailles rooms in their original arrangement (fig. A) are puzzling because of the distant placement of the original Salon de Vénus. Throughout the history of astronomical thought, Venus was always correctly recognized as being second only to Mercury in its proximity to the Sun. The Roman architect Vitruvius, in his description of a geocentric universe in Book IX of *De Architectura,* speaks of "The planets Mercury and Venus, with their orbits, encircling the sun's rays as on a centre . . .";[15] of Mercury completing one revolution of the firmament in 360 days, and Venus taking 485 days;[16] and of the other planets (Mars, Jupiter, Saturn), being further from the Earth and the Sun, needing much more time to complete their revolutions.[17] Vitruvius, in fact, had adopted the ancient order of the planets, which was to be codified in the second century A.D. by Ptolemy.[18] Clearly, the distant placement of the first Salon de Vénus at Versailles was totally out of harmony with all astronomical systems, and conflicted with Vitruvius, the ancient authority much studied by seventeenth-century architects.

The other "astronomical anomaly" at Versailles when the *appartements* are regarded as Ptolemaic sequences is the placement of the Salon de Mars between the Moon (Diana) and Mercury, instead of between the Sun (Apollo) and Jupiter (fig. A). The position of the Salon de Mars cannot be rationalized by reference to any other cosmological system[19] and, like the original placement of the Salon de Vénus, must be regarded as an inconsistency. Yet these deviations are not sufficient, in my estimation, to allow us to dismiss the notion that there is some link between the rooms and cosmological thought. If we accept the notion that a linearly conceived

Ptolemaic sequence underlies the Versailles rooms, can it be that extraneous but comprehensible "nonastronomical" factors accounted for the eccentric positioning of Mars and Venus?

In his encyclopedic survey of Versailles, Pierre Verlet (who did not concern himself with the possible relationship of these rooms to astronomical thought) wrote the following about the first Salon de Vénus:

> The last room is a little cabinet, very bright and very pleasant, which is lit by two windows on the western parterre and by three windows on the terrace of the first floor [fig. 12]; since these latter windows face towards the Queen's apartment, they thought (by flattery more touching than subtle towards their sovereign) to consecrate the decoration of this cabinet to Venus. . . .[20]

Verlet's interesting speculation introduces the possibility that at least one room of the king's suite was placed according to a noncosmological factor: that a room dedicated to the goddess of love and beauty was located nearest the queen's suite, given the physical separation of the two ceremonial royal apartments.[21] Furthermore, the positioning of the Salon de Mars can be explained even more convincingly in the same manner. This room originally functioned as the Salle des Gardes;[22] this explains the appropriateness of its dedication to the god of war, which is underscored by the appearance in the frieze of three-dimensional helmets of gilded stucco (fig. 70). Such a room, normally containing a contingent of soldiers, was logically placed between the staircase and those of the king's rooms that the monarch normally used: the Chambre de Parade (the Salon d'Apollon), which originally contained the ceremonial bed of state and was used by the king to receive ambassadors and other dignitaries; the Grand Cabinet (the Salon de Jupiter), used for council meetings; the Petite Chambre à Coucher (the Salon de Saturne), Louis' real bedroom (which had a view of the western gardens); and the Petit Cabinet (the Salon de Vénus), his private study (fig. A).

If we compare this suite of rooms with the situation at the Louvre (fig. F)—which was Louis XIV's official and primary residence until the transfer of the Court to Versailles in 1682—it is apparent that in both palaces a rectangular Salle des Gardes was placed on the *premier étage* between the main staircase and the king's personal rooms.[23] Furthermore, an *antichambre* was arranged in both buildings between the Salle des Gardes and the Chambre de Parade (cf. figs. A, F).[24] It was in the *antichambre* (the Salon de Mercure at Versailles) that visitors, having been admitted by the guard, would await their turn to proceed to the king's presence.[25] Certainly, the placement of a guardroom between the official staircase and the official reception rooms was common to the planning of palaces throughout Europe from the sixteenth through the eighteenth centuries,[26] and it is, of course, perfectly comprehensible. Hence, at Versailles, a Salle des Gardes in such a location was inevitable, and its dedication to Mars is perfectly logical also.[27] Clearly, as in the case of the Salon de Vénus, other factors may have been of greater import than the consistency of the room dedication within a planetary scheme.

At Versailles, therefore, a Ptolemaic system—undoubtedly influenced by the precedent of the Palazzo Pitti—was apparently modified by nonastronomical considerations. This may indicate that the designers of the Planetary Rooms were not guided by scientific advisers, who, presumably, would have insisted on a consistent cosmological order. It is interesting to note that this casual approach to the planetary system was adopted at a time (ca. 1670)[28] when astronomical activity and research in France was entering a heightened phase, due to the construction of the Paris Observatoire (by Claude Perrault, 1667–71)[29] and the arrival in France in April 1669 of the eminent Italian astronomer Gian Domenico Cassini (1625–1712).[30] A supporter early in his career

A: Salle des Gardes du Roi
B: Antichambre du Roi
C: Corridor
D: Galerie d'Apollon
E: Rotonde d'Apollon
F: Grand Cabinet du Roi
G: Chambre de Parade du Roi
H: Chambre à Coucher du Roi
I: Oratoire du Roi
J: Petit Cabinet du Roi
K: Chambre à Coucher de la Reine
L: Petite Chambre à Coucher de la Reine
M: Grand Cabinet de la Reine
N: Chambre de Parade de la Reine
O: Antichambre de la Reine

FIG. F. Louvre, Paris: Royal Suite (From L. Hautecoeur, *Le Louvre et les Tuileries de Louis XIV*, Paris and Brussels, 1927)

of Tycho Brahe's system, Cassini eventually renounced this concept and in 1693 wrote favorably of the Copernican model.[31] But about 1670, when the Planetary Rooms of Versailles were planned, there was almost no explicit support for the Copernican system in France among astronomers, and French theologians, of course, upheld the Ptolemaic conception.[32] As in Italy or in any other Catholic country in the seventeenth century, any endorsement of Copernicanism, explicit or implicit, risked Papal condemnation.[33] This reinforces the belief that the Planetary Rooms of Versailles basically followed a Ptolemaic arrangement. But even that arrangement, as we have seen, was not consistent, despite the presence at Versailles of the scientist Claude Perrault, the designer of the Observatoire in Paris.[34] Perrault's published scientific works and manuscripts, however, do not concern astronomy, but deal mainly with zoology, anatomy, biology, physiology, and mechanics.[35] His views on the planetary system are unknown.

The original Planetary Suites of the Enveloppe were drastically disturbed by the creation (beginning in 1678) of the Galerie des Glaces and its two salons (see chapter VI). In both the king's and queen's apartments, the salons of Jupiter, Saturn, and Venus were destroyed. The king's Salon de Jupiter was transformed into the Salon de la Guerre (fig. 86), and the queen's Salon de Jupiter became the Salon de la Paix (fig. 87); the rooms dedicated to Saturn and Venus simply disappeared, absorbed by the volume of the Galerie des Glaces. But in the king's suite, a room directly preceding the Salon de Diane was rededicated to Venus; this room, which had previously had no planetary dedication, could be directly entered from the right-hand landing of the Escalier des Ambassadeurs (figs. 65, 66).[36]

In the course of the transformation of the king's Salon de Jupiter into the Salon de la Guerre, the marble revetments and ceiling paintings were conserved and reutilized on the queen's side to work another metamorphosis: the change of the queen's Salon de Diane into the Salle des Gardes de la Reine (fig. 77).[37] As a result of these modifications, the *grand appartement du roi* presented the heavenly bodies in the following sequence of five (instead of seven) planetary rooms: Venus–Diana(Moon)–Mars–Mercury–Apollo(Sun). The *grand appartement de la reine* featured this sequence of four: Jupiter–Mars–Mercury–Apollo(Sun).

The ceilings of these rooms are still preserved *in situ* today, except for the central paintings of Mars and Apollo in their respective rooms of the queen's suite.[38] The important point, however, is that these planetary sequences of, respectively, five and four rooms now make no sense whatsoever if one attempts to correlate them with any accepted cosmological system. Clearly, if there was some link made between science and art during the planning of these rooms around 1670, there was absolutely none in 1678 and succeeding years, when the suites were drastically modified and rearranged under Mansart.

Thus, the sequences of dedications of the Planetary Rooms were apparently not intended as "scientific demonstrations" of cosmological theory, but as poetical-allegorical statements relating to Louis XIV. Despite all transformations, the rooms dedicated to Apollo retained their locations and identities. This was because of the centrality of Apollo in the iconography of the king and because the Château was thought of as the palace of the Sun, a literary image from Ovid which also underlay many designs of the 1660s for the east façade of the Louvre.[39] Madeleine de Scudéry, in her account (1669) of nocturnal illuminations during the *fête* of July 1668, wrote of the Petit Château and its setting:

> . . . as one arrived on a magnificent terrace, from which one discovers equally both the palace and the terraces which descend, and which form a garden amphitheater [the Fer-à-Cheval], one saw a prodigious change in all objects; and one can say that never was night so bedecked and so brilliant as that one. In effect, the palace appeared truly to be the palace of the Sun: because it was illuminated everywhere, and all the windows appeared filled with the most beautiful statues of Antiquity [fig. 81]. . . .[40]

In 1668 (before the construction of the Enveloppe) La Fontaine wrote "Versailles, ce seroit le palais d'Apollon";[41] Claude Denis, in his manuscript poem (circa 1675) on Versailles, referred to the Château as the "maison du soleil" in the very title of the work.[42] In 1686 Vertron suggested this Latin inscription for Versailles, with a free French paraphrase:

> Atria miraris sublimibus alta columnis;
> Desine mirari, Regia SOLIS opus.
>
> O Vous que la beauté de Versailles surprend!
> Cessez d'en admirer la gloire, & l'avantage;
> Pourquoi vous étonner, s'il vous paroist si grand?
> N'est-ce pas du SOLEIL le Palais & l'ouvrage?[43]
> [O you who are astonished by the beauty of Versailles!
> Cease admiring the glory and superiority of it;
> Why are you amazed, if it seems so great?
> Are not the Palace and the entire work of the Sun?]

The Planetary Rooms of Versailles intensified the celestial imagery, and the entire planetary scheme may have been recognized as having imperial Roman connotations, consonant with the widespread notion that the reign of Louis XIV was rival of and successor to ancient Roman grandeur. The link with imperial Rome would have been suggested by certain ancient Roman descriptions of the imperial palaces on the Palatine Hill in Rome, which indicate that vaults in these palaces were painted with depictions of the starry heavens.[44] The Roman writers do not specify planetary representations, and the Palatine decorations did not encompass a series of celestial rooms, but it is conceivable that the general relationship between the

Versailles rooms and the ancient texts was sufficient to establish the prestigious link with imperial Roman grandeur.

The planetary deities are depicted at Versailles in a manner totally different from the way they appear in the Palazzo Pitti, which was apparently the direct source for the basic conception of the Planetary Suites at Versailles.

At the Pitti, the deities enact their roles within unified narratives. Thus, Venus appears as a scantly clad beauty from whose clutches the young prince is snatched by Minerva, who will present him to Hercules (Sala di Venere); Apollo instructs the prince in a cloud-filled setting, while Hercules supports the celestial globe (Sala di Apollo); the prince defeats his enemies, aided by Mars and encouraged by Hercules (Sala di Marte; fig. 63); Fortune and Hercules bring the prince before Jupiter (Sala di Giove; fig. 64); and Saturn presides over the aged prince's apotheosis, with Hercules on his funeral pyre (Sala di Saturno).[45]

At Versailles, in the king's apartment, the celestial deities are depicted in a much more conventional manner: each is seated in a chariot drawn by various animals.[46] The result is a more overtly planetary-astronomical decorative system. In the surviving rooms of the original *appartement du roi* (figs. 67, 70, 72, 74), we still see Diana's chariot pulled by hinds (fig. 69), Mars's by wolves (fig. 71), Mercury's by cocks (fig. 73), Apollo's by horses (fig. 76), and Jupiter's by eagles (in the Salle des Gardes de la Reine; fig. 78). In the destroyed Salon de Saturne, that god's chariot was undoubtedly drawn by dragons, although no descriptions of the room survive; Venus's animals were surely doves, which appear in the central painting of the second Salon de Vénus (fig. 66). The association of specific animals with planetary deities can be traced to ancient texts; cycles of depictions of the gods in their chariots drawn by the various animals began in fifteenth-century Italian art, and this was a well-established, venerable tradition by the second half of the seventeenth century.[47]

In the queen's original Planetary Rooms, however, the depictions of the celestial deities were not as consistent as in the king's apartment. The decorations of the queen's Salon de Diane are unknown. In her Salon de Mars (Antichambre de la Reine), Mars in the central ceiling painting (not extant) is simply described as accompanied by his zodiacal signs (Capricorn and Scorpio).[48] In her Salon de Mercure (Salon de la Reine), the extant central painting (fig. 80) depicts Mercury hovering in the air, bestowing his influences upon a group of women, who, representing the arts and sciences, are seated upon clouds.[49] And in the lost painting from the queen's Salon d'Apollon (Chambre de la Reine), Apollo was represented as spreading his light over the world, but apparently not from his chariot; according to the description, his horses were being harnessed to this chariot by a group of Hours.[50] No descriptions survive of the paintings in the original salons of Jupiter, Saturn, and Venus of the queen's apartment.

It was only in the king's suite, then, that the planetary gods appeared in their traditional astronomical-iconographical format: placed in chariots drawn by their appropriate animals. But on every ceiling, both in the king's and the queen's suites, the central painting was accompanied by subsidiary scenes (figs. 66, 68, 70, 73, 75, 78, 79, 80), following a format already used by G.F. Romanelli in his Louvre decorations of 1655–58.[51] At Versailles, most of the accompanying paintings depict scenes from ancient history, with implied analogies between these past events and the deeds and qualities of Louis XIV, Marie-Thérèse, and the French monarchy. For example, in the king's Salon de Diane, *Alexander Hunting Lions* and *Cyrus Hunting Wild Boar* (fig. 68, left) probably allude to the king's prowess in the hunt, while *Jason Debarking at Colchos* and *Augustus Sending a Colony to Carthage* (figs. 67, 68 [bottom]) pehaps refer to the French colonization of Canada. These subsidiary paintings are thematically linked to the central *Diana*

in a Chariot Pulled by Hinds (fig. 69), where visual references to hunting and navigation appear. In the queen's Salon d'Apollon (now the Chambre de la Reine), Marie Thérèse was associated with four ancient queens in the *Feast of Cleopatra, Dido Founding Carthage, Rhodope Erecting the Egyptian Pyramids,* and *Nitocrix Dividing the Euphrates Against the Medes.* (For a full list of the subjects of the ceiling paintings and their artists, see appendix III.[52])

It is important to note that the ceiling decorations alluded to the sovereigns only indirectly; then, from at least the early 1680s, overt depictions of the king began to appear in some of the rooms of his royal suite, using the approach found to some degree in the Escalier des Ambassadeurs. Thus, Warin's full-length marble statue of Louis XIV dressed as a Roman emperor—willed to the king by the sculptor in 1672[53]—was reported in 1682 to be in its niche in the second Salon de Vénus (fig. 65).[54] In 1684 Bernini's famous bust of 1665 was moved from the Tuileries to the Salon de Diane, where it was provided with its present pedestal and enframement (fig. 67).[55] And by 1682, Mignard's painting of *Louis XIV Equestrian* (Versailles, Château) was hanging in the Salon d'Abondance, a new, nonplanetary room painted from 1678 to ca. 1682 by Houasse, preceding the second Salon de Vénus.[56] However, these effigies of the Sun King in the Escalier and in his *grand appartement* were sporadic as compared to the recurrent, pervasive monarchical presence that Le Brun devised for the new *pièce de résistance* of the Château—the Galerie des Glaces.

VI

Galerie des Glaces

THE long gallery is a type of room that had appeared in French domestic architecture at least as early as the fifteenth century. During the following 200 years it was developed as an important spatial feature, sometimes used to house sculpture collections and often decorated with works of art in praise of the owner of the house.[1] But there was no long gallery in the Petit Château (figs. 1, 2), and the Galerie Basse, located on the ground floor in Le Vau's Enveloppe (figs. 10 and 11, center top), was judged inadequate. When construction of the Enveloppe was temporarily halted in June 1669 to allow for a competition for a new château (see chapter II), one of the desired features was just such a room, although with a salon interrupting its length.[2] However, the Enveloppe was subsequently resumed and completed, still with only the Galerie Basse. Yet the king must still have felt a need for a gallery on the *premier étage,* and in 1678 the fateful step was taken: Le Vau's Italianate western terrace was destroyed (figs. 6, 7, 12) and an enclosed long gallery, flanked by salons at its ends, was created in its place.[3] This was the Galerie des Glaces, with the Salon de la Guerre and the Salon de la Paix (figs. 82, 84, 86, 87).

As noted previously, this decision also involved the destruction of the newly decorated rooms along the western range—the salons of Jupiter, Saturn, and Venus on both the king's and the queen's sides–thus disrupting the planetary arrangements. Clearly, much had to be weighed in deciding whether to construct this gallery, but in the end its perceived advantages won the day.

The decision-making process apparently took place in the first half of 1678. There are no provisions for a long gallery in the projected work for Versailles formulated in late 1677,[4] but by June 26, 1678, Le Vau's western terrace was being dismantled.[5] From that time on, architectural work proceeded rapidly, following the plans of Jules Hardouin-Mansart.[6] The earliest-

dated surviving drawing from Mansart's *atelier,* which shows the Galerie in cross-section (fig. 83), is signed and dated by Colbert, September 26, 1678.[7]

In the creation of the Galerie, the salons of Venus and Saturn on the king's and queen's sides were totally destroyed, but the two corner salons of Jupiter were retained, to be transformed by their decoration into the Salon de la Guerre and the Salon de la Paix (figs. 86, 87).[8] As a result of this, the Galerie was preceded at each end by an introductory room, decorated in a similar manner, with a flow of space between the three units. It is possible that Mansart used as his model the long gallery of the Palazzo Colonna, Rome (fig. 85), begun in 1654 by Antonio del Grande and frescoed by Giovanni Battista Coli and Filippo Gherardi from 1675 to 1678—thus finished in precisely the year when the planning of the Galerie des Glaces began.[9] The articulation of the end walls of the two galleries is similar: a full column and pilaster on each side of the central portal; furthermore, each vault is decorated with compartmentalized paintings. The similarities, however, end there. At the Palazzo Colonna, the openings between the gallery and the end rooms are trabeated, and there is space between the column-pilaster pairs, resulting in a closer spatial binding between the main and the subsidiary rooms. The Roman vault is more elliptical, and, most of all, the closely spaced, rhythmically grouped pilasters, the statue niches, and the famous mirrors of Versailles (fig. 84) are nowhere in evidence in the Roman example.

Although Mansart's early drawing (fig. 83) shows an undecorated end lunette, we may assume that an elaborate system of painted decoration was anticipated from the beginning. At first, a cycle devoted to Apollo was planned. A drawing (architecture by Mansart's *atelier* and vault decoration by Le Brun; fig. 88) showing part of a long wall with straight-headed openings and complex vault designs, allows identification of scenes of the Destruction of the Cyclops in the rectangular panel, Apollo Liberating Chryseis (?) in the circular one, and the Flaying of Marsyas in the small oval medallion.[10] A drawing by Le Brun of an end wall (fig. 89)—now showing the semicircular portal and frieze brackets of the final design—reveals a scene of the Slaying of the Niobids filling the lunette.[11] Finally, an engraving by Le Clerc of 1684 (fig. 90) depicts the vault filled with a decorative system based on Le Brun's Apollo-cycle project (fig. 88); Apollo in his chariot can be deciphered in the rectangular compartment.[12]

A drawing by Le Brun for the entire length of the vault (fig. 91)[13] shows a system of enframements that is closer to the final version (fig. 84) than to the Apollo-cycle scheme (fig. 88). The drawing contains a cycle devoted to Hercules, so it is apparent that this hero had superseded Apollo in the preliminary planning of the decoration.[14] The central field depicts the Apotheosis of Hercules; the small compartments show his labors; and the triumphs of Apollo, Bacchus, Neptune, and Pan appear in the four larger compartments. It is known from Nivelon (see text below) that the end lunettes would have shown Hercules rescuing the daughters of King Laomedon and winning the girdle of Hippolyta.

A letter by Le Brun to Colbert (Versailles, March 2, 1679) clearly reveals the painter passing on his designs to the minister for advice and approval:

> Monseigneur, here are the designs for Trianon and the one for the gallery of Versailles which the King has ordered from me. I am awaiting your orders before beginning anything. I shall ask you your opinion about all that, Monseigneur. With the taste that I know you have, I shall be without fear of the result.[15]

Kimball believed that the designs accompanying this letter were probably the ones with the Apollo cycle (figs. 88, 89), and dated them accordingly.[16] This is entirely possible, although the letter could also have referred to the Hercules scheme—in which case the Apollo project may

date from 1678. It is known that the first payments to the painters for their execution of the final scheme began on March 23, 1681.[17] So we may safely imagine the elaboration of the Apollo and Hercules cycles as having taken place during 1678–79, and the design of the ultimate vault decoration as occurring mainly in 1680.

Both the Apollo and Hercules cycles were meant, of course, to refer allegorically to Louis XIV; the final paintings are scenes of allegorized history, depicting the king himself performing glorious deeds of history, accompanied by classical divinities and personifications.[18] A radical change, then, occurred in the formulation of the final cycle, and a clue as to the reasons for this change is provided by Le Brun's biographer, Nivelon:

> During the construction of this location [the Galerie des Glaces] and when they were working in marble according to the order which he [Le Brun] gave, he devised, in his beautiful house of Montmorency, the design for the vault, which is 6 feet long, in pen and colors, containing in general all the labors of Hercules,[19] all allegorized upon the actions of the King and upon the subject of the war which then raged against Germany, Spain, and Holland. All these subjects inserted together, with their arches, borders, and ornaments, form a variety to the profit of painting.[20] The two lunettes at the ends are filled, the first with the ruin of Troy by Hercules, who carried off the three daughters of King Laomedon, and the other with this same hero carrying off the famous girdle of Hippolyta, Queen of the Amazons, after her defeat. . . .
>
> All the necessary studies were made for the execution of such a beautiful subject, which was approved; but the secret council of His Majesty found it advisable and resolved that its history of the conquests had to be depicted there. This sudden change, which would have confounded the most able geniuses (having to alter their ideas so promptly), served on the contrary to permit judgment about what was the extent of the genius of our author, depicting deeds which will astonish posterity and will give employment to the most fastidious pens of the time. The resolution being taken because of this change, M. Le Brun shut himself up for two days in the old Hôtel de Grammont and produced the first drawing of that great work, which is the painting in the center, which forms the principal knot of everything; thereupon he was ordered to continue the rest according to these same principles and with that beautiful intelligence, with this prudent restriction by M. Colbert to let nothing enter that was not in conformity with truth, nor was too burdensome to foreign powers who could be affected; which was executed in such a skillful way that they themselves, disposed in favor of their homelands, upon seeing or hearing about this narrative, are charmed by the beauty and by the nobility of this language which perpetuates unto posterity the actions of great kings.[21]

We learn from Nivelon that the Hercules cycle was rejected by the king's "Conseil secret," which desired a direct depiction of Louis XIV's recent conquests in the Dutch War (1672–78). Nivelon's reference is undoubtedly to the king's *conseil d'en haut,* or high council, a very small group of the most important ministers, who were primarily concerned with foreign affairs.[22] From 1678 to 1680, this council was composed of Colbert, Michel Le Tellier (chancellor of France), his son, the Marquis de Louvois (secretary of state and war), and Colbert's brother, the Marquis de Croissy (the foreign minister), who was replaced in November 1679 by Simon Arnauld de Pomponne.[23]

In August 1678 the Dutch War ended triumphantly with the Treaty of Nijmwegen, which established France as the military and diplomatic victor, and elevated the international prestige of Louis XIV to its highest point. It is easy to comprehend why the council—reveling in its mighty achievement—would have called for an overt portrayal of the recent military conquests, rejecting the generalized and indirect panegyrical approach of mythological allusion in the Apollo and Hercules cycles.[24] Nivelon then tells us that Le Brun withdrew for two days and produced a design for the central scene of the final ceiling scheme (perhaps fig. 92 or fig. 93), officially labeled, subsequently, as "The King himself takes control of the governance of his realm, and turns entirely to affairs of state. 1661."[25] Nivelon tells us that Le Brun's drawing pleased and that he was ordered to proceed with the other scenes, following the same principles of representation. It is useful, therefore, to examine the final scene (figs. 94, 95) in some detail, guided by the early descriptions.[26]

The youthful Louis XIV appears seated on a throne, dressed in a royal robe and holding the rudder of government. Behind him are the Three Graces, representing his charms. At the left appears France, seated to signify the peaceful condition of the realm. She holds a shield that crushes Discord. Near her are Hymen, with torch and cornucopia (a reference to the king's recent marriage), and a river-god representing the Seine.

A female figure seated near the king personifies Tranquility; she holds a pomegranate, which symbolizes the unity of the French people. The putti engaged in arts and sports signify the pleasures and diversions of court life.

Minerva (Wisdom), hovering on a cloud next to Louis, and Mars (Valor), in the sky, gesture to the figure of Glory in the air, who holds the crown of immortality. Glory is accompanied by Victory and Fame. The king, disdaining tranquility and pleasure, gazes at her in rapture. Time lifts a corner of the king's tent to indicate that he will reveal Louis' heroic deeds; the hourglass means that the monarch's moment to achieve glory has now arrived.

In the air, a group of Olympian deities (including Hercules) is present to offer aid to the king. The sun god in his quadriga courses through the heavens, and Mercury flies to announce the king's virtues and his resolution to the world. The other side of the painting (fig. 94) is occupied by personifications of the hostile states of Germany, Spain, and Holland, with allegorical dramas illustrating their vices.

The mode of imagery adopted in the central painting of the ceiling recurs throughout the vault decoration: the king appears (sometimes with his soldiers) in scenes referring to recent historical events (fig. 96); he is accompanied by classical deities, heroes, and personifications, with a symbolic language of pose, gesture, and accessories. This was a development of the simulated bas-reliefs around the skylight of the Escalier des Ambassadeurs (1674–80; see chapter IV), which included three scenes from the Dutch War, as well as representations of more generalized activities of the king (figs. 49–52). But these frescoes were placed high up on the vault, and they were bichromatic and small in scale. In the Galerie des Glaces (figs. 84, 94–96), however, Le Brun spread this mixed historical-allegorical mode across the entire vault in rich oils, with glowing colors, full spatial recessions, and more complex allegory, in a dramatic pageant that is located much closer to the spectator. The choice of oil on canvas instead of fresco (as in the Escalier) seems motivated by the painter's desire to execute the ceiling with his own hand in his favored medium, and sources confirm that he actually painted the principal scenes.[27] Nicolas de Largillière's portrait of Le Brun (1686; Paris, Louvre)[28] depicts the artist gesturing with pride toward his oil sketch for the *Second Conquest of Franche-Comté,* one of the major scenes of the vault (fig. 96). This painting, the *Crossing of the Rhine,* and the *Ordering of*

Three Sieges of Dutch Towns constitute three episodes from the Dutch War that had previously been represented far less conspicuously in the Escalier.

It is clear that Colbert's admonition as reported by Nivelon—that the paintings must conform to "la vérité"—did not necessitate the use of a literal, reportorial mode (as in Van der Meulen's simulated tapestries in the Escalier des Ambassadeurs [figs. 44–47]). But how are we to assess Le Brun's cycle in the light of Colbert's further stricture (again according to Nivelon), that the paintings must not be "too burdensome to foreign powers," who would be, in any case, more captivated by the beauty and nobility of the pictorial language than by the depiction of their military and political defeats? Had any previous cycle of art portrayed contemporary, rival nations so blatantly as objects of utter defeat and contempt? For comparable statements, one would perhaps have to refer back to Roman Imperial art. The aggressive, overt tenor of Le Brun's paintings (for example, figure 96) corresponds to the victorious, intoxicated national mood following the Treaty of Nijmwegen. Although the imagery was anticipated by the simulated bas-reliefs of the Escalier, a new type of propagandistic imagery burst out in full scale and color in the Galerie, contrasting markedly with the subtle, more indirect mythological-allegorical language of the other interiors of the Château and of the gardens.[29]

As Nivelon informs us, it was the *conseil d'en haut* that called for a more direct representation of the king's conquests. But it was Le Brun who formulated the specific kind of political language, with its mixture of historical narrative and mythological-allegorical accompaniment, and in this choice we may detect the adoption of Rubens' Marie de Médicis cycle as a model. Rubens' cycle, housed in one of the long galleries of the Luxembourg Palace in Paris, was readily accessible to artists and connoisseurs,[30] and it was the most famous example of a series of paintings depicting recent historical events in the mixed narrative-allegorical mode. Although there is no direct evidence that Le Brun studied the series, his interest in Rubens at the time that he painted the Versailles vault is demonstrated by the enormous *Descent from the Cross* (Rennes, Musée des Beaux-Arts), created by Le Brun during the same period in which he was painting the Galerie.[31] The *Descent* is directly based on Lucas Vorsterman's engraving of Rubens' famous altarpiece in Antwerp.[32] Earlier, during the 1670s, Le Brun had carefully studied Rubens' *Fall of the Rebel Angels,* in the collection of the Duc de Richelieu, as the model for his own version of the theme, intended for the vault of the chapel of Versailles; he may have executed at least one of the oil sketches (Dijon, Musée des Beaux-Arts) about 1684 or 1685, just as the painting of the Galerie des Glaces was being finished.[33] Thus, Le Brun's deep interest in the art of Rubens at the time of the creation of the Galerie can be historically documented. Although the Médicis cycle provided him with the basic principles of the mixed mode, specific borrowings are not evident, with the exception, perhaps, of the image of Louis XIV in the guise of Jupiter astride an eagle in *The Capture of Ghent,* which recalls Henri IV as Jupiter in Rubens' *Entry into Lyons* (Paris, Louvre).

The great aesthetic allure of the Galerie des Glaces is provided not by Le Brun's grandiose paintings, but by the mirrored inner wall that has given the room its name (fig. 84). In the early descriptions of the Galerie, the mirrors are invariably noted, but usually they are regarded simply as a means of reflecting the park, the furniture of the room, or even beautiful women.[34] A more rhapsodic appreciation is conveyed by the *Mercure galant* of 1682: "The glass creates false windows opposite the real ones, and multiplies a million fold that Gallery, which seems to have no end at all, even though there is only one end of it which one sees."[35]

But it is Madeleine de Scudéry in her late *Conversations nouvelles* (1684) who provides the most evocative description of the room:

One enters into that apartment [the *grand appartement du roi*], composed of nine different rooms, equally well lit, by an avenue of light [*une allée de lumiere*], if it is permitted to speak thus, whose length surprises in a pleasing way, and which will one day be much more beautiful when the famous Le Brun will finish painting it as finely as he has begun it. It is that beautiful gallery which I call a luminous avenue, because it is lit as if the Sun itself were lighting it; it has mirrored perspectives which redouble the length, orange trees in large silver boxes, and one can stroll there without being warm, as if one were strolling in shade.[36]

The luminous effect that Scudéry describes is particularly in evidence in the late afternoon, as the sun moves into the western sky, toward which the Galerie is oriented. Her phrase, "as if the Sun itself were lighting it," may also be a conventional allusion to the king, who regularly promenaded through the room; however, it seems particularly relevant in relation to one of the preliminary drawings discussed above which depicts the Slaying of the Niobids in an end lunette (fig. 89). In this drawing of 1678 or 1679, created when the Apollo theme was being developed for the Galerie, the bivalve door leading to one of the end salons is given in alternate renderings—either as a conventional wooden door of *boiseries* (right) or as a mirrored door (left)—and the mirrors are clearly rendered as small panels of glass. Although such panels are not specifically indicated on the drawing of the part of the eastern wall showing Apollo scenes (fig. 88), it is apparent from figure 89 that mirrors were already being considered in conjunction with the Apollo cycle—that is to say, from the initial stages of the planning of the Galerie. And the use of mirrored surfaces to increase the luminosity of a room dedicated to the god of light would have been eminently appropriate. The idea of placing mirrored portals at the ends of the Galerie was abandoned (the openings into the end salons were built without doors [figs. 86, 87]), but mirrors were retained on the long inner wall (fig. 84), even when the painting cycle was finally revised. But that cycle, after all, depicts *le roi-soleil,* for whom the enhanced luminosity provided by the mirrors was thoroughly suitable.[37]

In addition to these aesthetic and symbolic qualities, the mirrors were also proud products of the French glass-making industry, which was no longer dependent upon Venice.[38] As symbols of national pride, they complemented Le Brun's French order (fig. 97), a variant of the Corinthian, with a capital of palm leaves (symbols of victory), Gallic cocks, a fleur-de-lys, and an Apollo-head; a "Doric" frieze displays a fleur-de-lys on each "triglyph" (console) and a royal French crown in each "metope."[39]

Although the mirrored revetment of the Galerie des Glaces was unprecedented in scale and dramatic effect, it was by no means the first mirrored interior in European architecture or even at Versailles itself. The history of the use of mirrors in architectural decoration is yet to be written, but some preliminary work has been done by Böhmker,[40] whose research localizes the first mirrored rooms in Renaissance Germany, in particular at Schloss Hartenfels, near Torgau (1532–45, by Konrad Krebs) and at Schloss Heidelberg (the "Gläserne Saal," 1544–56). At Hartenfels, the main seat of the Saxon court, a mirrored room was an intimate domestic space set above the spiral stair, originally adorned only with three old-fashioned steel mirrors. At Heidelberg, by contrast, the "Gläserne Saal" (built for the Elector Friedrich II) was a large, vaulted room occupying the full length of a wing, and containing glass mirrors which were probably set against piers. The room was first used as a library, and later as the Electoral audit office.

From this time on, the prominent use of mirrors in interior decoration can occasionally be documented in European architecture.[41] Mirrors were used particularly for intimate domestic

rooms, such as bedrooms and boudoirs. A specimen survives in François Mansart's Château de Maisons (built 1642–51), where a circular boudoir lined with mirrors was described by an English visitor in June 1664: "Hence wee went into a little round Chamber, set all with looking glasses quite round; I may Calle it the Multipliing Glasse Chamber for whatsoever way you turne your selfe you see an army of your owne selfe."[42]

At Versailles, several of the small rooms of the Petit Château were adorned with mirrors in 1664–65; Mlle. de Scudéry mentions, in the *grand cabinet,* "mirrored pilasters interwoven with other pilasters of gilded leaves on a background of lapis with the monogram of the King; which makes a marvellous effect by the reflection of so many beautiful objects in these transparent pilasters which are all crowned with golden suns."[43]

By the 1660s such use of mirrored pilasters for a domestic room was no longer an innovation. A more unusual and poetic use of mirrors, however, appeared in an important garden feature at Versailles, the Grotto of Tethys (begun 1664). The mirrors were located on the walls and piers; they appeared as rectangles with intertwined frames on the piers flanking the central niche. Mirrors had never before been used in a grotto; their appearance in the Grotto of Tethys was calculated to enhance the illusion of space and thereby heighten the magical atmosphere as Félibien explained in 1672: "And because the piers and sides of the Grotto are filled with mirrors, each type multiplying itself, this Grotto seems of an extraordinary size, and like several grottoes which compose a palace in the middle of the sea, whose extent seems not to have limits."[44]

The use of mirrors in the Galerie des Glaces (and in the Salon de la Guerre and the Salon de la Paix) can simply be regarded as a spectacular development of earlier mirrored rooms, with the specific idea of enhancing the effect of light in a room originally destined for a painted cycle of Apollo and ultimately decorated with the heroic deeds of *le roi-soleil.* But since the Galerie des Glaces was conceived as a room for royal appearances, particularly for the reception of foreign ambassadors on special occasions,[45] it is interesting to speculate whether it was intended to rival and surpass another room used for such purposes. Only one mirrored room of state is known before the Galerie des Glaces—the Salon de los Espejos, or Hall of Mirrors, in the old Alcázar in Madrid.[46]

The Salon de los Espejos was not a long gallery, but rather a rectangular room measuring about 20 meters long by 10 meters wide, that was used for special receptions by the kings of Spain from 1638 on. It was here that they received ambassadors and high nobility on extraordinary occasions.[47] Like the later Galerie des Glaces, it was reached by an official route that led the visitor up a grand staircase and through the king's suite. In the 1640s the salon was decorated at each of its shorter ends by two pairs of large mirrors; these mirrors were enclosed by bronze frames decorated with the emblematic eagles of the Hapsburg dynasty. The mirrors hung above tables that were supported by gilded bronze lions, symbols of the kingdom of Léon and of the Crown of Castile. The mirrors were not integrated into the architecture, and appeared only at the shorter ends, facing one another. Nevertheless, their prominence led the room to be called the Salon de los Espejos instead of merely "la pieza nueva."

Beginning in the mid-1620s, the room was adorned with easel paintings from the Spanish royal collection. In 1659 Velázquez determined the definitive scheme of these pictures,[48] and in that year the ceiling frescoes were begun. These depicted five scenes from the myth of Pandora, and were the work of the Italian painters Angelo Michele Colonna and Agostino Mitelli (assisted by Francisco Carreño and Francisco Rizi). Although the scene of Pandora opening her vase (not a box in this instance) was not depicted, the allegorical meaning of the cycle may have been that the evils released by Pandora would be opposed by the Spanish monarchy.[49] The easel

paintings included Hapsburg portraits and an amazingly varied group of classical and biblical narratives, many of which were chosen to illustrate behavior worthy of emulation by princes and to show the just punishment of evil-doers.[50] The narrative paintings—mainly by sixteenth-century Venetian and seventeenth-century Baroque masters, with Titian and Rubens predominating—were perhaps a realization of the Spanish painter Carducho's recommendation (1633) that a royal gallery should be decorated with pictures that would inspire virtuous behavior in great princes.[51] The entire scheme was meant to refer to the Spanish Hapsburgs as Christian princes, the defenders of Catholicism, and three paintings in the 1659 arrangement directly depicted events from sixteenth- and seventeenth-century history: Titian's *Charles V at the Battle of Mühlberg* (Madrid, Prado), commemorating the emperor's defeat of the Protestant League of Schmalkalden in 1547; Titian's *Allegory of the Battle of Lepanto* (Madrid, Prado), with a scene referring to the naval victory of 1572 over the Turks and featuring Philip II; and Velázquez's lost *Philip III Expelling the Moriscos,* an event of 1609. In addition, there was an allegorical equestrian portrait of Philip IV by Rubens (lost; copy Florence, Uffizi).

Since foreign ambassadors and other important dignitaries were received by the Spanish king in the Salon de los Espejos, its appearance and contents must have been well known throughout Europe. In 1659 it was the setting for the reception of the Marshal-Duke of Gramont and his suite of French nobles; the duke had been sent by Louis XIV as his representative to ask Philip IV for the hand of his daughter, Maria Teresa, in marriage.[52] This grand occasion in particular, recorded by the duke, must have kept the memory of the room alive in French court circles. It is possible, therefore, that the Galerie des Glaces was intended to rival the Salon de los Espejos—perhaps as a means of surpassing the Hapsburg rival in the field of art. This gesture would have paralleled the military and political struggles waged against Spain through much of Louis XIV's reign.

More than anywhere else in the Château, it is in the Galerie des Glaces where the visitor of today can best savor the richness and splendor so admired during the reign of the Sun King by Frenchmen and foreigners alike. From its windows and from those of the adjacent salons, one can survey from a height large portions of the magnificent formal park that stretches away in three principal directions. The indoors is closely integrated with the outdoors by the abundance of light, reflections, and views, and even by the motif of the central painting of Apollo in his quadriga (fig. 94, center left), an echo of the Apollo Fountain on axis in the Petit Parc and visible from the windows. Although Mansart's addition obliterated the effective recessed center on the exterior of Le Vau's Enveloppe (figs. 6, 7), it provided an internal, logical spatial link between the north and south ranges.

Louis XIV walked almost daily in the Galerie des Glaces; from this cockpit he could survey the painted history of his reign in the vault, the magnificence of French marbles and glass, and the unending expanse of the gardens. The long gallery—a type of room long associated with political power—here reaches its unsurpassable climax.

VII

The Château in Official Use

THE decision of 1668 to enlarge the Château by building the Enveloppe (see chapter II) can be viewed in retrospect as a first step in the transformation of Versailles into the official monarchical residence, supplanting the Louvre. This transformation was formally effected in 1682. As the official seat of government, the building had to function as an impressive setting for receptions and ceremonies. Three such events, recorded in detail by contemporaries, vividly reveal how the spaces provided by Le Vau, d'Orbay, and Mansart were dramatically used.

The reception of the Russian ambassadors (May 1685) was recorded by the Marquis de Sourches:

> . . . the Ambassadors of the Grand-Duke [Czar] of Muscovy held audience with the King, in the accustomed manner, that is to say that they came from Paris in the coaches of the King, led by the Introducer of the Ambassadors. When they entered the *avant-cour,* the two regimental companies of guards were there with their arms, and the drums sounded when their coach passed. In the courtyard of the Château, the guards of the gate and the guards of the *prévôté de l'hôtel* were lined up with their weapons. And these Muscovites were led into the room reserved for the reception of Ambassadors.[1]
>
> At noon, the Grand-Master of Ceremonies, with his assistants, came to fetch them and led them to the marble staircase [the Escalier des Ambassadeurs; figs. 34–39], at the foot of which they were received by the Captain of the Guards with his officers, who led them up to the place where the King was. The Hundred Swiss were lined up along the staircase, and the King's guards [were] also in rows in the first two rooms

of the apartment [the Salon de Vénus II and the Salon de Diane; figs. 65, 67], all with their arms. The King was in the last room of the apartment [the Salon d'Apollon; fig. 74], near the salon [the Salon de la Guerre; fig. 86], seated on a silver chair, set up as a throne, on a platform covered with a magnificent rug of gold, silver, and silk.

The Muscovites did not approach closer to the King than the foot of the platform, where they all prostrated themselves, faces to the floor, in the oriental manner; following which the principal one among them delivered his address in his language, which was immediately repeated out loud by the translator. And having approached the King to give him the letter of the Grand-Duke, his master, His Majesty replied to his speech; and they retired as they had come, after having again prostrated themselves as they had already done, and were led back in the same way to the room of the Ambassadors, where the King's officers entertained them magnificently; and, after dinner, they were led back to Paris in the same coaches. . . .[2]

In this ambassadorial reception, the visitors must have been overwhelmed by the spectacle of the large, open staircase, lined with soldiers; the long, processional enfilade of the rooms of the king's *grand appartement;* and finally, by the throne room itself—the Salon d'Apollon—where His Majesty was set apart on a silver throne.

The decoration of the Salon d'Apollon calls for special comment. As we know, the permanent ceiling paintings centered upon the *Rising of the Sun* (fig. 76), with Apollo—the principal mythological personage in the iconography of Louis XIV—surging through the heavens in his chariot, accompanied by the Four Seasons. The lunettes (fig. 75 and appendix III) contain scenes of Coriolanus, Vespasian, Augustus, and Alexander, that allude to the deeds and virtues of the monarch. And the corner paintings display the Four Parts of the World, "where Fame carries the reputation of the King's arms."[3] In addition, the walls of the chamber were hung with easel paintings from the royal collection, selected for their aesthetic qualities and allegorical content. Four large canvases by Guido Reni depicted scenes from the life of Hercules, the ancient hero with whom the king was often identified: *The Abduction of Deianeira, Hercules Slaying the Hydra of Lerna, Hercules Wrestling with Achelous,* and *Hercules on the Funeral Pyre* (all Paris, Louvre). These prominent paintings were placed on the side walls. To the left of the throne hung Rubens' *Queen Tomyris with the Head of Cyrus* (fig. 98), a scene from ancient history illustrating "just retribution," and a reminder of the king's power and virtue.[4] Even presumably unsophisticated visitors like the Russian ambassadors, though perhaps unaware of the symbolic meanings of the ceiling paintings and the Hercules pictures, could not fail to make a meaningful connection between Rubens' grisly scene and the living ruler who occupied the adjacent throne. This throne no longer exists, but its appearance is recorded in a print and in a description in the *Mercure galant.*[5] On the back of the throne there was a standing Apollo, crowned with laurel and holding his lyre; figures representing Justice and Strength reclined along the top of the back.

On very special occasions, the throne was moved from the Salon d'Apollon and set up on a platform at the end of the Galerie des Glaces, just before the entrance to the Salon de la Paix. This arrangement accommodated more spectators, and it also created one of the most dramatic effects ever produced in a palace in the Western world: the king of France, magnificently dressed and seated at the end of the long gallery, with the glittering mirrors and the aggressive vault paintings of his triumphs visually activating the funneled space (fig. 84, but looking in the opposite direction). The necessity for foreign dignitaries to traverse this entire distance in itself constituted an act of obsequious homage.

This arrangement was utilized for Louis XIV's last grand reception, that of the Persian ambassadors on February 19, 1715, held almost seven months before his death on September 1. The occasion is described in detail in two sources: a dry recitation in the minutes of the *Cérémonies de la Cour de France;*[6] and an amusing account in the memoirs of the Duc de Saint-Simon, who regarded Mehemet Riza Beg as an imposter (he was not).[7] The preparations are vividly described by the duke:

> The long gallery and the state apartments were most beautifully decorated, and a magnificent throne was placed at the end of the gallery, with tiers of benches set at different levels along both sides. The rows nearest the throne were reserved for the ladies of the Court; the rest were for gentlemen and spectators; but no one was admitted except in full court dress. The King lent M. le Duc du Maine a set of diamond and pearl buttons for the occasion, and one of coloured stones to M. le Comte de Toulouse. M. le Duc d'Orléans wore a blue velvet coat, embroidered in a mosaic pattern, overlaid with pearls and diamonds, which was a veritable triumph of richness and good taste. The courtyards, roofs, and approaches swarmed with onlookers, which vastly delighted the King as he looked from the windows. He greatly enjoyed waiting for the ambassador's arrival, which took place at eleven o'clock, in one of the royal coaches, escorted by the Maréchal de Matignon and the Baron de Breteuil. They stopped in the avenue to mount their horses, rode into the great courtyard preceded by the ambassador's suite, and up to the door of the apartment of the colonel of the guard, as is the custom. The suite appeared in every way poverty-stricken, and the supposed ambassador highly embarrassed and very ill-clad. The presents were beneath contempt.[8]

At the appointed hour, the entourage entered the vestibule of the Escalier des Ambassadeurs, whence they were led up the staircase, preceded by servants, a kettledrummer, and eight trumpeters. Once again, as for the Russian ambassadors, the stair was lined with soldiers. Then came the sequence of rooms of the king's apartment, again with soldiers stationed in the first two chambers. The procession continued into the Salon de la Guerre and then into the Galerie des Glaces, where the floor was entirely covered with Savonnerie carpets.[9] Saint-Simon describes the Persian ambassador as "completely bewildered by the magnificence";[10] in the minutes of the *Cérémonies* we read:

> . . . at the entrance to the Galerie, the Ambassador, being able to be seen by the King, took the letter of the King of Persia, still wrapped in gold material, and carried it on his two hands; they continued to walk up to the foot of the throne, where the Ambassador greeted the King with a sole salute in his fashion. The King, seeing him enter the Galerie, rose and uncovered his head. . . . The Ambassador delivered his compliments, which were explained by the interpreter, as well as the King's reply; the compliments ended, the Ambassador presented to the King the letter of His Majesty [the King of Persia] (fig. 99)[11] . . . he also presented the chest in which were the gifts; the King did not touch it, [so] the Ambassador gave it to the Marquis de Torcy, then descended to the foot of the steps of the platform, from where he saluted the King, bowing while bringing his two hands to his head. He made a few steps turning at the side of the King, whom he lost sight of immediately because of the crowd of courtiers who blocked the passage.[12]

Saint-Simon tells us that the ambassador afterwards dined and had an audience with the king's great-grandson (the future Louis XV, then eight years old). He saw the Comte de Pontchartrain, the Marquis de Torcy, and then returned to Paris by coach.[13]

As a final instance of the ceremonial use of the Château, we turn to the procession of the Corpus Christi (Fête Dieu) on June 5, 1681, as recorded in the *Mercure galant:*

> . . . [the procession] of Versailles being ready to come forth from the parish church [Saint-Julien][14] which is in the new town, His Majesty went there to accompany it, followed by the entire Court, which was numerous and magnificent. All the pages of the King's bedroom, with those of the large and small stables, the Hundred Swiss, and the King's guards each carried a torch of white wax. Almost one thousand were counted. The King's pages are so numerous that one must not be astonished by that which I tell you. The fathers of the Mission, the Recollets, and the chaplains of the entire royal house were present at that procession, which passed before the pump [formerly located on the present rue des Réservoirs], and halted there. M. Denis, *fontainier* of His Majesty, had taken care to erect there a temporary altar of an extraordinary sort. It was a bower all filled with cascades of water and with rock-work. The procession passed from there into the *avant-cour* of the Château, and afterwards into the courtyard, both hung with the most beautiful tapestries of the Crown. All the balconies and all the windows, up to the roof of the Château, were bedecked with Persian tapestries with gold and silver grounds. The altar had been placed at the bottom of the large and magnificent stair [actually on the first landing of the Escalier des Ambassadeurs; see fig. 37]. . . . Large silver vases, filled with flowering plants, had been placed on the marble pedestals which accompany the balusters of gilded bronze [fig. 39]. Similar ones had been placed on the cornices and in other places where such ornaments could be suitable. The altar was on the first landing, in front of the fountain.[15] An altar-cloth of gold, of a surprising beauty, attracted admiration to the front of this altar; the tabernacle, which was perforated, was adorned with rubies, emeralds, and diamonds. A crown three feet in diameter formed the dome. It was all of precious stones, and threw off a brilliancy so dazzling, that one could scarcely tolerate the glare. The cascades of the fountain appeared through the tabernacle, and nothing was more pleasant to view than that water and the gems which the illumination caused to shine. There were large *guéridons* with large candelabra on both sides of the altar, as well as at the tops of the steps of the stair. The musicians of the King's chapel were placed above. It would be very difficult to find a place more advantageous for musical sound. The instruments and the voices were also heard there with great pleasure.[16] There was no disarray, and everything appeared on that day to be worthy of the Court of a Very Christian King. The procession, having emerged from the Château, passed in front of the superb stables of His Majesty, which were hung up to the new town with rich tapestries. That Prince led it [the procession] back to the church, having had his head uncovered during three hours, without even having used a parasol against the intense heat of the Sun. He heard High Mass at the parish church, where every evening during the Octave he comes for Evensong.[17]

At the time of the procession, the Château lacked a functioning chapel; a new one, located between the northern service wing and the Grotto of Tethys,[18] had been begun the preceding

month but was not dedicated until April 30, 1682.[19] In all probability, the Escalier was used for the service of the Corpus Christi procession only on this one occasion because of the lack of a chapel, and because the excellent acoustics recommended the setting for the sacred music.

If we imagine the rich altar and dazzling tabernacle on the landing of the Escalier (fig. 37), our first reaction may well be that this is incongruous: the secular architecture and monarchical decorations seem too wordly, and the bust of Louis XIV directly above the area where the priest officiated seems out of place.

But to the king, the clergy, and their contemporaries, the setting was surely acceptable, even meaningful. The tradition of Gallicanism had elevated the French ruler to the status of God's minister on earth, the protector of the special liberties of the French clergy against the claims of the papal See.[20] The placement of the bust of the king above the temporary altar in the Escalier could have suggested, I believe, the protective presence of the French monarchy, as could the royal French crown that is held above the main altar in an unexecuted project for the final chapel by Pierre Le Pautre (1707–8; fig. 100).[21] In both instances, visual form was given to the coronation oath sworn by Louis XIV (1654), Louis XIII (1610), and Henri IV (1594) to the French clergy in Reims Cathedral:

> I promise and grant to you that I shall maintain you in your canonical privileges, as well as in your churches, and that I shall give you good laws, and shall do justice, and shall defend you, God helping by His Grace, according to my power, as a king in his realm must do by right and reason with regard to bishops and their churches.[22]

In ways such as these did the Château of Louis XIV serve as a magnificent stage for ceremonial life in the Age of Absolutism.

Appendixes

I: THE CHRONOLOGY OF THE ENVELOPPE: SUMMARY

1668: Louis XIV resolves to preserve the Petit Château. Louis Le Vau designs the Enveloppe.

October 1668: Construction of the Enveloppe begins.

October 1668–June 1669: Construction of the Enveloppe proceeds.

Late 1668: Colbert writes the "Mémoire sur ce qui est à faire pour les bâtiments en l'année 1669."

June 8, 1669: Flooring of *premier étage* almost ready to be laid. Arches of western terrace partially completed.

June 1669: Louis XIV publicly declares that the Petit Château will be torn down. Construction of the Enveloppe halted. Competition held among six architects, who are guided by Colbert's "Mémoire de ce que le roi désire dans son bâtiment de Versailles," which calls for the destruction of the Petit Château.

June 26, 1669: Le Vau submits his competition design, of which a variant is preserved (fig. 18).

Summer 1669: Colbert writes the "Observations sur les plans présentés par différents architectes pour Versailles." Le Vau apparently wins competition (not certain whether his winning design was begun).

Late Summer or Fall 1669: Colbert writes the "Raisons générales," which calls for the abandonment of Le Vau's competition design and a return to the Enveloppe scheme, with the retention of the Petit Château (final decision).

Late 1669/Early 1670: Enveloppe resumed.

October 11, 1670: Death of Louis Le Vau. François d'Orbay assumes direction of architectural activity at Versailles.

1673/74: Completion of Enveloppe and new court-side structures.

II: THE 1669 COMPETITION: THE PROJECTS OF VIGARANI, GABRIEL, AND PERRAULT

The competition of June 1669 for a new château saw the participation of six architects: Louis Le Vau, Antoine Le Pautre, Jacques IV Gabriel, Claude Perrault, Carlo Vigarani, and Thomas Gobert. After receiving the designs, Colbert wrote a critique dealing only with the projects of Le Vau, Gabriel, Perrault, and Vigarani. As we have seen, Le Vau submitted a design essentially like THC 2392 (fig. 18), and Colbert commented on this (see chapter II). The designs of the other architects have never been identified, but Colbert's remarks on those by Vigarani, Gabriel, and Perrault are worth examining, mainly because they shed some light on the competition program that envisaged the elimination of the Petit Château.

The following are the "Observations sur les plans de Vigarani."[1]

> [1] Pour les dehors, en retranchant les avant-corps de 1 pied 8 pouces, il met presque le tout hors d'estat de servir.

In Colbert's "Mémoire de ce que le Roi désire dans son bâtiment de Versailles" (June 1669), the second stipulation was "Supprimer les avant-corps en retaillant les murs." The king evidently meant that the *avant-corps* of the Enveloppe should be retained in the competition projects, but diminished in their degree of projection. Vigarani's proposal to cut them back by 1 *pied,* 8 *pouces* was censured by Colbert as excessive.

> [2] L'entrée ne sera pas ornée des deux gros pavillons que le Roy demande.
> [3] L'escalier coupera les fenestres tant aux rampes qu'au palier.
> [4] La salle des gardes sera plus petite que l'antichambre.
> [5] Il n'y aura point de galerie.

From these comments it is evident that the king and Colbert desired an entrance with two large pavilions and a long gallery within the château. We already know of these demands, however, from the June 1669 "Mémoire," where there is a reference to [11] "la galerie basse," [30] "La galerie sur la face," and [13] "deux grands pavillons" on the court side (p. 9). The brevity of Colbert's comments perhaps indicates that Vigarani's design was not taken seriously. Carlo Vigarani (1622/23–before 1713) was a member of an Italian family active in France from the 1650s on, which specialized in the design of theaters and theatrical sets.[2] Carlo Vigarani was

not an architect of châteaux, and his appearance in that role in the 1669 Versailles competition is surprising.

The architect in question in the "Observations sur les plans de Gabriel"[3] is Jacques IV Gabriel (after 1636–86), who acted as contractor of Le Vau's Enveloppe from its inception in October 1668 (see chapter II).[4] The first nine of Colbert's comments grant only a vague notion of a few features of Gabriel's proposal. These remarks demonstrate, however, the superintendent's semiprofessional grasp of three-dimensional architectural relationships and structure.

[1] L'entrée du grand escalier, dans le coin d'une galerie.

[2] Doit estre dans le milieu: la face, deux portes et une croisée.

[3] L'entrée du milieu, sous un palier, a 10 ou 11 pieds de haut.

[4] Les rampes coupent les croisées.

[5] Le troisième palier, où est marqué un balcon, est dans le milieu des deux étages, n'a rapport ni à l'un ni à l'autre et coupe tous les ornemens.

[6] Les colonnes à quatre qui doivent soutenir le mur du premier étage seront coupées par la troisième ou quatrième rampe.

[7] Le mur marqué sur cette rampe sur ce plan ne peut estre, parce qu'il seroit en l'air, estant nécessaire qu'il n'assise sur la voûte portée par les colonnes.

[8] Le vestibule par bas ne peut estre voûté, estant impossible d'expliquer comme elle [la voûte] pourra estre conduite sur les colonnes qui sépareront le carré de l'ovale.

[9] Le mur du salon d'en haut portera à faux; s'il est de cloisonnage, il sera trop foible pour porter le cintre de 10 toises et la couverture.

A notation following these points suggests that the architects were free to propose partial demolitions of the Enveloppe:

[10] Sur 34 toises de face du costé du jardin, il en conserve 20 et en rase 14.

The length of 34 *toises* is close to the measurement of 33 *toises,* which is the length of the north and south façades of the Enveloppe; "costé du jardin" must refer to either the north or the south parterre.

[11] Le milieu de tout bastiment doit estre régulier et percé. Ce sera une niche.

This is a consequence of [9] of the June "Mémoire": "Que du milieu de la cour les quatre vues soyent percées" (see p. 9).

Colbert's remaining criticisms clearly show that he had no use at all for Gabriel's project:

[12] Il n'y aura point de milieu dans la cour, les portes des vestibules n'ayant rapport à rien.

[13] Le milieu est de niveau à la cour; il marque trois degrés pour monter dans le vestibule de la face; en sorte que pour donner l'écoulement des eaux hors des bastimens, il faudra que la partie des bastimens enfermée dans cette estendue soit enterrée de deux ou trois pieds.

The remarks in the "Observations sur le dessin du sieur P . . ."[5] pertain to the project of Claude Perrault (1613–88), whose participation in the competition is indicated in Charles Perrault's letter to Colbert of June 25, 1669.[6]

[1] Les avant-corps ne sont point conservés, ni les murs de refend.

Perrault apparently obliterated Le Vau's *avant-corps,* which the king evidently wanted only diminished in projection. Apparently the architects were expected to retain the partition walls of the Enveloppe.

[2] L'on n'entre point en face dans l'escalier.

This is related to [3] of Colbert's criticism of Le Vau's competition project (see p. 11).

[3] L'entrée principale estant celle de la cour, et non par la salle destinée pour les Suisses, seroit sous une rampe.

[4] Le Roy ne voulant point que les carrosses entrent par cette cour, les ambassadeurs ne pourroient pas entrer par la salle des Suisses.

[5] La cour, 23 toises de large sur 41 toises de longueur, paroistroit trop longue pour sa largeur.

A court 28 *toises* wide by 34 *toises* long had been called for in the June "Mémoire" [33] (see p. 9).

[6] Le grand vestibule de face, de 8 toises sur 7½, seroit bien proportionné.

[7] Les deux autres [vestibules] des ailes, de 5 sur 10, seroient trop longs pour leur largeur.

[8] Le grand appartement du Roy seroit composé d'une salle de 13 toises sur 5; antichambre de 5 toises, en carré; grande chambre de 6 toises ½; petite chambre, 4 toises; petit cabinet, 2 toises; grand cabinet de 6 toises ½.

[9] Ces ressauts de grande salle en petite antichambre, de là en grande chambre, petite chambre, petit et grand cabinet, ne seroient pas agréables.

[10] Il seroit à désirer que l'antichambre fust pour le moins aussy grande que la chambre, et que le petit cabinet de 2 toises fust retranché.

[11] La galerie de 3 toises ½ paroist trop étroite.

[12] Il est vray que sur la longueur de 13 toises la proportion seroit bonne; mais le salon séparé des deux galeries ne sera pas selon l'intention du Roy.

[13] Les galeries n'enfileront point le salon par le milieu.

[14] Les pièces M, N, O seront inutiles et ne serviroient que de passage.

[15] I et P auront 7 toises sur 2½.

[16] L'appartement de commodité D, E, F, G aura pour seul escalier X, qui n'a que 4 pieds de marches.

[17] L'appartement de M^gr le Dauphin, mesme degré.

[18] L'appartement de la Reyne sera plus grand que celuy du Roy, à cause que la salle des gardes occupe les deux largeurs.

This last remark may indicate that Perrault's design had wings of double thickness.

[19] La chapelle aura 6 toises en carré.

[20] Les passages B, A, Q des deux appartemens ne seront point éclairés.

[21] Les deux escaliers X, sur la face, ne serviront qu'au dégagement des gardes-robes I, ne pourront avoir rien au-dessus, par le défaut de jour, et que la galerie sera cintrée jusqu'au haut.

[22] Les arcades du dehors ne seront que de 6 pieds d'ouverture, ce qui sera peu.

[23] Le défaut universel de tous les dessins sera qu'il faut trop abaisser le bastiment sur les cours.

III: THE CEILING PAINTINGS OF THE PLANETARY ROOMS— SUBJECTS AND ARTISTS

Grand Appartement du Roi

Salon de Diane
Center: *Diana in a Chariot Pulled by Hinds* (Gabriel Blanchard)
East wall: *Cyrus Hunting Wild Boar* (Claude II Audran)
Opposite windows: *Augustus Sending a Colony to Carthage* (Claude II Audran)
West wall: *Jason Debarking at Colchos* (Charles de La Fosse)
Above windows: *Alexander Hunting Lions* (Charles de La Fosse)

Salon de Mars
Center: *Mars in a Chariot Pulled by Wolves* (Claude II Audran)
Flanking scenes: *Allegory of Fury* (René Antoine Houasse); *Allegory of Victory* (Jean Jouvenet)
East wall: *Cyrus Assembling His Army* (Claude II Audran)
Opposite windows: *Caesar (or Cyrus?) Haranguing His Troops* (Jean Jouvenet); *Demetrius Poliorcetes Capturing a City* (Claude II Audran)
West wall: *Triumph of Constantine* (René Antoine Houasse)
Above windows: *Marc Antony Making Albinus Consul* (Jean Jouvenet); *Alexander Severus Reproaching an Officer* (René Antoine Houasse)

Salon de Mercure
Center: *Mercury in a Chariot Pulled by Cocks* (Jean Baptiste de Champaigne)
East wall: *Alexander the Great and the Gymnosophists* (Jean Baptiste de Champaigne)
Opposite windows: *Ptolemy, King of Egypt, Conversing with Scholars in a Library* (Jean Baptiste de Champaigne)
West wall: *Augustus Receiving the Indian Ambassadors* (Jean Baptiste de Champaigne)
Above windows: *Alexander the Great Providing Aristotle with Animals* (Jean Baptiste de Champaigne)

Salon d'Apollon
Center: *Apollo in a Chariot Pulled by Horses* (Charles de La Fosse)
East wall: *Coriolanus Lifting the Siege of Rome* (Gabriel Blanchard)
Opposite windows: *Vespasian Building the Colosseum* (Gabriel Blanchard)
West wall: *Augustus Building the Port of Messina* (Gabriel Blanchard)
Above windows: *Porus and Alexander* (Gabriel Blanchard)
Corners: *The Four Parts of the World* (Charles de La Fosse)

Salon de Jupiter (Ceiling now in the *Salle des Gardes de la Reine)*
Center: *Jupiter in a Chariot Pulled by Eagles* (Noël Coypel)
Above fireplace: *Ptolemy Philadelphus Freeing Jewish Slaves* (Noël Coypel)
Opposite windows: *Septimius Severus Distributing Bread to the Romans During a Famine* (Noël Coypel)
Opposite fireplace: *Trajan Receiving Petitions From the Nations of the World* (Noël Coypel)
Above windows: *Solon Upholding the Laws Against the Objections of the Athenians* (Noël Coypel)

Salon de Saturne
Destroyed. Painted by Charles Nocret and/or Pierre de Sève

Salon de Vénus I
Destroyed. Painted by Charles Nocret and/or Pierre de Sève

Salon de Vénus II
Center: *Venus in a Chariot Pulled by Doves* (René Antoine Houasse)
East wall: *Augustus Giving Chariot Races* (René Antoine Houasse)
Opposite windows: *Nebuchadnezzar Building the Gardens of Babylon* (René Antoine Houasse)
West wall: *Alexander the Great Marrying Roxanne* (René Antoine Houasse)
Above windows: *Cyrus Reviewing His Troops* (René Antoine Houasse)

Grand Appartement de la Reine

Salon de Diane
Destroyed

Salon de Mars (Antichambre de la Reine)
Center: *Mars* (Claude François Vignon). Destroyed
West wall: *Rodogune, Queen of Syria, Swearing Vengeance* (Claude François Vignon)
Opposite windows: *Artemisia, Queen of Caria, Sailing with Xerxes Against the Greeks* (Antoine Paillet); *Fury and War* (Antoine Paillet); *Queen Zenobia Battling Aurelian* (Antoine Paillet)
East wall: *Ipsycratée Following Her Husband, King Mithridates, to War* (Antoine Paillet)
Above windows: *Clelia and Her Companions Crossing the Tiber* (Antoine Paillet); *Bellona* (Claude François Vignon); *Harpalice Rescuing Her Husband, Harpalus* (Claude François Vignon)

Salon de Mercure (Salon de la Reine)
Center: *Mercury Bestowing His Influence on the Arts and Sciences* (Michel II Corneille)
Above fireplace: *Sappho* (Music, Poetry) (Michel II Corneille)
Opposite windows: *Penelope* (Tapestry-Weaving) (Michel II Corneille)
Opposite fireplace: *Aspasia* (Philosophy) (Michel II Corneille)
Above windows: *Cesicene* (Painting) (Michel II Corneille)
Corners: *Vigilance* (Michel II Corneille); *Diligence* (Michel II Corneille); *The Academy* (Michel II Corneille); *Commerce* (Michel II Corneille)

Salon d'Apollon (Chambre de la Reine)
Center: *Apollo with the Hours and the Four Parts of the World* (Gilbert de Sève). Destroyed
Flanking scenes (destroyed): *Feast of Cleopatra* (Gilbert de Sève); *Dido Founding Carthage* (Gilbert

de Sève); *Rhodope Erecting the Egyptian Pyramids* (Gilbert de Sève); *Nitocrix Dividing the Euphrates Against the Medes* (Gilbert de Sève)

Salon de Jupiter
Destroyed. Painted by Nicolas Loir

Salon de Saturne
Destroyed. Painted by Nicolas Loir

Salon de Vénus
Destroyed. Painted by Charles Nocret

Notes

CHAPTER I

1. The royal architects of Versailles were Louis Le Vau (1661–1670), François d'Orbay (1670–78), and Jules Hardouin-Mansart (1678–1708). Le Vau and Hardouin-Mansart held the title of first architect of the king (*premier architecte du roi*), Le Vau from 1654, Mansart from 1681.

The superintendents of the king's buildings (*les surintendants des bâtiments du roi*) were Jean Baptiste Colbert (1664–83), the Marquis de Louvois (1683–91), Colbert de Villacerf (1691–99), and Jules Hardouin-Mansart (1699–1708).

CHAPTER II

This chapter is a revised version of my article on the chronology (1980), where I erroneously argued that Colbert's document entitled "Raisons générales" was written in early 1669 and concerned the Enveloppe. I now realize that it dates from the late summer or the fall of 1669, and concerns Le Vau's competition project of that summer.

1. [October 20–November 4, 1668]: "à [Viart and Maron, *terrassiers*], pour leur parfaict payement des terres qu'ils ont enlevées des anciennes terrasses du chasteau . . . 1424 *livres, 10 sols*" (*Comptes*, I, cols. 255–56).

2. [November 4, 1668]: "aud. Maron, pour les ouvriers qui ont travaillé à l'enceinte du nouvel attelier . . . 331 *livres, 8 sols*" (*Comptes*, I, col. 256).

3. [November 22–December 3, 1668]: "à Jacques Gabriel, à compte des ouvrages de maçonnerie qu'il fait pour le nouveau bastiment . . . 21000 *livres*" (*Comptes*, I, col. 251).

4. "Mémoire sur ce qui est à faire pour les bâtiments en l'année 1669" (Colbert, v, 276–78, doc. 33).

5. *Ibid.*, v, 277:

Voir l'estat des plants de Versailles et ce qui est à faire pour achever le tout;

Les plans, dessins et élévations des nouveaux bastimens, pour régler tout ce qui est à faire sur ce sujet.

Commencer à faire les dessins et résoudre tous les dedans, pour donner ordre dès à présent aux marbres et aux ornemens qui seront nécessaires.

6. [January 25, 1669]: "à Jacques Gabriel, entrepreneur du nouveau bastiment de Versailles, à compte des ouvrages de maçonnerie qu'il fait aud. bastiment" (*Comptes*, I, col. 330).

7. [February 15, 1669]: "à André Mazières et Anthoine Bergeron, à compte des ouvrages de maçonnerie par eux faits au chasteau de Versailles . . . 1500 *livres*" (*Comptes*, I, col. 331).

8. [February 15–March 28, 1669]: "à Claude et Benjamin Guillot, et Nicolas Langlois, carreyers de Meudon, pour reste et parfait paiëment de 8200 *livres* à quoy montent les dix-sept grandes pierres qu'ils ont fournies et voiturées à Versailles . . . 2500 *livres*" (*Comptes*, I, col. 331).

9. [March 19, 1669]: "A [Boursault, *terrassier*], pour son remboursement de ce qu'il a payé aux ouvriers qui ont travaillé à lever le pavé de la fausse braye dud. lieu, et autres despences. . .112 *livres*, 17 *sols*" (*Comptes*, I, col. 340). The *fausse braye* is the platform which the Petit Château stood upon; it is clearly labeled in figure I.

10. [May 8–November 9, 1669]: "à Cliquin et Charpentier, charpentiers, à compte de la charpenterie du nouveau bastiment de Versailles . . . 46000 *livres*" (*Comptes*, I, col. 331).

11. [June 2, 1669]: "à [Boursault], pour son remboursement de ce qu'il a payé aux ouvriers qui démolissent les dedans des deux pavillons dud. chasteau et qui font des tranchées pour poser des thuyaux de fonte . . . 369 *livres*, 12 *sols*" (*Comptes*, I, col. 340). Kimball (1949, 356) proposed that this payment referred to the western *pavillons décrochés* of the Petit Château. It is possible, however, that the entry concerns the eastern ones, the shells of which were retained in the Enveloppe scheme, unlike the western pavilions which were totally demolished.

12. "Le mur de face du costé du parterre à fleurs est à 19 pieds 4 poulces de hauteur. Celuy du costé de la grotte est à 20 pieds 4 pouces. Le mur de pierre dure en arcade qui doit porter la terrasse entre les deux pavillons du chasteau du costé du grand parterre est à 13 pieds de haut. Les gros murs susdits à la réserve du dernier en arcade sont à haulteur pour pozer les platteformes sur lesquelles la charpenterie des planchers doibt estre pozée, il n'y reste qu'à pozer quelques pierres et plattebandes au derrière desdites croisées. Nous avons 566 ouvriers qui travaillent icy scavoir 7 appareilleurs, 8 picqueurs, 142 tailleurs de pierre, 118 limosins et 291 manoeuvres. Le Réservoir est entièrement rétabli et fort propre tant au dedans qu'au dehors, l'on y pouvoit mettre l'eau dedans vendredi dernier, n'eut esté qu'il faut remplir auparavant les deux autres. Le Roi veut que l'on dresse les allées du grand parc particulièrement celles qui conduisent à St-Anthoine et à Trianon, pour empescher les cahots des caleiches c'est où l'on travaille en diligence. . . . Les sieurs Clicq[in] et Charpentier font préparer les chemins pour faire voiturer en diligence le bois du premier plancher du bastiment que l'on commencera à lever la semaine prochaine" (Paris, Bibliothèque Nationale, Département des manuscrits, Mélanges Colbert, vol. 153, fol. 248; published in Laprade, 170, n. 3).

13. The south parterre was often called the "parterre de fleurs."

14. The Grotto of Tethys.

15. Measuring from ground level, the south façade extended almost to the bottom of the entablature of the *rez-de-chaussée*, the north elevation reached almost to the cornice of the ground floor, and the western façade was built up to half the height of the *rez-de-chaussée*. Petit's measurements of the western façade were made from ground level since the terrace and steps at its base were not under construction until 1672 (Colbert, v, 329, doc. 85).

In designing the Enveloppe (figs. 10, 11), Le Vau indicated narrow openings to accord with those of the Petit Château (see Kimball, 1949, 359–60; Le Guillou,

1976, 59; Pühringer-Zwanowetz, 1976, 114). These were executed in those parts of the Enveloppe constructed between October 1668 and June 1669. In addition, the nonparallel alignments of walls in the Petit Château were precisely followed in the Enveloppe (Le Guillou, 1976, 49–60). As Le Guillou emphasizes, this means that the Enveloppe was constructed so as to "mesh" perfectly with the axial vagaries of the older structure. Such a procedure only makes sense if the Petit Château was intended to be preserved.

16. Colbert, v, 284, n. 1:

> Pour ce qui est des dessins de Versailles, Monseigneur ne peut en avoir aucun aujourd'huy. J'ay esté ou envoyé partout.
>
> M. Le Vau promet de luy porter ce qu'il a fait, demain, à huit heures du matin.
>
> M. Le Pautre m'a mandé qu'il ne pourroit porter le sien avant samedy au matin.
>
> Gabriel dit qu'il a beaucoup corrigé le sien, qu'il est encore après, et qu'il ne peut l'avoir mis au net qu'à la fin de la semaine.
>
> Mon frère [Claude Perrault] pourra avoir fait demain ou jeudy matin.
>
> M. Vigarani est aux champs, et on luy a envoyé mon billet.
>
> Je n'ay pas trouvé M. Gobert chez luy. A mesure qu'il y aura quelque chose de fait, je l'enverray ou le porteray à Monseigneur avec les remarques que j'auray faites sur les dessins que je verray.
>
> Comme tous ces Messieurs travaillent nuit et jour, je crois que Monseigneur doit leur donner le temps dont ils ont besoin.

17. Pühringer-Zwanowetz (1976, 101ff.) has drawn attention to the manuscript diary of Cosimo de' Medici (later Cosimo III), written by Lorenzo Magalotti and Marchese Filippo Corsini. Cosimo visited Versailles on August 11, 1669. The diary states that " . . . la casa dessinata alle comodità delle Persone Reali non è ridotta perfettamente al suo essere, si va però tuttavia acrescendo per renderla capace di tutta la Reale Famiglia, e del suo seguito, con una maestosa prospettiva di facciata disegnata dal Cav.ʳ Bernini, per rendere più cospicuo questo Regio Edifizio quando si compisca sul modello" (103). Pühringer-Zwanowetz speculates that Bernini may have taken part in the 1669 competition, and that his design was for the court side of the Château (116). However, Bernini is not mentioned in any document connected with the 1669 competition; hence, it seems that Cosimo may simply have been told an unfounded rumor, and this was recorded in the diary.

18. Dated 1665 by Marie (1952, 50–55; idem, 1968, I, 55ff.); dated towards May 1669 by Kimball (1949, 371). On Marie's erroneous dating, see below, n. 38.

19. The following passage from Charles Perrault's *Mémoires* (ca. 1700) corresponds to this moment in time: "Dans ce temps-là, M. Colbert et presque toute la Cour, ayant considéré que ce qui restoit du petit et ancien château de Versailles n'avoit aucune proportion ni aucun rapport avec les bâtimens neufs qu'on y a ajoutés [the Enveloppe], tâchèrent à porter le Roi à faire

abattre ce petit château pour faire achever tout le palais du même ordre et de la même construction que ce qui est bâti de nouveau" (Perrault, 1909, 112).

20. Colbert, v, 282–84, doc. 38 (Paris, Archives Nationales, K 899, nos. 8, 9 [new classification]), "Mémoire de ce que le roi désire dans son bâtiment de Versailles":

[M1] Sa Majesté se veut servir de tout ce qui est fait de neuf.

[M2] Supprimer les avant-corps en retaillant les murs.

[M3] Élargir les arcades de la face du devant.

[M4] Ces deux démolitions emportent le total; en sorte que, sous prétexte de laisser ce qui est fait, l'on demeure contraint dans l'estendue des fondations, et ainsy l'on en reçoit l'incommodité sans aucun avantage.

[M5] Observer qu'en baissant la voûte de la face, il faut refaire les fondations de l'un des murs.

[M6] Les autres voûtes des ailes n'ayant ni air ni jour, ce seront des caves et des trous remplis de mille ordures, quelque soin que l'on en prenne.

[M7] S'il faut leur donner de l'air et du jour, il faut les transporter ou sur la face du jardin, ou sur celle de la cour.

[M8] Le Roy veut que la cour soit propre, qu'il y ayt une fontaine dans le milieu, et que les carrosses n'y entrent point;

[M9] Que du milieu de la cour les quatre vues soyent percées:

[M10] Celle de l'entrée par le milieu, qui sera vide;

[M11] Celle de la face du jardin par les arcades de la galerie basse;

[M12] Celle des deux costés par des vestibules percés.

[M13] La face sur la cour, deux grands pavillons:

[M14] Dans celuy à droite en entrant, le grand escalier tout de marbre;

[M15] Dans celuy à gauche, la chapelle et l'escalier.

[M16] La symétrie des deux pavillons de mesme.

[M17] Dans le bas du corps de logis à droite, l'appartement des bains, composé de quatre pièces.

[M18] Un petit appartement du costé de la cour.

[M19] Du costé de l'escalier, deux appartemens petits.

[M20] Dans le grand corps de logis, à gauche, les appartemens pour les enfans de France, et deux ou trois autres.

[M21] En haut, le grand appartement du Roy, salle, antichambre, grande chambre, grand cabinet.

[M22] Autre cabinet. [In the margin: A sçavoir.]

[M23] Sur la cour, petit appartement.

[M24] De l'escalier, il faut entrer dans les deux appartemens, en sorte que le grand soit toujours fermé.

[M25] Du costé de la Reyne, son grand appartement sur les jardins, une chambre et une garde-robe sur la cour, pour son appartement de commodité.

[M26] Le reste, un appartement pour Mgr le Dauphin.

[M27] Un étage carré dans l'attique, pour y faire quantité d'appartemens, dont quatre à six doivent estre composés d'antichambre, chambre, garde-robe et cabinet, et les autres de chambre et cabinet seulement.

[M28] Observer de mettre le plus d'escaliers qu'il se pourra pour dégager ces appartemens d'en haut.

[M29] Observer que les appartemens du Roy ayent aussy leurs dégagemens.

[M30] La galerie sur la face doit avoir un salon dans le milieu, s'il est possible.

[M31] Observer que, si l'on continue les ailes jusqu'aux pavillons de la basse-cour, les milieux ne se trouveront plus qu'en abattant les avant-corps, et, en les abattant, il ne restera plus rien.

[M32] Observer qu'en arrivant des jardins, il faudra que le Roy tourne dans l'appartement des bains, ou de l'autre costé, ou traverse toute la cour pour aller trouver son escalier.

[M33] La cour aura 28 toises de large sur 34 toises de long.

[M34] La face sur le jardin a 35 toises.

[M35] Jusqu'au pavillon de la basse-cour, 7 toises.

[M36] En tout, 42 toises.

	Toises.	Pieds.
Le cabinet sur la face a	5	1
La grande chambre a	5	2
L'antichambre a	8	1
La salle des festins a	11	4
L'épaisseur des murs a	2	–
Les deux murs de face	2	–
Total	34	2
Il reste pour l'escalier	7	4
Total	42	–

[M37] Ajoutant les 7 toises, le milieu ne se trouvera plus qu'en ostant les avant-corps. Ostant les avant-corps, il faut démolir les murs derrière et les arcades de devant. C'est démolir le bastiment tout entier.

21. "Observations sur les plans présentés par différents architectes pour Versailles" (Colbert, v, 284–88, doc. 39). On the basis of Perrault's letter of June 25, 1669 (see above, n. 16), Clément logically dated the document 1669; it must date shortly after June 25. The dating was adopted by Kimball (1949, 365ff.). Marie (1968, i, 57ff.) apparently assigns it, illogically, to 1664–65.

22. Marie, 1952, 50–55; idem, 1968, i, 57ff.

23. Kimball, 1949, 366–67.

24. Figure 18 is an authentic drawing by Louis Le Vau—this is proven by the handwriting of the inscriptions and by the architectural style. Le Vau's handwriting has been analyzed by Y. Metman (Laprade, 1960, 351). Laprade acknowledges the handwriting on figure 18 as Le Vau's, but assigns the architectural invention and draughtsmanship to François d'Orbay, Le Vau's assistant (Laprade, 1960, 170ff., and caption to pl. 5.5). But Laprade ascribes to Le Vau the invention of the three pavilions of the western façade, which he judges

would have appeared unsatisfactory in an oblique view. Marie (1968, I, 57) credits Le Vau with the design but believes that d'Orbay was the draughtsman. For a discussion of the style of figure 18 and its artistic paternity, see chapter III. A *terminus post quem* of ca. 1666 for the drawing is provided by the Bassin de la Sirène, indicated at the upper right. This basin is shown in its new, more westerly location (work completed ca. 1666).

25. Colbert, v, 287–88, doc. 39 (Paris, Archives Nationales, K 901, no. 11), "Observation sur le dessin du sieur Le Vau":

> [1] Il conserve tout ce qui est fait.
>
> [2] Les pavillons et les entrées sont comme le Roy les désire.
>
> [3] L'entrée du milieu du pavillon n'est pas l'entrée du milieu du vestibule de l'escalier.
>
> [4] Les figures rondes qu'il affecte aux vestibules et salons ne sont point du bon goust de l'architecture, particulièrement pour les dehors.
>
> [5] Les vestibules composés d'une grande pièce ronde, d'une petite ovale et d'une grande carrée ne seront pas approuvés.
>
> [6] Le grand escalier précédé d'un grand vestibule sera bien.
>
> [7] Le retour qu'il faudra faire dans la salle des gardes désire une nécessité pour l'excuser.
>
> [8] La suite du grand appartement du Roy est belle et bien proportionnée, excepté le vestibule du grand salon, qu'il faudroit supprimer.
>
> [9] Les petites cours seront les réceptacles de toutes les ordures.
>
> [10] Les petits appartemens n'auront point d'enfilade.
>
> [11] L'escalier du vestibule n'aura qu'un faux jour.
>
> [12] Les deux escaliers de dégagement, pour monter dans l'attique, n'auront de jour que par les petites cours.
>
> [13] Du costé de la Reyne: la chapelle de 13 toises sera trop grande.
>
> [14] La tribune en haut sera trop grande.
>
> [15] Si les carrosses n'entrent point dans la cour, il y aura loin à aller pour trouver l'escalier. Pour faire la suite de l'appartement belle, il n'y aura qu'un escalier qui monte à l'attique.
>
> [16] La Reyne n'aura point d'appartement de commodité, ou Mgr le Dauphin.
>
> [17] Il n'y a point d'entrée du grand appartement de la Reyne au petit, ni belle, ni commode.
>
> [18] Les avances des deux pavillons et vestibules dans les ailes ne seront pas agréables.
>
> [19] Les ornemens du dehors, de pilastres et colonnes, sont trop communs et ordinaires.
>
> [20] La distribution du salon, qui sera séparé de la galerie, est un défaut.
>
> [21] Les ouvertures des arcades auront 7 pieds.

26. Inscription in the right vestibule: "Vestibule po. l'escalier"; inscription in the left vestibule: "Vestibule pour l'escallier et chapelle."

27. Kimball, 1949, 367.

28. Concerning [16] Kimball wrote: "It is hard to reconcile this complaint . . . with the plan of Stockholm, which seems to be quite amply provided in this regard" (1949, 367). Kimball here assumes that these apartments were on the ground floor, but this cannot be determined from figure 18.

29. Kimball, 1949, 364, n. 25.

30. The central room in the *corps-de-logis* is labeled "vestibulle"; the flanking galleries are identified as such.

31. Mauricheau-Beaupré, 1933, 31–40. The south building was a stable; the north housed the kitchens; lodgings were provided in both (see fig. 3). These service structures were apparently still standing in 1669, but they were soon remodeled to become the so-called *Vieille Aile* (the south wing, still extant) and its northern counterpart, the *Aile du Gouvernement et des Offices*. These new blocks are depicted in Silvestre's print of 1674 (fig. 4).

32. The identical structures in wash at the sides of the drawing are not suggested new locations for the service blocks. On the right is the Grotto of Tethys and its adjoining building to the rear (see Marie, 1968, I, pl. 34 lower). Le Vau proposed a corresponding structure (of unknown function) to achieve symmetry.

33. Kimball (1949, 369–70) speaks of [M32] as one of Colbert's *criticisms* of the architectural projects; in reality, it was a *demand*.

34. The built courtyard actually measures 31 *toises* in length at the maximum.

35. Kimball, 1949, 365.

36. This agrees with Kimball (1949, 366): "Since '*il conserve tout ce qui est fait,*' the main existing walls of the Château Neuf as begun, with their several *avant corps*, must have remained unchanged, as they are today."

37. At the request of Alfred Marie, excavations were made in 1949 under the direction of Patrice Bonnet, architect-in-chief of the Palace of Versailles, at two points near the Parterre d'Eau in front of the west façade. No formal report was ever issued, but Marie claims that a number of features revealed correspond to figure 18 (Marie, 1952, 52–53; idem, 1968, I, 60). In the latter publication, Marie writes: "Pour nous résumer, les témoins de deux colonnes du vestibule central, d'une autre dans le salon du Midi, de trois dans le vestibule de l'escalier de la Reine, les murs des deux galeries et les murs de refend entre ces galeries et la façade actuelle, prévue façade sur la cour, sont des éléments suffisants pour assurer que ce projet de Le Vau a reçu plus qu'un commencement d'exécution."

In addition, Kimball in 1949 (367–68) published a communication from Marie concerning these excavations:

> Nous avons faits deux tranchées, l'une sur le bord du perron vers l'orangerie, l'autre au centre de la façade sur le perron. La première a donné une masse correspondant à une colonne du salon rond; l'autre a montré deux massifs reliés par un arc de décharge, les 2 massifs à l'aplomb de deux colonnes du vestibule central. De plus il y a sous le perron un réservoir étroit et long, en partie comblé mainte-

nant, dont les deux long murs, parallèles à la façade actuelle, correspondent aux fondations de la façade du plan de Stockholm et à celle du mur de la Galerie entre celle-ci et les pièces sur cour.

As confirmation that Le Vau's competition plan was begun, Marie calls attention to Charles Perrault's note of 1693: "On commença par quelques bastimens qui, estant à moitié, ne plurent pas et furent aussytost abattus. On construisit ensuite les trois grands corps de logis qui entourent le petit chasteau et qui ont leur face tournée sur les jardins" (Marie, 1968, I, 60). The passage is from Perrault's destroyed 1693 ms. on his brother's designs; see Colbert, v, 266, n. 1.

It is apparent from our main analysis that Perrault's thumbnail sketch of the building history of Versailles is misleading, since he states that an initial structure (Le Vau's competition scheme?) was started, torn down, and followed by the Enveloppe, whereas we know that the Enveloppe was begun, then suspended, and then finally resumed and continued to completion. It is possible, however, that Perrault was here referring to accompanying structures, and not to the Château itself.

Since Marie's *sondages* of 1949 have never been published in a form where they can be critically examined, it is a delicate matter to decide about how much of Le Vau's competition plan was actually put into execution in 1669. On August 11, Cosimo de' Medici visited Versailles and his diarists (see n. 17, above) wrote that " . . . la casa dessinata alle comodità delle Persone Reali non è ridotta perfettamente al suo essere, si va però tuttavia acrescendo per renderla capace di tutta la Reale Famiglia. . . . " Pühringer-Zwanowetz (1976, 116) believes that this must refer to the beginning of Le Vau's competition scheme, but the diarists' lines might equally apply to the Enveloppe.

38. Colbert, v, 266–68, doc. 23 (Paris, Archives Nationales, K 899 I [new classification]).

Clément placed the document in 1665, Nolhac (1901, 208, n. 1 [30]; 220, n. 1 [92]) dated it 1667 to early 1669, and Kimball (1949, 357ff.) argued that it must have been written in the spring of 1669, about early May. Recently, Marie (1968, I, 62) claimed that the document bears the date August 18, 1665, but this is incorrect for the document is undated. (The absence of a date has been confirmed by M. Jean Favier of the Archives de France in a personal communication and by my own examination of the document.) The date cited by Marie actually belongs to the document that precedes the "Raisons générales" in Colbert, v, 265, doc. 22, as pointed out by Pühringer-Zwanowetz (1976, 110 and 110, n. 20). Pühringer-Zwanowetz dated the "Raisons générales" about June 1669. Discussion of this document can also be found in Teyssèdre, 1967, 163–66. Most recently, Walton (1977, 141, n. 2) also dated it Spring 1669.

Marie's erroneous dating led him to place the beginning of Le Vau's Enveloppe in 1664/65 (1952, 50–55; 1968, I, 55ff.), an argument that has been refuted by Pühringer-Zwanowetz, 107ff.

It is clear that Clément's decision to place the undated "Raisons générales" first among Colbert's surviving papers on Versailles has conditioned later writers (see, for example, Berger, 1980, 108ff.) to accept it as preceding in time the others published by Clément.

Here is the text of the "Raisons générales":

[1] Tout ce que l'on projette de faire n'est que rapetasserie qui ne sera jamais bien.

[2] Toutes les belles maisons doivent estre élevées, et le plus d'élévation est toujours le mieux.

[3] Celle de Versailles est presque cachée de la pièce d'eau du fond par le parterre en amphithéâtre. Ainsy il seroit plus nécessaire de l'élever.

[4] Il faut perdre la beauté que l'élévation de l'avant-cour et de la cour donnent, à cause des fondations du nouveau bastiment.

[5] Quoy que l'on fasse, les croisées et les arcades seront toujours petites, ne pouvant avoir au plus que 6 pieds ½, et elles devroient en avoir 9 ou 10.

[6] L'élévation du dedans de la cour sera de 60 pieds de hauteur, et la cour n'aura que 28 toises de large sur 34 toises de longueur.

[7] Il n'y a aucune proportion gardée dans ces mesures.

[8] Il n'y aura qu'une seule cour dans toute cette maison qui sera bien plus large que longue.

[9] La grandeur des pièces, qui seront de 6, 7, 8 et 10 toises sur 5 toises et 5 toises ½ de large, n'aura aucune proportion avec la petitesse de la cour et du bastiment en général.

[10] Tout homme qui aura du goust de l'architecture, et à présent et à l'avenir, trouvera que ce chasteau ressemblera à un petit homme qui auroit de grands bras, une grosse teste, c'est-à-dire un monstre en bastimens.

[11] Par ces raisons, il semble que l'on devroit conclure de raser et faire une grande maison.

[12] Il n'y a que 52 toises de largeur entre les allées des deux parterres, et 90 toises de longueur entre l'allée du grand parterre de face et l'entrée de la demy-lune.

[13] Il est impossible de faire une grande maison dans cet espace.

[14] Le terrain est serré non-seulement par les parterres, mais encore par le village, l'église, l'estang. La grande pente des parterres et des avenues ne permet pas d'estendre ni d'occuper davantage de terrain sans renverser tout et sans faire une dépense prodigieuse.

[15] Il est vray que le parterre de fleurs est au niveau du chasteau, mais l'autre [the north parterre] a une grande pente, joint qu'il faut du chasteau avoir un parterre uny ou de plain-pied, ou une terrasse, ce qui seroit impossible.

[16] Il n'y a pas d'apparence que le Roy veuille occuper plus de terrain que celuy que cet endroit peut naturellement produire, d'autant que pour en occuper davantage, il faudroit tout renverser, faire une prodigieuse dépense, laquelle il sera plus à propos ou plus glorieux au Roy de faire au Louvre ou en quelques grands ouvrages, et que le Roy se

retranchast pour longtemps du plaisir qu'il prend en cette maison.

[17] Il n'y a donc pas d'apparence que Sa Majesté prenne cette résolution [i.e., to destroy everything and construct a large château].

[18] Il reste à examiner s'il faut tout raser ou conserver ce qui est élevé de neuf.

[19] En rasant tout, il est certain que l'incertitude, le changement perpétuel et la grande dépense ne concourent pas à toutes les grandes actions du Roy. Joint que ne pouvant faire une grande maison, tout ce qui se fera n'aura aucune proportion avec le reste de la conduite de Sa Majesté.

[20] En conservant ce qui est élevé, l'on tombe dans les inconvéniens cy-dessus marqués.

[21] Il y auroit un troisième party, de demeurer dans la résolution prise l'année dernière, de laisser le petit chasteau, et faire l'enveloppe suivant le dessin commencé.

[22] Ce party satisfait à l'avis raisonnable que le Roy ne fist rien pendant son règne qui ne fust proportionné à sa grandeur, c'est-à-dire monstrueux, mais en monstre bien composé.

[23] Tout le monde verra que le Roy avoit cette petite maison de plaisance et y ajouta seulement des bastimens pour son logement et pour toute sa cour. En un mot, ce bastiment ne sera pas considéré pour estre un ouvrage de Sa Majesté seule. Mais il faudra bien se donner de garde, ni de vouloir joindre une pièce du petit chasteau avec une du grand, ce qui ne se peut jamais sans tort, ni revestir ou joindre au mur du petit [château] du dedans de la cour un autre mur orné de colonnes et de marbres, et élevé pour cacher les combles, d'autant que ce petit chasteau seroit alors enfermé entre un grand mur et un grand corps de logis, ce qui pourroit estre blasmé plus que toute autre chose.

[24] Ce qui pourroit estre contre cette résolution, c'est la grande et publique déclaration que le Roy a faite de raser le petit chasteau, ce qui donne un engagement tel que l'on ne peut pas s'en retirer.

[25] Il restera donc à prendre le party, ou de ne rien faire qui vaille en conservant ce qui est fait [i.e., the parts of the Enveloppe already standing, to be incorporated into Le Vau's "revised competitive plan"], ou de ne rien faire que de petit en le rasant [because the site could not accommodate a truly large château]. En l'un et en l'autre, la mémoire éternelle qui restera du Roy par ce bastiment sera pitoyable.

[26] Il seroit à souhaiter que le bastiment tombast quand le plaisir du Roy sera satisfait.

[27] Prendre la résolution du Roy.

39. Colbert first wrote "parterre en fer-à-cheval," then substituted "parterre en amphithéâtre" (Nolhac, 1901, 220, n. 1 [92]). The Fer-à-Cheval (fig. 7) was known by both names.

40. See above, n. 32.

41. See above, n. 15.

42. In the original document there is no comma after "maison"; the comma is an interpolation by P. Clément.

43. Kimball, 1949, 358, but quoted in the order [8], [6], [7].

44. I believe that this "initial project" for the Château Neuf, as postulated by Kimball, never existed (Kimball, 1949, 358, figs. 2, 3).

45. This passage is omitted in Kimball, 1949, 361.

46. Ibid., 354–55; Kimball quotes from Perrault's destroyed Louvre ms. (1693) and his *Mémoires* (ca. 1700). Marie (1968, I, 61) also argues unconvincingly against the notion that the king wanted to preserve the old Château as a remembrance of his father.

47. Félibien, 1674, 2–3: " . . . comme sa Majesté a eu cette pieté pour la mémoire du feu Roy son Pere de ne rien abatre de ce qu'il avoit fait bastir, tout ce que l'on y a adjoûté n'empesche point qu'on ne voye l'ancien Palais tel qu'il estoit autrefois. . . . "

48. Colbert, v, 268–70, doc. 24. The letter bears month, day, but no year. Clément dated it 1665, but Nolhac (1901, 207–8, n. 1 [30]) proved through a fine analysis that it was written in 1663 (hence, a few months before Colbert became superintendent of the king's buildings).

49. Cf. [16] of the "Raisons générales" in the text, above.

50. [Versailles] "regarde bien davantage le plaisir et le divertissement de Vostre Majesté que sa gloire . . . "; [that] pendant le temps qu'elle [Your Majesty] a dépensé de si grandes sommes en cette maison, elle [Your Majesty] a négligé le Louvre, qui est assurément le plus superbe palais qu'il y ayt au monde et le plus digne de la grandeur de Vostre Majesté . . . ; Vostre Majesté sçait qu'au défaut des actions éclatantes de la guerre, rien ne marque davantage la grandeur et l'esprit des princes que les bastiments; et toute la postérité les mesure à l'aune de ces superbes maisons qu'ils ont élevées pendant leur vie. Ô quelle pitié, que le plus grand roy et le plus vertueux, de la véritable vertu qui fait les plus grands princes, fust mesuré à l'aune de Versailles! Et toutefois, il y a lieu de craindre ce malheur."

51. On the successive châteaux of Louis XIII at Versailles (1623–24; 1631–34), see mainly the publications of Batiffol (1909; 1910, 636–74; 1913). See also Coüard, 1906, and Coural, 1959.

52. Laprade (1960, 171) states that work on Le Vau's competition plan began about July 1669, and was halted in October when the fabric had risen nine French feet. However, Laprade does not cite evidence for this assertion, nor for his claim that work on the Enveloppe was resumed in November.

53. *Comptes*, I, col. 330.

54. Ibid., I, col. 414: "24 janvier 1670–4 janvier 1671: à Gabriel, maçon [sic], à compte et en avance des ouvrages de maçonnerie du nouveau bastiment de Versailles."

55. *Comptes*, I, col. 331: "8 may–9 novembre [1669]: à Cliquin et Charpentier, charpentiers, à compte de la charpenterie du nouveau bastiment de Versailles . . . 46000 *livres*"; *Comptes*, I, col. 415: "6 febvrier 1670–4 janvier 1671: à Cliquin et Charpentier, charpentiers, à

compte des ouvrages de charpenterie qu'ils font au chasteau de Versailles . . . 158500 *livres.*"

56. [May 5, 1670] "Pour Versailles, la corniche de la face sur le parterre est entièrement posée. L'on continue avec grande diligence, et l'on commence à tailler le bois pour le comble; je fais encore augmenter le nombre des ouvriers pour les pavillons de la grande avant-cour.

"Les couvertures des deux ailes et pavillons joints au petit chasteau sont presque achevées, et les stucateurs travailleront au dedans, la semaine où nous entrons" (Colbert, v, 296, doc. 49).

The king wrote on this letter: "J'approuve ce que vous faites" (Colbert, v, 298, n. b). The wings and pavilions of the court side referred to here are undoubtedly the structures indicated in figures 4 and 12.

57. The Trianon de Porcelaine by Le Vau (1670).

58. [May 9, 1670] "Je fus hier à Versailles et à Trianon, où tous les ouvrages s'avancent en sorte que j'espère que Vostre Majesté en aura satisfaction.

"A l'égard de Versailles, la corniche de la face sur le parterre sera achevé demain, et l'attique en quinze jours suivans. Le charpentier travaille en mesme temps à préparer le comble. . . .

"Le sieur Le Vau persiste à soutenir qu'il est nécessaire de fermer les deux arcades du vestibule, et je suis aussy persuadé de cette nécessité pour rendre d'autant plus solide le petit chasteau" (Colbert, v, 298–99, doc. 50).

The king wrote on the letter: "Je consens que l'on ferme les deux arcades. Faites-y travailler aussytost pour mettre toutes choses en seureté" (Colbert, v, 299, n. b).

59. [May 22, 1670] "Pour Versailles, il y a deux ateliers de charpentiers, dont l'un travaille le jour et l'autre la nuit" (Colbert, v, 300, doc. 51).

60. These structures principally included the remodeling of the *Vieille Aile* and the *Aile du Gouvernement et des Offices* (see above, n. 31) and the colonnaded porticoes at the ends of these wings (see figs. 4 and 12).

61. Relevant extracts from the *Comptes* for the early 1670s may be found in Marie, 1968, I, 235ff. See also Colbert's letter to the king of July 17, 1672 (Colbert, v, 328–31, doc. 85) and the minister's *mémoire* of September 30, 1672 (Colbert, v, 337–41, doc. 94).

Three working drawings of the Enveloppe façades in Stockholm (figs. 15–17) may well date from this period. The drawings include sectional details of stones for the aid of masons. Figure 15 shows in section and elevation the *placage* of the western terrace elevations against the Petit Château; the smaller openings of the latter are indicated by parallel hatching. Figure 17 is a study for the north façade of the structures that connect the northern wing of the Enveloppe to the northern service block of the courtyard (see the detail of Silvestre's engraving of 1674, published in Marie, 1968, II, pl. 115, top). On figures 15–17, see also the captional comments in Laprade, 1960, pl. 5.7.

62. See Laprade, 1960, 83, n. 1. Laprade is incorrect in claiming (1960, 83) that Le Vau was hardly active in 1669 and 1670.

63. Jal, 1872, 785.

64. Radically different reconstructions of the Enve-

loppe chronology have been recently proposed by Walton (1977) and Le Guillou (1980). I have already published my objections to these in Berger, 1980, 129–30, n. 72. A new study by Le Guillou (1983) calls for comment here.

Le Guillou believes that the building begun in October 1668 was not the Enveloppe in its final form but a "premier projet"; his ground plan is a revised version of the plan postulated in his 1980 article, with elevations (his figs. 4, 6, 7) based on CC 271 (my fig. 14). I turn to his proposed ground plan once again (1983, fig. 1, revised version). In reply to my previous criticism that there is no visual evidence for carriageways through the western range of the building and that there is no previous or contemporary French example for his proposed circulation system, Le Guillou first responds (1983, 206–7, n. 5) by citing a passage from Chantelou, 1885 [1665], in which Bernini proposes covered loggie in his Louvre project for mounting to and descending from carriages, and another in which he criticizes the French for generally neglecting such a feature (present in Le Guillou, 1983, fig. 1). Le Guillou then declares (1983, 207, n. 5): "Louis XIV et le Vau s'étaient forcément interrogés sur cette commodité, et les deux élévations que nous avons publiées [1980, figs. 1, 2] prouvent qu'ils en avaient d'abord retenu l'idée pour Versailles." Aside from the dubious assertion that the Archives Nationales drawings prove this (I still hold to my objections as stated in Berger, 1980, 130, n. 72), it may be asked why in 1668—two years after Bernini's Louvre projet had been abandoned—the king and Le Vau would have felt obliged to follow the Italian's Louvre proposal and recall his comments. Le Guillou, however, then goes on (in answer to my objection to the notion of carriageways through the western range of the Château) to make the assertion, on the basis of wording in Petit's report of June 8, 1669, that the western garden façade was not considered in 1668 to be the principal garden façade (hence, it could be cut through for carriageways); he also claims that a number of such passages dating from the time of Louis XIV still exist at Versailles. But none of the passages cited by Le Guillou pierces through the original Enveloppe. As for the western garden façade, one has only to consider it (in any of its forms) in relation to the park with its dominant east-west axis to realize that it was always treated as the principal façade facing the gardens.

Le Guillou has published (1983) his own reconstructions of the façades of the alleged "premier project" (his figs. 4, 6, 7). Just as his proposed circulation system finds no precedent in French tradition, so, too, the strong contrasts in textures within the *rez-de-chaussée* given in his figures 4 and 6 are foreign to French design. It is difficult to imagine these un-unified elevations proceeding from the drawingboard of Le Vau; there is no such conception in his earlier work, and it is totally alien to royal French style as formulated in the contemporary new Louvre façades of 1667 and 1668 (my figs. 22, 23). In addition, the presence of pilasters directly above the two proposed arches of the carriageways in his reconstruction (his fig. 4) would have been

an inadmissable violation of correct use of the orders (structural member above a void).

For the upper stories in his figures 4, 6, and 7, Le Guillou has adopted Le Vau's early colossal order project as known from CC 271 (my fig. 14), but interpreted as containing rooms of *one* story in height (despite two tiers of windows), corresponding to the high vaulted room of the Petit Château, shown in section in the same drawing. Le Guillou's point is that CC 271 corresponds to an early stage in the planning of Versailles when its internal size was still relatively modest; the final Enveloppe, with a *deuxième étage* in the form of an attic, represents (again according to Le Guillou) a change caused by a need to house more persons.

I do not believe that Le Guillou is correct in this. It will be noted that in my figure 14 there is no dormer window in the Petit Château (cf. my fig. 3). Surely, the high vaulted room of my figure 14 in the Petit Château (doubtless in the center of the *premier étage*) is a *proposal*, not a record of something already in existence. The old building had two stories and a third level within the roof lit by dormers (see my fig. 3); surely Le Vau's two levels of windows framed by the colossal Ionic order in my figure 14 represented two stories above a *rez-de-chaussée*—essentially the same solution as in the final design.

CHAPTER III

1. Noted by Walton, 1977, 127.

2. See Frommel, 1961, chap. VII; Ackerman, 1963; Forster, 1974.

3. Saint-Simon's famous criticism applies here: "Du côté des jardins, on jouit de la beauté du tout ensemble; mais on croit voir un palais qui a été brûlé, où le dernier étage et les toits manquent encore" (Saint-Simon, 1879–1928, XXVIII, 163; the passage was written in 1715).

4. In Le Vau's Hôtel Sainctot of 1639–42 (26, Quai de Béthune, Paris; drastically remodeled), colossal pilasters unite the upper two floors, but these are due to later work, perhaps after 1839 (see Tooth, 1961, 120; Hillairet, 1963, I, 193). Colossal Corinthian pilasters decorate the court of the Hôtel Comans d'Astry (18, Quai de Béthune, Paris), but it is not certain that Le Vau was the architect (Dumolin, 1930, 13). The building is dated 1647 by Babelon, 1965, 254.

The colossal order is also a feature of the east and south Louvre façades (figs. 22, 23), designed in 1667 and 1668 respectively by the *petit conseil* of Le Vau, Le Brun, and Claude Perrault. Le Vau's younger brother, François (also an architect), defended the colossal order in his "Advis du sieur le Vau le jeune sur le nouveau dessin du Louvre" (Paris, Archives Nationales, O¹ 1669 [late 1667 or early 1668]; published in Laprade, 1960, 340ff., left cols., esp. [6], 342–44). It is reasonable to accept François' views as having been shared, entirely or in large part, by his older brother (in fact, François may here be simply repeating Louis' ideas). François compares architecture to music, affirming that both aim at "la délectation" of the senses. Just as music makes use of a variety of sounds (high and low) to achieve harmony, so "l'on se peut de même servir de toutes les différentes ordres, grandes, petites ou médiocres, membres et mesures qu'il y a dans l'architecture, pour en composer toutes les sortes d'édifices de ladite architecture pourvu qu'ils soient aussi convenables au sujet de son édifice." When the orders are used appropriately and "avec raison," the result is eurythmy, "qui délecte la vue sans la choquer." To François, the colossal orders of the Louvre satisfy these demands, and are particularly well suited for the distant views from the Left Bank and the Pont Neuf. In addition, the colossal orders are better in proportion to the *rez-de-chaussée* than are one-story orders. François' defense of the colossal orders of the Louvre is in reply to pointed criticisms of them by an anonymous critic (Laprade, 1960, 342–43 [6], right col.).

5. See François Le Vau's comments in the above note.

6. Laprade (1960, caption for pl. 5.7) suggests that the draughtsman was Pierre Lambert.

7. The complete program of statues, reliefs, and keystone masks for the three façades of the Enveloppe is given in Félibien, 1674, 38–49. The statues of the western façade depict the twelve months of the year, which Félibien notes as being in harmony with the king's emblem, the sun. The south façade features sculpture relating to flowers and fruits; the sculptures of the northern façade concern water themes. See also Souchal, 1972.

8. In the original Enveloppe (before Mansart's modifications), an *avant-corps* of four equally spaced columns also stood at the rear of the terrace (figs. 6, 7, 12).

9. Blunt, 1970, 201.

10. On these *palazzi* see Frommel, 1973: Palazzo Caprini (I, 93–96; II, 80–87); Palazzo Caffarelli-Vidoni (I, 119–20; II, 53–61). As Frommel notes, the Palazzo Caffarelli-Vidoni, although based on the Palazzo Caprini, reveals the influence of Raphael's architecture and was ascribed to Raphael from at least 1638 on (Frommel, 1973, II, 61). In contrast to Bramante's building, the Palazzo Caffarelli-Vidoni features window frames tightly hemmed in by the orders, unified pedestals for the paired columns, and, on the ground floor, more delicate and regularized rustication. These features are found at Versailles, with the ground floor treated with a smoother and more regularized pattern. I cannot agree with Walton (1977, 134) when he writes: "En réalité, si la comparaison avec les palais italiens s'impose lorsque l'on regarde la façade du nord telle qu'elle s'élève aujourd'hui, elle s'avère bien moins juste lorsque l'on considère l'état original de l'ensemble, avec ses fenêtres rectangulaires à reliefs sculptés entre le haut de la fenêtre et la frise du premier étage. Sans les gracieux demi-cercles des fenêtres de Hardouin-Mansart ajoutées en 1678, la façade a un aspect plutôt trapu et lourd, difficilement comparable aux chefs-d'oeuvre italiens." See below, n. 12.

11. Frommel, 1973, II, 60.

12. The panels of the Enveloppe contained sculp-

tured reliefs of putti engaged in activities appropriate to the various seasons; some of these reliefs survived Mansart's remodeling of the windows of the *premier étage* in 1678. See Félibien, 1674, 39.

13. In the Roman *palazzo,* a network of paired framing bands articulates the attic, whereas at Versailles a dwarf pilaster order is used.

14. Marie (1968, II, 233) sees sixteenth-century Venetian palaces as the sources for the Enveloppe, particularly Sansovino's Palazzo Corner della Cà Grande of the 1530s. This building, however, lacks villa-type massing and has entirely different proportions between the three floors. The top floor is a full story, not an attic, with a columnar order, and the windows are arched throughout, unlike the original rectangular windows of Le Vau's Enveloppe.

Tadgell (1980, 334/337) has recently proposed that Le Vau's model for the elevation of the Enveloppe was Salomon de Brosse's Palais du Parlement, Rennes. Tadgell invites the reader to imagine the Palais du Parlement *without* its high roof and *with* an attic above the order to approximate the Enveloppe; such mental maneuvers are not required when comparing the Versailles elevations with the Italian buildings discussed in the text, which were surely Le Vau's sources.

15. Louis Le Vau apparently never visited Italy. His knowledge of Italian architecture was absorbed by means of engravings, drawings, and reports by other architects, including his assistant François d'Orbay (in Rome in 1660) and his brother François, who was in Rome sometime before 1667–68 (see Berger, 1976, 42).

16. On the competition of the summer of 1669 and the documentation surrounding Le Vau's design, see chapter II.

17. Noted by Kimball, 1949, 366, and Marie, 1968, I, 59.

18. Marie, 1968, I, 59. Laprade (1960, 171) surmised that the corner pavilions were domed, but it is not possible to determine whether this was so.

19. Le Vau's columnar vestibules in châteaux were usually linked, vertically or horizontally, to two-story salons, typically articulated with pilasters (see Berger, 1976, 39ff.). In his comments on Le Vau's competition plan (summer 1669), Colbert wrote that [8] "La suite du grand appartement du Roy est belle et bien proportionnée, excepté le vestibule du grand salon, qu'il faudroit supprimer" (Colbert, v, 287, doc. 39; see chapter II); however, the king's apartment probably occupied the north wing (as in the Enveloppe), so it is not possible to determine what stood above the vestibule of the *corps-de-logis* in figure 18. Certainly, there was no monumental stair to link the vestibule to a salon above, as was customary in Le Vau's designs.

20. This axis was created by ca. 1666; see Weber, 1969, 212.

21. See chapter II.

22. "Les figures rondes qu'il affecte aux vestibules et salons ne sont point du bon goust de l'architecture, particulièrement pour les dehors" (Colbert, v, 287, doc. 39, from the "Observations sur le dessin du sieur Le Vau" [4], summer 1669; see chapter II).

23. For a review of Le Vau's châteaux designs with these features, see Berger, 1976.

Colbert's critical attitude towards Le Vau is usually ascribed to the minister's discovery of structural problems in the Hôtel de Bautru, Paris, an early building by Le Vau (1634–37) which Colbert purchased for his own use in 1665. But as Blunt has pointed out (1970, 276, n. 9), this occurred one year after Colbert had halted Le Vau's Louvre. However, Colbert's coolness towards Le Vau had appeared already in a letter of 1662 concerning the Collège des Quatre Nations in Paris (Laprade, 1960, 72); also, an entry in Chantelou's journal in 1665 reflects the general unhappiness with the construction of the Collège and the foundations of Le Vau's eastern Louvre façade (Chantelou, 1885 [1665], 169–70 [September 19, 1665]; see also p. 85 [August 5, 1665], where Colbert contrasts the vanity of Le Vau with the modesty of Bernini!). In addition, in his famous letter to the king of September 28, 1663, the minister may have alluded to Le Vau (and Le Nôtre) as the two men more interested in pleasure and their own interests than in the king's glory (Colbert, v, 269–70, doc. 24).

24. The only exceptions are the east and south Louvre façades of 1667 and 1668 (figs. 22, 23), but these cannot be regarded as purely by Le Vau, even if one regards him as the principal architect. In the revised competition plan of 1669 (fig. 18), only the ground floor is shown, and this was undoubtedly rusticated, without pilasters, like the Enveloppe. Hence, Le Vau's approach in this project to the corner pilaster problem cannot be ascertained from this plan.

The order of the *premier étage* at Versailles is Ionic, and this necessarily led to problems involving the corner capitals of this order. (For discussion of these problems in relation to François Mansart's architecture, see Blunt, 1941, 60; Braham and Smith, 1973, I, 54.) The solution adopted at Versailles (shared corner volute projecting at 45° from the plane of the building [fig. 9]) follows Mansart's treatment on the *deuxième étage* of the side frontispieces at Maisons (Blunt, 1941, fig. 4, no. 3; Braham and Smith, II, pl. 233c).

The setting-back of pilasters from corners is discussed by Collins (1959, 165–66), who notes that such treatment avoids the broad effect an oblique view would produce, but that the result is an emphasis on the pilaster as decoration rather than as structure. Collins suggests that the model for this practice was the Arch of Constantine in Rome.

The problem of the corner pilaster was first discussed in the Académie Royale d'Architecture on May 13, 1675. It was then decided that two complete pilasters could adjoin each other at salient or re-entrant angles only in the Tuscan or Doric orders, since these capitals could merge; in the case of other orders, however, the practice was condemned (Lemonnier, 1911–29, I, 98). On August 1, 1687, the Académie decreed that the best procedure was to have pilasters meet at corners (without specifying orders), but on September 10, 1688, the question arose again, and this time the academicians were divided in their opinions with regard to pilasters at salient angles (Lemonnier, 1911–29, II, 148, 166).

25. Laprade, 1960, 165–73, for a discussion of the authorship of the Enveloppe.

26. See reviews by Champigneulle, 1960; Hautecoeur, 1960; Blunt, 1961; Chastel, 1961; Kalnein, 1960; Meeks, 1960.

27. Laprade (1960, 119–21) tends to attribute the Hôtel de Lionne to d'Orbay, but his arguments are entirely conjectural. The building was designed and constructed before 1665, the year in which Le Vau began his business dealings in Beaumont-la-Ferrière (Nivernais), which Laprade claims absorbed much of his time and energy between 1665 and 1670.

28. On d'Orbay's trip to Rome and on the S. Trinità dei Monti design, see Laprade, 1960, 109–14. Figure 27 bears the following important note, probably written by Elpidio Benedetti, Mazarin's agent in Rome: "Questo è il disegno da Mr d'Orbais giovane francese mandato qui a studiare da Mr Le Veau per la Scalinata della Trinita de' Monti." D'Orbay's design was sent to Mazarin, who judged it to be not practicable and too expensive.

Laprade claimed that d'Orbay first assisted Le Vau in the 1650s at the Château de Vincennes. He worked under Le Vau in the Royal Building Administration from 1663 on, but Laprade argued that he assisted the *premier architecte* in private commissions from the beginning of the 1660s, after his return from Rome in 1660.

29. D'Orbay's later uncontested independent designs—the Theater of the Comédie Française, Paris (1688–89); the Arc de Triomphe du Peyrou, Montpellier (1691–92); and the Cathedral of Montauban (begun in 1692)—are late in date and cannot be used as indications of his personal style in the late 1660s.

30. Two almost identical comprehensive ground plans of the Enveloppe survive (figs. 10, 11); these may have been presentation drawings. Kimball (1949, 370) asserted that the handwriting on these two plans is by d'Orbay, but Laprade (1960, 351)—even though he ascribed the invention and draughtsmanship to d'Orbay—identified the inscriptions as Le Vau's, in accordance with the analysis of the two architects' handwriting by Y. Metman. As Marie has noted (1968, II, 230–31), the plan in the Archives Nationales (fig. 11) shows a more developed connection between the wings of the Enveloppe and the courtyard wings, and hence is probably slightly later in date.

31. "On construisit ensuite les trois grands corps de logis qui entourent le petit chasteau et qui ont leur face tournée sur les jardins. . . .ces trois corps de logis . . . sont du dessin de M. Le Vau . . . " (from Perrault's manuscript text to the two-volume collection of Claude Perrault's designs, destroyed in 1871; extract published in Colbert, v, 266, n.). The Enveloppe had earlier been attributed to Le Vau in *Le Mercure galant,* November 1686, II, 132.

32. See, for example, the following extract from a letter from Daniel Cronström to Nicodemus Tessin the Younger (January 28, 1694): " . . . vous ne serez peut estre pas fasché de scavoir, quil fist elevé un grand orage contre la mémoire de feu Mr. [Claude] Perrault, en ce qu'un certain Dorbais qui dessignoit soubs Mr. le Veaux s'est avisé tout d'un coup de disputer le dessein de la façade du Louvre a feu Mr. Perrault et de l'attribuer a Mr. le Veaux et a luy mesme. Il prètend faire un escrit sur cela; Mr. [Charles] Perrault d'aujourdhuy, qui a des preuves plus que convaicantes du contraire, ne dit mot exprès afin qu'il s'enferra, en suitte de quoy il prétend repondre; et ç'est ce qui donnera occasion à un ouvrage curieux et savant qu'il veut faire, dans lequel toute l'histoire du Louvre et du Cavallier Bernin sera déduite avec exactitude . . . " (Weigert and Hernmarck, 1964, 44–45). Perrault subsequently gave his account of the Louvre history in his *Mémoires de ma vie.*

33. Perrault became Colbert's *premier commis* in the Royal Building Administration in 1664; he was also a founding member of the Petite Académie (concerned with royal iconography) from 1663.

34. "Cette grande face de bastiment qui regarde le Parterre d'eau, & les deux costez qui font l'enceinte du Château meritent bien d'estre considerez, tant pour la grandeur majestueuse de toute cette masse, que pour la beauté des pierres dont elle est bastie le soin qu'on a pris à les bien tailler, & le choix qu'on a fait des Figures & des ornemens qui l'embelissent" (Félibien, 1674, 37).

CHAPTER IV

1. On this early building see Coural, 1959.

2. On the château of 1631–34, see Batiffol, 1913.

3. The royal building records are lacking for the early 1660s, but the date 1661 for the start of work at Versailles under Louis XIV is given by the official historiographer of the royal buildings, Félibien (1674, 1).

4. In Silvestre's engraved plan of 1667 (fig. 2), the stairs are shown in their new locations, but this detail of the curved treads is not depicted.

5. ". . . je fis sortir la belle Etrangére de cét appartement bas, & je la menai par l'escalier qui est à l'aîle de ce costé-là [the left-hand wing], qu'elle trouva fort agréable; en effet, les marches en sont d'un marbre jaspé, le rampant est de bronze doré d'un fort beau travail, tous les costez sont peints en bassetailles dorées, il est fort bien éclairé, & pour n'estre pas extrêmement grand il est noble & commode. Il y en a un tout pareil à l'aisle opposée, dont le dôme semble estre un ciel ouvert" (Scudéry, 1669, 41–42). See also Félibien, 1674, 17–18. Rose (1922, 191) believed that Mlle. de Scudéry's description referred to a painted ceiling over the stair, but this is not certain.

6. Figures 10 and 11 indicate that the two stairs also received horizontal lighting from windows and doors.

7. In the early 1640s; see Berger, 1976, 39, fig. 2. Le Raincy was Le Vau's first château.

8. Figures 10 and 11 indicate that the Swiss Guard was to occupy the king's short wing, guarding the approach to his stair.

9. The drawing was ascribed to d'Orbay by Nolhac (1925, I, 179), Kimball (1952, 116), and Laprade (1960, 179–180 and caption for pl. 7. 1A); Laprade identified the inscriptions as d'Orbay's. By contrast, Marie (1968,

II, 263–64) ascribed the drawing to Le Vau. Kimball dated the drawing spring 1671 (1952, 116).

10. Laprade (caption for pl. 7. 1A) and Marie (1968, II, caption for pl. 133, top) describe the stair as having one flight, ignoring the inscription on the verso.

11. Kimball (1952, 121) and Laprade (1960, 179) noted the use of herms in earlier works by Le Vau and Le Brun (the attic of the cupola of Vaux-le-Vicomte; the tapestry designs of 1667–68), but the motif was too common to serve as an index of design authorship.

12. Braham and Smith, 1973, II, pl. 248.

13. A view of this room (restored 1943–45) is in Marie, 1968, II, pl. 127; drawings of the decorative scheme are in Stockholm, Nationalmuseum, CC 2977, CC 2978 (Marie, 1968, II, pl. 126). The room, which was ready for gilding and ceiling decoration by October 1679 (Margry, 1873, 40, doc. 2), is decorated with painted trophies alluding to the Four Parts of the World, a theme developed in the Escalier des Ambassadeurs.

14. See Walton, 1977, 138, where the salon or gallery design is discussed for the first time. Walton rightly notes that the project was probably rejected because the room could have been lit only from its north end. Payments recorded in the *Comptes* (I, col. 514) were made between June 4 and November 9, 1671, for columns and pilasters for this room, indicating that work went beyond the planning stage: "à Noel Briquet, sculpteur, pour parfait payement de la sculpture des colonnes et pilastres avec leurs chapiteaux pour la gallerie proche le grand escalier . . . 3240 *livres*."

15. *Comptes*, I, cols. 485–86.

16. Ibid., col. 523.

17. Ibid., col. 529.

18. Ibid., col. 587: "Pour les marbres, termes, balustrades et stuc de la voulte et de la corniche dud. escallier."

19. *Comptes*, I, cols. 607, 609, 610.

20. "Le comble de l'escalier est aussy presque tout taillé et l'on commence à le poser" (Colbert, V, 329, doc. 85).

21. "Demander au sieur d'Orbay les devis de tout ce qui est à faire pour le grand escalier du Roy" (Colbert, V, 338, doc. 94).

22. *Comptes*, I, col. 619.

23. ". . . deux rampes, l'une à droit & l'autre à gauche, & qu'on est arrivé par la première dans le grand paillier, l'on entre dans sept autres pieces [the king's apartment] . . . " (Félibien, 1674, 28). Félibien's guidebook, published in 1674, was printed on December 30, 1673. A payment to the carpenter Cliquin was made on that day (*Comptes*, I, col. 693).

24. *Comptes*, I, col. 737:

Pour l'incrustement de marbre de diverses couleurs dans les murs du grand escalier et de la pièce d'en haut qui luy sert de pallier, avec les chambransles et les pieds d'estaux pour porter les figures captives . . . 30000 *livres*.

Pour poser les marches de pierre de liais de Senlis dud. escallier . . . 3000 *livres*.

Pour poser la balustrade de marbre dont le socle et l'appuy sont de marbre blanc et noir, et les balustres de marbre blanc et rouge . . . 9000 *livres*.

Pour faire une fontaine dans la niche qui est sur le pallier de l'escallier et y mettre une figure de bronze doré . . . 3000 *livres*.

Pour le pavé du bas de l'escallier du grand pallier et des cinq petits . . . 22000 *livres*.

Pour tous les ouvrages et ornemens de stuc dud. escallier . . . 25000 *livres*.

25. Marie, 1968, II, 272.

26. *Comptes*, I, cols. 757, 763. It is not certain whether the payment to Jean Théodon in 1677 (*Comptes*, I, col. 964) was for this model or another one.

27. Kimball, 1952, 122; Laprade, 1960, 180, n. 3; Marie, 1968, II, 266.

28. *Comptes*, I, col. 759: "à Rossignol, pour les ouvriers qui ont crespy, enduit et peint à fresque le grand escallier. . . ."

29. *Comptes* payments are collected in Marie, 1968, II, 272–77. On March 1, 1678, Colbert wrote to the king: "Les marbres de l'escalier s'avancent fort, et j'espère qu'il sera entièrement achevé dans le mois de juillet" (Colbert, V, 382, doc. 140). In 1679 the scaffolding was removed and the frescoes were shown to the Spanish ambassador (*Le Mercure galant*, August 1679, 257–58). The principal executants of the frescoes were François Bonnemer and René Antoine Houasse.

30. Verlet, 1961, 357–58.

31. Detailed early descriptions can be found, especially in *Le Mercure galant*, September 1680, II, 276–320 and in [Le Fevre], 1725, the latter publication containing the engravings illustrated in figures 35–52. On the model by M. Arquinet (fig. 34), see Revel, 1958.

32. For ambassadorial receptions the stair was lined with soldiers (see chapter VII).

33. On the *salon à l'italienne*, see Berger, 1976, 40ff.

34. Hôtel Hesselin (ca. 1640–ca. 1644) and Tuileries (1665–66), Paris.

35. The door at the top of the right-hand flight led directly into the second Salon de Vénus (fig. 65), beginning the sequence of rooms of the *grand appartement du roi*. Some of the doors were false, as can be deduced from figure 12, which shows the staircage at *premier étage* level.

36. On this type of staircage, see Wilkinson, 1975, 65ff.

37. Josephson, 1927, 181–82; see also Kimball, 1952, 119. Perrault's two stair designs for the Louvre are now in Stockholm (fig. 33 and THC 2204, the latter illustrated in Josephson, 175). Both drawings were originally part of the two-volume manuscript *recueil* of Claude's drawings, compiled and annotated by his brother Charles in 1693, that perished by fire in the Paris Commune in 1871. These drawings (along with several others by Claude) were obtained from Charles Perrault by Daniel Cronström and sent in 1693 and 1695 to Nicodemus Tessin the Younger in Stockholm. See Josephson, 174ff., which contains extracts from the

correspondence between Cronström and Tessin on these drawings, later published in Weigert and Hernmarck, 1964.

The date of ca. 1667–69 for Perrault's stair projects is suggested by a payment in 1670 for models of Louvre staircases, executed in 1667–69 (*Comptes*, I, col. 402). A model by Perrault for a Louvre staircase was first reported in 1698 (Brice, 1698, I, 38). On Perrault's stair designs, see also Blondel, 1752–56, IV, 10, n. q, 26.

38. Cf. Le Vau's Hôtel Lambert, Paris (1640–44; Vacquier, 1914, pl. 7) and a drawing from his *atelier* of 1667 (inscribed by d'Orbay) showing a plan of the Louvre Colonnade (Paris, Louvre, Cabinet des Dessins, Recueil du Louvre, I, fol. 3, published by Braham and Whiteley, 1964, 356, figure 10, and by Braham and Smith, 1973, II, pl. 510). In both these cases, the lower stair is accompanied by higher returning flights, unlike the Escalier des Ambassadeurs. At the Hôtel Lambert, only one flight ascends; symmetry is suggested by a corresponding balustrade. (The relationship of the Hôtel Lambert stair to Versailles was noted by Rose, 1922, 192, and by Hautecoeur, 1948, I, 82.) In the Louvre drawing, the stair is apparently shown at both ground and first-floor levels; its anticipation of the Versailles stair was noted by Braham and Whiteley, 1964, 356–57.

Le Vau may have borrowed the idea of the double-branched stair from the initial flights of the Palazzo Doria-Tursi in Genoa (Palazzo Comunale or Municipale) (designed 1564 by G. Ponsello; built ca. 1568). The form is also present (without the continuing flights) in two buildings illustrated in Rubens' *Palazzi di Genova* (Antwerp, 1622): the Palazzo Carrega-Cataldi (part I, figs. 2, 7) and the Palazzo Balbi (part II, fig. 19).

Le Vau's stairs thus precede Perrault's designs of ca. 1667–69, and the latter may have derived the basic architectural form from Le Vau's examples.

The double-branched stair first appeared in Renaissance architecture in the projects of Covarrubias (1550) and Villalpando (1553) for the Alcázar of Toledo; the executed stair by Herrera (1574) follows this type (see Wilkinson, 1975, 65–90).

39. D'Orbay undoubtedly also knew Perrault's model, if one corresponding to figure 33 actually existed (see above, n. 37).

A drawing in Stockholm presents two alternative solutions for the stair (figs. 54, 55), which may be records of d'Orbay's thoughts during 1671–74. Both depict the staircage and adjacent rooms of the Château at first-floor level. The introductory flights of steps of the ground floor are indicated with dotted lines; in figure 54 the flight is in the form of a rectangular island, while in figure 55 a curvilinear shape appears. Both versions, however, show short flights diverging from the first landing, leading to intermediate landings, with 90° turns of the flights up to the *premier étage* level, in the pattern ⟶. This is related to one of Perrault's Louvre stair designs (Josephson, 1927, 175) and to an alternative stair design by Pierre Cottard (Cottard, n.d., pl. 4, left), except that d'Orbay's ramps return forward while the others move back into depth in ascending. D'Orbay's designs trace their parentage to

Longhena's stair in the monastery of S. Giorgio Maggiore, Venice (1643–45), itself dependent on the stair of the Palazzo Doria-Tursi, Genoa (see above, n. 38).

In the final design at Versailles (figs. 34, 35, 37), the diverging double-branched flights running along the wall were doubled in length (following Perrault's scheme, fig. 33), so that the visitor reached the upper floor on a straight line, directly in front of doors leading into the king's suite. It is interesting that Tessin in 1687 mildly criticized the long flights of twenty-one steps as of a length not very much approved of "parmy les bons autheurs" (Tessin, 275). Alberti (19 [I, xiii]) recommended a maximum of seven or nine steps in one flight on the basis of ancient architecture. Palladio (34 [I, xxviii]) set a limit of eleven to thirteen steps.

In his analysis of figure 54 (1968, II, 264), Marie has acutely pointed out that the screen of bunched columns between the staircage and the gallery of the apartment of Mme. de Montespan overlooking the courtyard represented an attempt to light the stair by conventional, horizontal lighting.

40. For a catalogue of the preparatory drawings, see Guiffrey and Marcel, 1907–28, VII, 112–16 (GM 5738–94), with illustrations on 113, 114, 117. See also below, n. 54.

41. "Ce Lieu est embelly de cette maniere, pour représenter un jour de Feste, où les Divinitez du Parnasse sont assemblées pour recevoir le Roy à son retour de la guerre. Ainsi une partie des Sujets en sont peints dans les Tableaux & dans les Tapisseries feintes. On supose que tout l'a esté [peint] par ces Génies qui paroissent en l'air, ornant encor la Voûte de Festons de Fleurs, apres en avoir mis en plusieurs endroits le long de la Corniche, & dans de grandes Corbeilles ou Vazes qui sont au dessus des Thermes & des Pilastres.

Sa Majesté est placée dans le milieu [that is, the sculptured bust above the first landing, fig. 37], pour marquer que c'est pour Elle que cette Feste se fait" (*Le Mercure galant*, September 1680, II, 302–4; repeated in November 1686, II, 305–6).

42. "Le sujet en général est composé sur ce qui arriva en ce temps, qui est le fameux combat naval donné près de Messine par les Français contre l'armée navale d'Espagne et de Hollande, où le grand amiral Ruyter finit glorieusement sa vie, et le tout y paraît comme une fête ou réjouissance publique" (Nivelon quoted in Marie, 1968, II, 269).

43. In March 1676, Messina fell to the French under Vivonne. The city was successfully defended against a Hispano-Dutch naval attack, and in April the Dutch admiral de Ruyter was killed at the battle of Augusta, further down the Sicilian coast.

44. *Le Mercure galant*, September 1680, II, 303, 304–5.

45. "[These figures] semblent aller et venir dans les appartements du prince, s'entretenant la plupart ensemble ou regardant la voûte de ce lieu selon leur génie, ce qui fait une variété naturelle très agréable, et on peut dire que lorsque ce grand Roi descend par cet escalier au milieu et suivi de tous les princes et princesses, cela fait un spectacle si grand et si superbe que l'on croirait que

tous ces peuples se rendent en foule dans ce lieu pour honorer son passage et voir la plus belle cour du monde de la manière que ces sujets sont si artistement mêlés ensemble le naturel avec ce qui est feint" (Nivelon quoted in Marie, 1968, II, 270–71).

46. In the Fête-Dieu procession of June 5, 1681, at Versailles, Persian carpets were hung from the balconies and windows of the Château (see chapter VII).

47. The simulated tapestries by A.F. Van der Meulen showed four events of 1677: the sieges of Cambrai, Saint-Omer, and Valenciennes, and the battle of Cassel. Van der Meulen, Le Brun, and Le Nôtre were sent by Louis XIV to Flanders during the siege of Cambrai to observe the events at first hand (Nolhac, 1901, 227, n. 1 [114]).

48. See again the account of the Pentecostal procession of 1681 (chapter VII), where the Château courtyards were hung with royal tapestries and silver vases filled with flowers were set up on the balustrades, cornices, and other locations in the staircage.

49. See above, n. 47.

50. See the interesting drawings (Paris, Archives Nationales, O¹ 1776) published in Marie, 1968, II, pl. 140. This unprecedented form for a skylight was noted by Tessin in 1687: ". . . le jour en haut donne par des glaces, qui montent en triangle" (Tessin, 275).

51. Tessin wrote that ". . . le jour d'en haut est fort advantageux pour les peintures" (Tessin, 274). As noted by Kimball (1952, 120), Perrault's drawing (fig. 33) does not reveal the apex of the vault, so it is not possible to determine whether a skylight was intended. If Perrault did design one, however, he surely would have revealed it in his drawing. The skylight of the Escalier des Ambassadeurs measured 11m. 36 × 3 m. 88, and was 17 m. 53 above the floor.

52. "LE GRAND QUADRE parallélogramique qu'on voit à la cime du Plafond et qui est orné tout à lentour dans le dessous d'un cordon de fleurs et de fruits en Sculpture, est le seul canal par ou passe la lumière pour éclairer cette grande machine. Les Consoles qui regnent sur ce quadre sont droites à plomb sur les Colonnes et les Pillastres d'embas et supportent pour couronnement une Corniche sur laquelle est posée en forme de toît un compartiment de glaces qui ferment l'ouverture et empeschent la pluye de pénétrer dans l'interieur. L'impossibilité ou lon étoit de tirer du Jour par d'autres endroits que par le milieu de la Voûte a produit un éffet merveilleux; le bas de l'Edifice n'est point interompu par des fenestres dont les jours trop vifs petillent et nuisent aux yeux des Spectateurs. Il en paroist plus d'harmonie dans les Peintures, la lumiére en devient Majestuëuse, et si l'on fait attention à l'allégorie de tout l'ouvrage, on peut prendre la disposition de ce jour, pour un simbole de cette lumiere céleste qui guide les véritables Héros dans toutes leurs Actions, et qui doit les Couronner dans l'Eternité" ([Le Fevre], 1725, 9).

53. It should be noted that J.F. Blondel, while voicing his approval of top-lighting for stairs to improve the visibility of the flights, specifically disapproved of the skylight of the Escalier des Ambassadeurs because it did not present a visible form in exterior views; he recommended a traditional lantern: "Par le nom de lanternes, je n'entends pas celles qui sont inclinées, telle qu'est celle de l'Escalier [des Ambassadeurs]; cette forme convient d'autant moins dans ce lieu qu'il est vaste & qu'il appartient à une Maison Royale, où il auroit été convenable que cette lanterne eut été élevée perpendiculairement, dans le goût des coupoles de nos Eglises" (Blondel, 1752–56, I, 41). In the year in which this passage was published (1752), the Escalier was destroyed; four years later Blondel expressed "beaucoup de regret" over its destruction (IV, 124–25, n. 0).

54. For modern studies of Le Brun's paintings, see Nolhac, 1900, 54–68, and Bacou, 1974, 13–27. See also *Collections de Louis XIV,* 1977, 270–74, nos. 278–81 and above, n. 40.

55. Of particular interest is the figure of a European (fig. 41) who gazes upward while adjusting his eyeglasses, a sophisticated connoisseur contemplating the paintings above. In Perrault, 1688–97, I, 113, the chevalier says: ". . . mais les lunettes de ce Monseigneur étonné de voir quelles gens nous sommes presentement dans tous les Arts, me réjoüissent extrêmement." This figure was in the right-hand bay above the stairs (fig. 37), and was therefore conspicuously placed.

The theme of the Four Parts of the World reappears in the contemporary decorations of the *grands appartements du roi et de la reine* (see chapter V): Salon d'Apollon (figs. 74, 75; corner personifications by Charles de La Fosse) and Chambre de la Reine (the lost central ceiling painting by Gilbert de Sève, depicting Apollo accompanied by the Four Parts of the World; see Morellet, 1681, 64). In the Salle des Gardes de la Reine (figs. 77, 78), a painting by Noël Coypel, *Trajan Receiving Petitions from the Nations of the World,* contains figures in variegated costumes, as in the Escalier des Ambassadeurs.

56. In the Galerie d'Apollon of the Louvre (1663–77), Le Brun had designed pairs of stucco atlas herms, each pair representing a sign of the zodiac.

57. Allusions to the Ménagerie of Versailles according to [Le Fevre], 1725, 7; depictions of the rarest birds of the four parts of the world according to *Grand Escalier,* fol. 131r.

58. See Montagu, 1963, 395ff.; Goldstein, 1965, 239ff. Only in Le Brun's project for the *salon ovale* of Vaux-le-Vicomte (late 1650s) does architecture play so important a role, but there Le Brun depicted a specific structure—the Palace of the Sun—whereas in the Escalier des Ambassadeurs it is a question of an illusionistic architectural scaffolding. On the project for Vaux, see Berger, 1970, 394ff. and text figure 1. In the dome of the chapel of Sceaux (ca. 1674), Le Brun created a continuous balustrade along the perimeter, but the spatial effect was mainly created by the foreshortened figures (see the engraving by G. Audran in Wildenstein, 1965, 31, fig. 177).

59. Painted by Noël Coypel. Payments to him, perhaps for this room, began on May 8, 1673, and from February 27 to December 11, 1678, he received substantial payments for work in the "Cabinet du Roy" (Marie, 1968, II, 311, 314).

60. Painted by Michel II Corneille. Payments to him for this room appear from December 19, 1671, to April 9, 1680 (Marie, 1968, II, 320–23). The allegorical figures represent Vigilance, Diligence, Commerce, and the Academy (Morellet, 1681, 63).

61. See Schnapper, 1966, 73ff.

62. A suite of rooms (destroyed) on the ground floor of the north wing of the Enveloppe.

63. On Colonna's works in the Hôtel de Lionne and at Versailles, see Schnapper, 1966, 73ff. These decorations no longer exist.

64. Schnapper, 1966, 77.

65. Ibid., 74–75.

66. On Cortona's works in the Palazzo Pitti, see Campbell, 1977. The dates of these decorations are as follows: Sala della Stufa (1637 and 1641), Sala di Venere (1641–42), Sala di Giove (1642–43/1644), Sala di Marte (1644–46), and Sala di Apollo (1645–47). Ciro Ferri finished the Sala di Apollo in 1659–61 and executed the Sala di Saturno in 1663–65.

67. Marie, 1968, II, 268.

68. See Briganti, 1962, 35ff.

69. Mention should be made of the staircage of the Hôtel de Châteaurenard in Aix-en-Provence, frescoed by Jean Daret in 1654. Here a servant appears in a window, drawing aside a curtain to gaze out at the spectator. Louis XIV slept in this building in 1660 and greatly admired the paintings. See Vaudoyer, 1947, 55, pl. 37.

70. Destroyed but known from engravings by M. Dorigny. See Crelly, 1962, 114–16, 257, no. 246, figs. 136–39. Le Brun, along with Pierre Mignard, executed New Testament scenes for the walls of the chapel, following Vouet's designs (Crelly, 113).

71. Briganti, 1962, pl. 30.

72. Martin, 1965, 164. Painted copies of the frescoes of the Farnese Gallery were made by *pensionnaires* of the French Academy in Rome in 1667 and installed in the Tuileries in Paris (Martin, 81). These may have included the atlas herms.

73. But Le Brun did use the overlapping panels motif in the second Salon de Vénus (1678–80; figs. 65, 66). For the influence of Carracci's herms, cf. Le Brun's cartoon for *September* (Bacou, 1974, fig. 5) with the Farnese herms illustrated in Martin, figs. 47, right, 48, left.

74. Some of Le Brun's preparatory drawings and cartoons for the corner motifs have been published; see Bacou, 1974, figs. 6–11, 14; Nolhac, 1901, 116.

75. Montagu, 1963, 401.

76. Ibid., 401–2.

77. See also Campbell, 1977, figs. 89, 95. The relationship of the Salon du Dôme prisoners to those of the Sala di Marte is noted by Montagu, 1963, 402.

78. See also Campbell, 1977, figs. 96, 97, 102–6.

79. Ibid., figs. 89, 96. See also Bacou, 1974, 15–16, for comments on Le Brun's sources.

80. Color descriptions of each panel are in *Grand Escalier*, fols. 131v–134v. Cf. the simulated reliefs (bluish figures, gold backgrounds) in the second Salon de Vénus and in the Galerie des Glaces.

81. Piganiol de La Force (1701, 25), writing about the overall decoration of the stair, stated that "Le tout est disposé avec tant de choix & tant de sagesse, que cette grande variété de sujets & de figures n'y cause pas la moindre confusion."

82. See the engraving of the entire vault by Picard (Montagu, 1963, fig. 19). The mixture of perspectival modes is noted as typical of Le Brun by Montagu (399). On the theoretical implications of Le Brun's practice and his dispute with Abraham Bosse, see Goldstein, 1965.

83. These depict scenes from the careers of illustrious females of antiquity: Rodogune, Harpalice, Artemisia, Zenobia, and Ipsycratée (see Morellet, 1681, 52–59; Piganiol de La Force, 1701, 111–14).

84. The most authoritative account of the iconography is in *Le Mercure galant*, September 1680, II, 276–320, especially 302ff. This anonymous article appeared about one year after the unveiling of the stair in 1679.

85. *Le Mercure galant*, September 1680, II, 292–93. The relationship of the frescoes to Ripa's *Iconologia* was analyzed by Mâle (1927, 379–81), who drew attention to Le Brun's prior reliance on Ripa in the Salle des Muses at Vaux-le-Vicomte, and believed that the painter had probably used Baudouin's translation of 1644, which is briefer in text than Italian editions but more profusely illustrated.

86. *Le Mercure galant*, September 1680, II, 308. All of the Muses are identified by symbols borrowed from Ripa (see Mâle, 1927, 380–81).

87. *Le Mercure galant*, September 1680, II, 308.

88. So identified in *Le Mercure galant*, September 1680, II, 309.

89. Ibid., 308–9. France fought the Triple Alliance in the Dutch War (1672–78), which raged while the Escalier was being created. The war ended in 1678 with the Peace of Nijmwegen.

90. *Le Mercure galant*, September 1680, II, 310: ". . . beaucoup de part aux recits des actions de tous les grands Hommes. . . ."

91. *Le Mercure galant*, September 1680, II, 310–11.

92. Ibid., 309–10: "[His Majesty] a mis fin aux Guerres civiles, & empesché les Rebellions secretes que les Ennemis ont voulu faire naistre dans la France. Ces Rebellions sont figurées par le Serpent Pithon . . . parce qu'il ne tire son origine que des grossieres impuretez de la terre, & qu'il fut percé presque en naissant des fleches d'Apollon, qui représente la Personne du Roy dans ce Sujet. . . ." See also Nivelon as quoted in Marie, 1968, II, 270; [Le Fevre], 1725, 5, 6.

93. On the symbolism of the Python and its appearance in the Petit Parc, see my forthcoming book on the gardens of Versailles. The Fronde may also have been alluded to by a ceiling in one of the rooms in the *appartement des bains* depicting *Apollo Dispersing Storms* (destroyed), although the Python was not depicted (see also my forthcoming book for this ceiling).

94. *Le Mercure galant*, September 1680, II, 291.

95. Ibid.

96. Ibid., 307–8.

97. Ibid., 284–85.

98. Ibid., 312–13: "Les quatre Parties du Monde sont représentées dans ce charmant Lieu, pour faire voir que le Roy a fait rechercher pour l'embellir, ce qu'il y a de plus rare dans toute la Terre, tant pour les Meubles, que pour les Plantes, Animaux, & autres choses; ce qui rend ce magnifique Palais si considérable, qu'il semble donner de la curiosité à tous les Hommes, en attirant une partie des Nations les plus éloignées."

99. *Le Mercure galant,* September 1680, II, 298–99, 300–301, 307–8, 311–12.

100. Ibid., 286, 306–7.

101. Ibid., 294–98.

102. Ibid., 299–300.

103. See above, n. 47.

104. On Warin's bust, see Courajod, 1881, 10–12; Pérαté, 1896, 5; Mazerolle, 1932, I, 120, no. 211.

On August 3, 1666, Warin's bust was referred to as a rival to Bernini's by Christiaan Huygens (1888–1950, VI, 81 [letter to Philippe Doublet]). On September 2, 1666, Louis XIV viewed the bust at Colombes and ". . . loüa fort ce bel ouvrage, ainsi que tous les seigneurs qui l'accompagnoyent, jugeans par là que la France possede, dans les beaux-arts, d'aussi grands hommes qu'il s'en puisse trouver ailleurs" (*Gazette de France,* September 11, 1666, quoted in Courajod, 1881, 10, n. 1). By 1669 Warin's bust was supposedly set up in the Louvre next to Bernini's—that is, if we accept the strong probability that the French bust referred to in the following account was indeed Warin's.

This extract from the travel diary of Prince Cosimo de' Medici (later Grand Duke Cosimo III), written by L. Magalotti and Marchese F. Corsini, is dated August 21, 1669:

> Vide S.A. due Teste, o Busti di marmo rappresentanti il Re, che uno lavorato dal Cavaliere Bernini in cui a maraviglia si scorgevano le fattezze di S.M., e l'altro fatto da uno Scultore Francese, e se bene questi non poteva concorrere coll'altro, come che era di maniera più eccellente, non di meno i Francesi se riguardavano con distinzione commendando quell' opera a vantaggio dell'altra del Bernino, con trassegno dell'affetto parziale, che conserva quella nazione alle cose proprie, e del Paese. (Quoted in Pühringer-Zwanowetz, 1976, 104, n. 12)

Warin's and Bernini's busts were later moved to the Palais des Tuileries and again displayed as a pair; the busts were placed in proximity to each other after Bernini's was moved from the Tuileries to the Salon de Diane (fig. 67) in 1684 (see *Comptes,* II, cols. 627 [August 19, 1685], 621 [September 10, 1685], 994 [August 18, 1686]).

In 1666, François Charpentier, a member of the Petite Académie, wrote the following sonnet on Warin's bust (Paris, Bibliothèque Nationale, Département des Manuscrits, Mélanges Colbert, vol. 37, fol. 92r,v; published in Mazerolle, 1932, II, 64–65):

> *Sur le buste du Roy fait en marbre par le S^r Varin.*
> Quand du divin Louis, Alcide eut veu l'image,
> Et cet air plus qu'humain sur le marbre exprimé,

> Du sçavoir de Varin il demeura charmé,
> Et creut voir son portrait en ce fameux ouvrage.

> C'est moy mesme, dit-il, c'est icy mon visage,
> C'est ainsy que j'estois quand de gloire enflammé
> Je purgeay l'Univers de monstres opprimé
> Et des astres brillans je m'ouvris le passage.

> Je veux bien que Varin, Praxitèle nouveau,
> D'un prophyre animé sous son docte ciseau,
> Imite des humains et les traits et la grace;

> Qu'il exerce icy bas son fer industrieux,
> Mais la main d'un mortel ne sçauroit sans audace
> Imiter de si près la majesté des Dieux.

> Quos vivo expressit Varinus marmore vultus,
> Hos melius nostro pectore sculpsit amor.

Colbert wrote the following note: "Bon: mettre avec le latin."

105. Coysevox's bust, dated 1681, is now in the Salon de l'Oeil-de-Boeuf. See Keller-Dorian, 1920, I, 26, no. 23, pl. 34; and Souchal, 1977– , I, 182, no. 12, fig. 12. The date of its placement in the Escalier in lieu of Warin's is uncertain.

The niche below the king's bust originally held a fountain of superposed marble basins (described in *Le Mercure galant,* September 1680, II, 279). In 1712 a basin with the antique group of *Silenus and Sea-Centaur* was installed (figs. 34, 37). The sculptural group (now in the Louvre), found in Rome in 1702, was presented to Louis XIV by Prince Alessandro Albani. After "restoration," it was sent to Versailles in 1712. On the antique group, see Michon, 1906, 389–96.

106. On this problem see my forthcoming book on the gardens of Versailles.

CHAPTER V

1. "Et comme le Soleil est la devise du Roy, l'on a pris les sept Planettes pour servir de sujet aux Tableaux des sept pieces de cét appartement. De sorte que dans chacune on y doit representer les actions des Heros de l'antiquité, qui auront rapport à chacune des Planetes & aux actions de Sa Majesté" (Félibien, 1674, 33–34). See also Perrault, 1688–97, I, 116–17.

2. "Et les peintures qui ornent les plafonds doivent aussi representer les actions des Heroines de l'antiquité, avec rapport aux sept Planetes" (Félibien, 1674, 36).

Félibien does not describe any of the paintings in the king's or queen's suites, because the decorations were then in progress. The first writer to describe the completed decorations of the original rooms was Morellet, 1681, 30ff. On the decoration of these suites (1671–80), see Schnapper, 1974, 58ff. (with the dating of the individual rooms).

3. Félibien, 1674, 28–33. In 1681 Morellet (42) referred to the Salon d'Apollon as the "Chambre du Roy" (as did Félibien), but by December 1682 it had been transformed into a throne room (*Le Mercure galant,* December 1682, 13–17). See also chapter VII.

4. Félibien (1674, 35–36) did not mention the specific dedications or functions of the rooms of the

queen's suite. By the time Morellet published his guidebook in 1681, Mansart's remodeling of the western range of the Enveloppe had seriously disturbed the original sequence of rooms. But Morellet did note (52–68) that the three rooms unaffected by the new work (the Antichambre, the Salon, and the Chambre de la Reine) were respectively dedicated to Mars, Mercury, and Apollo, their placement identical to the corresponding salons in the *grand appartement du roi*. From this we may reasonably conclude that the original seven rooms of the queen's apartment precisely followed the cosmological system of the king's suite. The queen's ceremonial bedroom (dedicated to Apollo) corresponded to the king's Salon d'Apollon, but the queen's bedroom (unlike the king's) always retained its original location and function throughout the course of the *ancien régime*.

Johnson (1981) has proposed that the arrangement of separate but equal king's and queen's suites was meant to symbolize Marie-Thérèse's claim to the throne of Spain (and, hence, her status as an independent monarch).

5. On these decorations, see Campbell (1977). As noted in chapter IV, Le Brun (who was in charge of the decorations of the king's and queen's suites) was in Italy in 1642–45 and probably visited the Palazzo Pitti. It has long been acknowledged that Le Brun's decorative vocabulary is heavily indebted to Cortona's Pitti decorations.

6. Vitzthum, *Charles Le Brun e la sua scuola a Versailles* (1965).

7. Ibid., 3.

8. On the Ptolemaic grouping of the planets, which has its origins in ancient Babylonia and in the Stoic philosopher Diogenes of Babylon (fl. ca. 160 B.C.), see Dreyer, 1953, 169.

9. In *Pietro da Cortona at the Pitti Palace* (1977).

10. Ibid., 78–79. The patron of the Pitti decorations was Grand Duke Ferdinand II de' Medici (1610–70), the pupil, protector, and admirer of Galileo Galilei, the champion of Copernican theory. The problem of Ferdinand's Ptolemaic fresco cycle and his simultaneous support of Galileo is discussed by Campbell (1977, 80–81), who argues that in the first half of the seventeenth century, the arts and sciences were compartmentalized to such a degree that artists seldom availed themselves of scientific knowledge, and scientists viewed art in traditional humanistic terms, without recourse to their new critical outlook. I do not find Campbell's argument persuasive. Surely, the Grand Duke commissioned a Ptolemaic fresco cycle and not a Copernican one because the latter system had been condemned by the Catholic church; Galileo's trial and forced renunciation had taken place in 1633, only eight years before the planetary rooms of the Pitti were begun. A permanent cycle of frescoes following the Copernican system would have been a dangerous gesture in seventeenth-century Italy.

11. Campbell, 1977, 177.

12. This was the system of Tycho Brahe, first published in 1588, and a rival to Copernicus' in the seventeenth century. In this scheme, the planets Mercury, Venus, Mars, Jupiter, and Saturn revolve around the Sun (with Mercury closest to the Sun, Saturn farthest away), but the Sun and Moon revolve around the Earth, which maintains its central position in the universe, with the sphere of fixed stars equidistant from it. See Dreyer, 1953, 363ff. If correlated with the rooms of the Palazzo Pitti, Tycho's system would be aligned as follows (with missing bodies indicated by dotted orbits):

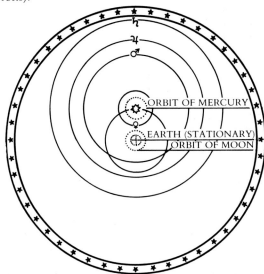

13. The position of the Earth in Copernican theory seemed fallacious to many people because, according to traditional thought, it implied that Man lived in the heavenly regions. This was clearly expressed in 1665 by G.L. Agricola of the University of Wittenberg, who stated that it is "ridiculous to include the earth among the planets, because then we would be living in Heaven, forsooth, since we would be in a star" (quoted in Stimson, 1972, 77).

14. System of Tycho Brahe Correlated with Versailles Rooms.

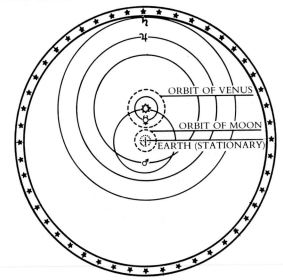

15. IX, i, 6. Vitruvius's geocentrism is clearly stated in IX, i, 2.

16. IX, i, 8, 9.

17. Ibid., 10.

18. Ibid., 5. See above, n. 8.

19. One other cosmological theory available to the designers of Versailles was by Father G.B. Riccioli, S.J., published in 1651 (see Stimson, 1972, 79ff.). This was a modified Tychonic scheme, with only Mercury, Venus, and Mars rotating around the Sun; the latter, along with the Moon, move around a fixed, central Earth, with the orbit of Mars also encompassing the Earth. Jupiter and Saturn were placed near the fixed stars, in their own distant heaven. Yet no matter how the planets might be positioned in accordance with Riccioli's sytem (as either a linear or a centralized schema), they never match the sequence of the Planetary Rooms at Versailles.

20. Verlet, 1961, 96.

21. Since the queen's apartment apparently duplicated the king's in its form and dedications, it is apparent that the first form of the Enveloppe featured a western terrace flanked by two rooms dedicated to Venus (fig. 12, fig. A).

22. It is so termed by Félibien, 1674, 29, and Morellet, 1681, 33. Le Mercure galant (December 1682, 24–31) described it as a gaming-room, and in 1687 Tessin noted that it served as a ballroom, with musicians' tribunes (Tessin, 278). Yet in 1688 Charles Perrault still referred to it as the Salle des Gardes (Perrault, 1688–97, I, 117–18).

23. This relationship is studied by Baillie (1967, 185ff.), whose pioneering study surveys the relationship of ceremony to planning in English, French, and German palaces. Two of his statements concerning the original functions of the king's rooms at Versailles are incorrect (188): the Salon de Mercure was never a throne room, and the corner room (the Salon de Jupiter) was not the king's real bedroom.

The Salle des Gardes of the Louvre is the present Salle des Bronzes Antiques, reached by the Escalier Henri II in the central pavilion of the western wing. On the king's appartement in the Louvre, see also Hautecoeur, 1927, 50–51.

24. The antichambre of the Louvre is the present Salle Étrusque.

25. Baillie (1967, 186) incorrectly states that the king dined in public in the antichambre of the Louvre; in reality, his Chambre de Parade was used for this purpose (Hautecoeur, 1927, 92).

26. Baillie, passim and the comparative chart on 199.

27. At the Palazzo Pitti, the Sala di Marte (decorated 1644–46) was described as the "antechamber of the courtiers" in an inventory of 1663/64; in 1638, before Cortona's work, it was simply designated as "the second room of the new apartment." The guardroom in 1638 was one of two rooms later refashioned into the Sala di Venere (decorated 1641–42), which in 1663/64 was described as a "general antechamber" (Campbell, 1977, 67ff.). No guardroom is mentioned in the later inventory, but it seems likely that one of the rooms near the staircase served this purpose (see Campbell, 1977, 69, plan of piano nobile).

28. The Enveloppe was designed and begun in 1668, and essentially finished in 1673/74. The decoration of the grands appartements began 1670/71.

29. On the Observatoire, see Petzet, 1967.

30. For the biography of Cassini, see Taton (1971). The astronomer remained in France until his death in 1712.

31. Taton, 1971, 101, 103; Stimson, 1972, 96–97.

32. Ibid. Many French intellectuals of the seventeenth century followed Descartes' theory (published in his Principia of 1644) which, in reference to the planetary model, saw little difference between the Tychonic and the Copernican systems (see Stimson, 1972, 85–86).

33. The writings of Copernicus and Galileo were first omitted from the Index in 1835 (Stimson, 1972, 100).

34. Claude Perrault's designs for Versailles were contained in two MS volumes (compiled in 1693 by Charles Perrault) that were destroyed in 1871. The drawings included projects for the Grotto of Tethys, the Bain de Diane, the Allée d'Eau, the Bosquet de l'Arc de Triomphe, the Château, and the Chapel (see Blondel, 1752–56, IV, 95, 103, n. n, 104–5, n. r, 107, n. x, 142–43; Weigert and Hernmarck, 1964, 15–16 [letter (April 19, 1693) from Daniel Cronström to Nicodemus Tessin the Younger]). Claude was one of the architects who competed in June 1669 for a revised Château design; Colbert's criticisms of this design are published in appendix II. Claude's technical notes on the water supply of Versailles of October 14, 1671, are preserved (Paris, Archives Nationales, O¹ 1854¹). A letter to Colbert (January 27, 1674; Paris, Bibliothèque Nationale, Département des Manuscrits, Mélanges Colbert, vol. 167, fol. 245b) may be by Claude: "Jay envoyé a Monseigneur le dessein en grand pour les portes de bronze des grands apartemens de Versailles. Il me les renvoyera s'il lui plaist avec sa resolution."

35. Perrault's bibliography is listed in Herrmann, 1973, 217–19. On Perrault the scientist, see Herrmann, chap. 1, and Keller, 1974.

36. The placement of the columns of this room (fig. 65) may have been the topic of discussion at the Académie Royale d'Architecture on May 20, 1675 (Lemonnier, 1911–29, I, 99–100). Its ceiling paintings (fig. 66) center around a depiction of Venus in her chariot, described as completed in 1680 (Morellet, 1681, 26–30; privilège du roi dated November 7, 1680).

37. The original decoration of the queen's Salon de Diane is unknown. Verlet (1961, 111) believes that the doors with hour-glass decorations came from the king's Salon de Saturne.

38. In the queen's Salon de Mars (Antichambre de la Reine), the central area is occupied by a nineteenth-century copy of Le Brun's Family of Darius at the Feet of Alexander; the queen's Salon d'Apollon (Chambre de la Reine) originally featured a central painting of Apollo in his chariot with the Hours and the Four Parts of the World (lost); the present ceiling dates from 1735 (Verlet, 1961, 460).

39. See Berger, 1970.

40. ". . . comme l'on arrivoit sur une magnifique terrasse, d'où l'on découvre également, & le palais, & les terrasses qui vont en descendant, & qui font un amphithéâtre de jardins [the Fer-à-Cheval], on vit un changement prodigieux en tous les objets; & l'on peut dire que jamais nuit ne fut si parée, & si brillante que celle-là. En effet, le palais parut veritablement le palais du Soleil: car il fut lumineux par tout, & toutes les croisées parurent remplies des plus belles statuës de l'antiquité . . . " (Scudéry, 1669, 601).

41. La Fontaine, 1669, in the edition of 1883–92, VIII, 121.

42. "Explication de toutes les grottes, rochers et fontaines du chasteau royal de Versailles, maison du soleil, et de la Ménagerie. En vers héroïques" (Paris, Bibliothèque Nationale, Département des Manuscrits, ms. fr. 2348), published by Raynal. On this poem, see also Berger, 1984.

43. Vertron, 1686, 51. The Latin distich—translating as, "You wonder at the lofty halls of stately columns; / Do not wonder, the work is the Palace of the Sun"— recalls the opening line of book II of Ovid's *Metamorphoses*: "Regia Solis erat sublimibus alta columnis. . . ." This is the *locus classicus* for the description of the Palace of the Sun (see Berger, 1970, 395).

44. Martial, *Epigrams* VII.56, IX.91; Statius, *Silvae* IV.2; see Dudley, 1967, 168–69, 174–75; MacDonald, 1965, 61–62. See also an important passage by Dio Cassius on Septimius Severus' decorations of the basilicas of the Palatine complex, quoted in Lehmann (1945, 8). On the possible importance of the Palatine descriptions for the planetary rooms of the Palazzo Pitti, see Campbell, 1977, 157.

45. See Campbell, 1977, pls. 27, 60, 124.

46. For the artists of these paintings, see appendix III. These artists undoubtedly worked according to designs formulated by Le Brun. See also below, n. 52.

47. For the literary sources and early appearances in Renaissance art of the planetary gods in their animal-drawn chariots, see Tervarent, 1958–64, I, cols. 65–66; 74 (Diana); 86, 252 (Mars); 80, 113 (Mercury); 74–75 (Apollo); 4, 71 (Jupiter); 82 (Saturn); 80, 104–5 (Venus); figs. 17, 19–21, 25. See also Battisti, 1960, cols. 39ff., esp. cols. 48–52, 57, 62–64, 67–68.

In describing Perugino's decorations of the Sala dell'Udienza of the Collegio del Cambio, Perugia (1497–1500), Vasari wrote that Perugino painted "nel partimento della volta i sette pianeti tirati sopra certi carri da diversi animali, *secondo l'uso vecchio* [my italics] . . ." (Vasari, III, 581).

48. Morellet, 1681, 52; Piganiol de La Force, 1701, 111.

49. Morellet, 1681, 60; Piganiol de La Force, 1701, 109.

50. Morellet, 1681, 64–66; Piganiol de La Force, 1701, 106–7. For the artists of the paintings of the queen's suite, see appendix III.

51. See Hautecoeur, 1927, pls. 8, 9.

52. The painters of the ceilings undoubtedly worked according to designs formulated by Le Brun. However,

only two preparatory drawings by him for the second Salon de Vénus have survived: *Ninus and Semiramis Ordering the Building of Babylon* (Vienna, Albertina, inv. no. 11684; illus. in *Charles Le Brun*, 1963, 352) and *Nymph Seated on a Dolphin* (Paris, Louvre, Cabinet des Dessins, inv. 29.849; illus. in *Charles Le Brun*, 1963, 348).

53. Mazerolle, 1932, I, 79–80, 120, no. 212; II, pl. 17.

54. *Le Mercure galant,* December 1682, 36.

55. *Comptes,* II, cols. 621 (September 10, 1685), 627 (August 19, 1685), 994 (August 18, 1686).

56. On Mignard's painting, see Constans, 1976, 159 and fig. 3. Rigaud's famous *Portrait of Louis XIV* (Paris, Louvre) dates from 1701–2; intended to be sent to Madrid, it was placed "temporarily" in the Salon d'Apollon in 1702, where it remained (see Constans, 163, fig. 11; 172, n. 64). Dates of creation and placement remain uncertain for Coysevox's stucco bas-relief of *The Triumph of Louis XIV* in the Salon de la Guerre (fig. 86; see Keller-Dorian, 1920, I, 37–39, no. 30; Kuraszewski, 1974; Souchal, 1977– , I, 186, no. 25).

CHAPTER VI

1. See Prinz, 1970, and the reviews by Hoffmann, 1971; Büttner, 1972; Lossky, 1971; and Berger, 1973. See also Prinz, 1972, for his replies to Hoffmann and Büttner.

On the decoration of royal French galleries, see Thuillier, 1975.

2. [30] "La galerie sur la face doit avoir un salon dans le milieu, s'il est possible" (from Colbert's "Mémoire de ce que le roi désire dans son bâtiment de Versailles"). The variant of Le Vau's design (fig. 18) has a long gallery interrupted at its center by a vestibule on the *rez-de-chaussée.*

3. Kimball's words (1943, 41) are relevant here: "In the matter of a gallery, Louis XIV by 1678 found himself outshone both by his mistress at Clagny [Madame de Montespan] and by his brother at Saint-Cloud [Philippe, duc d'Orléans]. At Versailles, there was still only the Galerie Basse. Its inadequacy had now become insupportable, especially since Mignard's dazzling decorations at Saint-Cloud had been revealed to the Court in October of 1677 [actually 1678; but Mignard was at work in the gallery in 1677, and this was known by Louis XIV. See Berger, 1969, 68 and n. 16]. The King's decision to house the Court at Versailles, to make it the true capital [effected in 1682, but probably considered in 1678], rendered immaterial the existence of the Galerie des Ambassadeurs at the Tuileries, the completion of the unfinished Galerie d'Apollon at the Louvre. Versailles was no longer to be merely a country seat, however magnificent; it must have its gallery, the most splendid of all."

The spatial arrangement at Versailles (long gallery flanked by salons) was anticipated at Mansart's Château de Clagny (1675–80), and recalls the second design for the Château de Verneuil (after 1575, by Jacques I Androuet Du Cerceau). See Hautecoeur, 1943, I, 353; Kimball, 1943, 40–41. But Mansart may have been

mainly influenced by the Palazzo Colonna, Rome (see text).

4. *Comptes*, I, cols. 1013–16.

5. Ibid., col. 1040: "à [Gabriel], à compte de la démolition de la terrasse du costé du grand parterre . . . 2300 *livres.*"

6. On the architectural planning and construction, see Nolhac, 1903a, 177–91; Kimball, 1940, 1–6; idem, 1943, 41ff.; Marie and Marie, 1972, II, 435ff., esp. 455–63.

7. The adjoining room may be the Salon du Roi or the Salon du Conseil.

8. The original wall and vault decorations of the king's Salon de Jupiter were transferred to the present Salle des Gardes de la Reine (figs. 77, 78; see chapter V).

9. Prinz (1970, 15–16) erred in claiming that the gallery of the Palazzo Colonna was influenced by the Galerie des Glaces. The relationship between the two rooms is precisely the reverse, as pointed out by Büttner, 1972, 80.

10. The suggestion of Apollo Liberating Chryseis is found in Marie and Marie, 1972, II, 439. On this drawing see Kimball, 1940, 3; *Charles Le Brun*, 1963, 357; Marie and Marie, 1972, II, 438–39; *Collections de Louis XIV*, 1977, 274, no. 282.

11. First published by Hautecoeur (1927, pl. 21) as a design for the Galerie d'Apollon of the Louvre, it was identified as a study for the Galerie des Glaces by Kimball, 1940, 2, n. 12.

12. Préaud, 1980, II, 279, no. 3061.

13. On this drawing see Jouin, 1889, 560; *Charles Le Brun*, 1963, 359; Marie and Marie, 1972, II, 443ff.

14. It should be noted that a tradition linking Hercules to the Sun was alive from the sixteenth century on (Cartari); hence, the association of Louis XIV with the ancient hero may have preserved solar imagery in the minds of erudite seventeenth-century Frenchmen (see Utz, 1971, 358–60).

15. "Monseigneur, voicy les dessins pour Trianon et celuy pour la galerie de Versailles que le Roy m'a commandés. J'attends vos ordres devant de rien commencer. Je vous demanderay vostre avis sur tout cela, Monseigneur. Avec le goust que je sçais que vous avez, je dois estre sans crainte du résultat" (Colbert, V, 563).

16. Kimball, 1940, 3. Kimball's dating (Spring 1679) was adopted by Marie and Marie (1972, II, 436).

17. Marie and Marie, II, 472; entries from the *Comptes* relating to the Galerie appear on 468–77.

18. The vault decorations (preliminary and executed) place the Galerie des Glaces in the tradition of the "Hall of Princely Virtue." On this tradition, see Brown and Elliott, 1980, 147ff.; see also Langner, 1970/71, for a brief discussion of the vault paintings in relation to contemporary political theory.

19. If Nivelon's measurement of "6 pieds de long" (1.949 m.) is to be trusted, the drawing here referred to is not figure 91, because this measures only 0.841 m. long (× 0.445 m. wide).

20. This description corresponds to figure 91, except that it is 0.841 m. long, not six French feet.

21. "Pendant la construction de ce lieu [the Galerie des Glaces] et que l'on travaillait au marbre sur l'ordre qu'il [Le Brun] en donna, il composa, dans sa belle maison de Montmorency, le dessin de la voûte, qui est de 6 pieds de long, à la plume et coloré, contenant en général tous les travaux d'Hercule, tous allégorisés sur les actions du Roi et au sujet de la guerre qui se faisait alors contre l'Allemagne, l'Espagne et la Hollande. Tous ces sujets enchâssés ensemble, avec leurs arcs, bordures et ornements, forment des variétés à l'avantage de la peinture. Les deux cintres des extrémités sont remplis, le premier de la désolation de Troie par Hercule, qui enleva les trois filles du roi Laomédon, et l'autre ce même héros ôtant le baudrier fameux d'Hippolyte, reine des Amazones, après sa défaite. . . .

Toutes les études nécessaires étaient faites pour l'exécution d'un si beau sujet, qui était agréé; mais le Conseil secret de Sa Majesté trouva à propos et résolut que son histoire sur les conquêtes devait y être représentée. Ce changement subit, qui aurait embarrassé les plus habiles génies, ayant à changer si promptement d'idées, a servi au contraire à faire juger quelle était l'étendue du génie de notre auteur, représentant des actions qui étonneront la postérité et donneront de l'occupation aux plus délicates plumes du temps. La résolution étant prise par ce changement, M. Le Brun se renferma deux jours dans l'ancien hôtel de Grammont et produisit le premier dessin de ce grand ouvrage, qui est le tableau du milieu, qui fait le noeud principal de tout, sur lequel lui fut ordonné d'en continuer la suite sur ces mêmes principes et ces belles lumières, avec cette prudente restriction de la part de M. Colbert de n'y rien faire entrer qui ne fût conforme à la vérité, ni de trop onéreux aux puissances étrangères que cela pouvait toucher; ce qui est exécuté d'une manière si savante qu'eux-mêmes, intéressés en faveur de leur patrie, les voyant ou entendant ce récit, sont charmés de la beauté et de la noblesse de ce langage pour perpétuer à la postérité les actions des grands rois" (Nivelon quoted in Nolhac, 1903b, 280).

Nivelon played a role in the history of the Galerie des Glaces: he made official drawings of it in 1686 and 1687 (payment was made on January 4, 1688; *Comptes*, III, col. 194).

22. On the *conseil d'en haut*, see Wolf, 1968, 164ff.; Rule, 1969, 26ff.

23. Rule, 1969, 27.

24. The council was not necessarily guided in its final decision by the writings of Antoine de Laval, as suggested by Thuillier (1975, 188). The reasons for the changes of program have also been discussed recently (1984) by Ann Friedman in a paper ("*Ut Politics Pictura: The Hall of Mirrors at Versailles*") presented at the CAA annual meeting in Toronto.

25. "Le Roy prend luy-mesme la conduite de ses Estats, & se donne tout entier aux affaires. 1661" (Rainssant, 1687, 1). Charpentier (1684, 6) had earlier called it "Le Roy preferant la gloire aux plaisirs," but explained that it depicted France at the time when the king assumed control of government. The painter Lorne (otherwise unknown) described the scene as ". . . le Roy dans la fleur de la jeunesse, envisageant la

Gloire, prend apres son Mariage le Gouvernement de l'Etat, & quitant pour la mériter les plaisirs d'un Regne paisible, médite de rendre les Sujets heureux, & d'humilier ses Ennemis" (Lorne, 1684, 10).

26. Detailed early descriptions provided by Charpentier (1684, 5–11), Lorne (1684, 17–25), and Rainssant (1687, 1–8) elaborate the iconography. The iconographic description offered in my text is a composite from these three writers, who basically offer the same iconographic analysis, except for certain details.

27. According to *Le Mercure galant,* August 1681, 121, Le Brun painted the large pictures with his own hand. The same publication later stated (December 1684, 83; November 1686, II, 273) that he painted everything himself—undoubtedly exaggerations. Payments to assistant painters are recorded in the *Comptes* from March 1681 on (Marie and Marie, 1972, II, 472ff.). Surviving preparatory drawings for the Galerie, the Salon de la Guerre, and the Salon de la Paix are catalogued in Guiffrey and Marcel, 1907–28, VII, 116–23 (illustrations on 117, 118, 121, 122).

28. Blunt, 1970, pl. 190a. The oil sketch still exists (*Charles Le Brun,* 1963, 118).

29. The question of whether Le Brun's paintings exceed diplomatic propriety is discussed by an anonymous writer in the *Journal de Trévoux,* LIII (I), December 1753, 2784–87 (review of Massé, 1753). He concludes that the painter's imagery follows that traditionally found in epic poetry, and that foreign nations depict their victories over France in the same manner. Furthermore, "toutes ces licenses ne doivent blesser personne" and they do not "obscurcir la gloire des Peuples voisins."

An explanation of the allegorical approach is offered by Lorne (1684, 3–7). The inclusion of allegorical figures is specifically defended as based on Antique precedent in Rainssant (1687, 51): "L'Allegorie, que l'on vient de voir si ingenieusement employée dans les grands Tableaux, regne encore dans tous [les petits tableaux]; & on a suivi en cela l'exemple des Anciens, qui pour jetter plus de merveilleux dans la Poësie & dans la Peinture, n'ont point trouvé de meilleur moyen, que d'y mêler par tout des Personnages allégoriques."

The final cycle portrays events from 1661 to 1678, with the large pictures (e.g., fig. 96) concerned mainly with the Dutch War (1672–78). For a complete explanation of the subject matter, see the early writings cited above, in note 26.

30. Upon the death of Marie de Médicis in 1642, the building passed to her son, Gaston d'Orléans. At his death in 1660, it was inherited by his second wife, Marguerite de Lorraine, duchesse d'Orléans, and his daughter, Mlle. Montpensier. In 1672 another daughter, the Duchesse de Guise, inherited Marguerite de Lorraine's portion. She and Mlle. Montpensier owned the palace at the time of the creation of the Galerie des Glaces (see Thuillier and Foucart, 1970, 132ff.). Drawings by Laurent de La Hyre (1606–56; Thuillier and Foucart, figs. 94, 95) demonstrate that French artists were copying the paintings well before interest in Rubens developed later in the century. In 1677—on the

eve of the creation of the Galerie—Roger de Piles published his *Conversations sur la connaissance de la peinture,* which contains "virtually the first pages of any importance concerning the Medici Gallery in any French book" (Thuillier and Foucart, 134, with trans. extracts). Germain Brice, in his guidebook to Paris (1684), noted that "Often the young painters go to study in this gallery; and since it is entirely in his [Rubens'] manner, they can easily acquire ideas there of what is fine painting" (Thuillier and Foucart, 134).

31. *Charles Le Brun,* 1963, 120–21, no. 41, where the work is dated ca. 1679. However, Guillet de Saint-Georges in his life of Le Brun states that it was painted "en différents intervalles de temps" while Le Brun was at work in the Galerie des Glaces (*Charles Le Brun,* 1963, 121)—that is, 1681 to 1684.

32. Reproduced in Rosenberg, 1964, fig. 156. Vorsterman's engraving reverses the original image.

33. See *Charles Le Brun,* 1963, 101–3, 106–7, no. 35.

34. Park: Piganiol de La Force, 1701, 100; Le Rouge, 1716, 323; Blondel, 1752–56, IV, 125. Furniture: *Le Mercure galant,* November 1686, II, 275. Beautiful women: Saint-Aignan, 1682, 362–63 (the Galerie is not specifically cited, but the author undoubtedly had it in mind).

Moisy's interesting speculations (1961, 48) about the mirrored Galerie as a metaphor for the ambiguity of existence are not confirmed by any recorded statements by seventeenth-century viewers.

35. "Des Glaces font de fausses Fenestres vis à-vis des veritables, & multiplient un million de fois cette Galerie, qui paroist n'avoir point de fin, quoy qu'il n'y ait qu'un bout qu'on en voye" (*Le Mercure galant,* December 1682, 9–10).

36. "On entre à cet Apartement [the *grand appartement du roi*], composé de neuf pieces differentes, également bien éclairées, par une allée de lumiere, s'il est permis de parler ainsi, dont la longueur surprend agreablement, & qui sera un jour beaucoup plus belle quand le fameux le Brun aura achevé de la peindre aussi bien qu'il a commencé. C'est cette belle Galerie que j'appelle une Allée lumineuse, parce qu'elle est éclairée comme si le Soleil luy-même l'éclairoit; qu'elle a des perspectives de Miroirs qui en redoublent la longueur, des Orangers dans de grandes quaisses d'argent, & qu'on s'y peut promener sans avoir chaud, comme si on se promenoit à l'ombre" (Scudéry, 1684, I, 18–19).

37. The first mention of mirrors in the building records occurs in the provisions for 1680: "Pour achever les ouvrages de marbre, menuiseries, sculpture, peinture, glaces et bronzes, à faire dans la Grande Gallerie . . . 200 000 *livres*" (*Comptes,* I, col. 1233).

38. Moisy, 1961, 43; Scoville, 1950, chap. IV. The Royal Plate Glass Company was organized by the Crown in 1665, but was privately owned and run. In 1672 Colbert expressed his belief that French glass was superior to Venetian, and the king forbade the importation of foreign glass in that year.

39. See Nolhac, 1903a, 184; Hautecoeur, 1948, II, 543–44; Langner, 1967, 233–40; Pérouse de Montclos, 1977, 223–40. Le Brun lectured to the Académie Royale

de Peinture et de Scuplture on the French order in 1671 (Fontaine, n.d., 43). His French order at Versailles is a development of his French order for the Galerie d'Apollon of the Louvre (begun 1661) and his design of 1672 for the 1671 competition for the top floor of the Cour Carrée of the Louvre.

40. "Spiegel-Räume im Zeitalter Ludwigs XIV" (1946).

41. See Thornton, 1978, 75ff.; Kimball, 1943, 22–23.

42. Browne, 1923, 21. On this room see Braham and Smith, 1973, I, 222; II, figs. 261, 262; Thornton, 1978, pl. 81. Mirrors were also used to decorate a salon in the Château de Fresnes, perhaps also due to Mansart (ca. 1644–50 and ca. 1660); see Braham and Smith, I, 231.

An imaginative use of mirrors in an unusual location (a staircage) could be found in Louis Le Vau's Hôtel Hesselin in Paris (ca. 1640–ca. 1644), where a mirrored wall faced a straight, monumental stair: "Cette disposition est si galante, qu'elle double l'escalier, le vestibule & les colosses" [the caryatids supporting the stair] (Sauval, 1724, III, 14). See also Sauval's description of mirrors in the Hôtel d'Aumont, Place Royale, Paris (by Louis Le Vau, 1640s), which allowed one to view outdoor traffic in the Place from one's bed (Sauval, II, 157–58).

43. Scudéry, 1669, 48–49: ". . . des pilastres de miroirs entremêlez d'autres pilastres à feüillages dorez sur un fonds de lapis avec les chiffres du Roi; ce qui fait un effet merveilleux par la reflexion de tant de beaux objets dans ces pilastres transparens qui sont tous couronnez de soleils d'or."

44. "Et parce que les piliers & les costez de la Grotte sont remplis de miroirs, chaque espece venant à se multiplier, cette Grotte paroist d'une grandeur extraordinaire, & comme plusieurs Grottes qui composent un Palais au milieu des eaux, dont l'etenduë semble n'avoir point de bornes" (Félibien, 1672, in the edition of 1689, 385).

45. See, for example, Claude Guy Hallé's painting of the *Reception of the Doge of Genoa, May 15, 1685* (Versailles, Musée National du Château de Versailles; illus. in Marie and Marie, 1972, II, 461) and figure 99 (see chapter VII).

46. The relationship between the Salon de los Espejos and the Galerie des Glaces was previously suggested by Moisy, 1961, 44ff. The salon has been studied in detail by Orso, 1978, I, chap. 2, and my discussion of it is drawn from this source. The appearance of the salon is known mainly by the portraits of Charles II and Queen Mariana by Juan Carreño de Miranda (such as the *Portrait of Charles II* in the Gemäldegalerie, East Berlin). The room, originally called "la pieza nueva," was part of a wing of the palace built from 1619 to 1627 by Juan Gómez de Mora. The Alcázar was destroyed by fire in 1734. See also Volk, 1980, with a plan of the palace as figure 17 (the Salon de los Espejos is numbered "26").

47. The room was used for these functions until the destruction of the Alcázar in 1734 (Orso, 1978, I, chap. 2).

48. Some later changes were made under Charles II and Philip V.

49. As suggested by Orso, 1978, I, chap. 2. See also Panofsky and Panofsky, 1965, 157–58 (where the room is wrongly called the "Pieza ochavada"). A vase rather than a box was depicted in two scenes from the destroyed cycle, as we know from a text by Palomino (ibid., 158).

50. Orso (I, 114) points out that the cycle of hung paintings could not constitute an entirely systematic iconographic group: "The conflicting circumstances under which the Alcázar was decorated should also be acknowledged. Considerations other than programmatic ones came into play: the availability of pictures in the royal stockpile, the evolution of the ensemble over several decades, and the character of the room as a showcase for fine paintings not necessarily chosen for their content. As a result, the program never attained the ironclad consistency of such ensembles as the great cycles designed by Rubens; rather, it was a looser, more casual assemblage."

51. Carducho, discussed by Orso, 1978, I, 111. Ideas similar to Carducho's can be found earlier in France in the writings of Antoine de Laval (ca. 1600); see Thuillier, 1975.

52. Orso, 1978, I, chap. 2.

CHAPTER VII

1. A room on the ground floor of the *Vieille Aile* (figs. 4 and 5, left foreground; see Marie and Marie, 1972, I, 222).

2. Sourches, 1882–93, I, 223–24:

. . . les ambassadeurs du grand-duc [Czar] de Moscovie eurent audience du Roi, à la manière accoutumée, c'est-à-dire qu'ils vinrent de Paris dans les carrosses du Roi, conduits par l'Introducteur des ambassadeurs. Quand ils entrèrent dans l'avant-cour, les compagnies des deux régiments des gardes y étoient sous leurs armes, et les tambours appelèrent quand leur carrosse passa. Dans la cour du château, les gardes de la porte et les gardes de la prévôté de l'hôtel étoient en haie sous leurs armes. Et l'on conduisit ces Moscovites dans la chambre destinée pour la réception des ambassadeurs.

A midi, le Grand-Maître des cérémonies, avec ses aides, vint les prendre et les conduisit à l'escalier de marbre, au pied duquel ils furent reçus par le capitaine des gardes avec ses officiers, qui les conduisirent jusqu'au lieu où étoit le Roi. Les cent-suisses étoient en haie le long de l'escalier, et les gardes du corps aussi en haie dans les deux premières pièces de l'appartement, les uns et les autres sous leurs armes. Le Roi étoit dans la dernière pièce de l'appartement, proche du salon, assis sur une chaise d'argent, posée en forme de trône, sur une estrade couverte d'un magnifique tapis d'or, d'argent et de soie.

Les Moscovites n'approchèrent pas plus près du Roi que le pied de l'estrade, où ils se prosternèrent tous le visage en terre, à la manière des Orientaux;

ensuite de quoi le principal d'entre eux fit sa harangue en sa langue, qui fut sur-le-champ récitée tout haut par l'interprète. Et, s'étant approché du Roi pour lui remettre la lettre du grand-duc, son maître, Sa Majesté répondit à sa harangue; et ils se retirèrent comme ils étoient venus, après s'être de nouveau prosternés comme ils avoient déjà fait, et furent reconduits de la même manière à la chambre des ambassadeurs, où les officiers du Roi les traitèrent magnifiquement; et, après le dîner, on les ramena à Paris dans les mêmes carrosses. . . .

3. ". . . où la Renommée porte la reputation des Armes du Roy" (Morellet, 1681, 44).

4. The placement of the pictures by Reni and Rubens in the Salon d'Apollon was first reported in *Le Mercure galant,* December 1682, 13–17. On the decoration of the room, see Constans, 1976, 162–63 (Reni's paintings are illustrated on 173); Berger, 1979, 20–21. For the theme of *Queen Tomyris with the Head of Cyrus* in art, see Berger, 1979, passim.

5. See Berger, 1979, 21, n. 93.

6. The full text is given in Marie and Marie, 1976, 449–52.

7. Saint-Simon, 1967–68, II, 403–6. Saint-Simon believed him to be Persian, but no more than a provincial intendant or a merchant. However, Mehemet Riza Beg was on an official ambassadorial mission (see Bouret, 1983).

8. Saint-Simon, 1967–68, II, 404–5.

9. Marie and Marie, 1976, 451.

10. Saint-Simon, 1967–68, II, 405.

11. Saint-Simon reported (1967–68, II, 405) that Antoine Coypel was placed close to the throne to paint the scene. The text published by Marie and Marie (see above, n. 6) may well be by C. Gros de Boze, secretary of the Académie Royale des Inscriptions et Belles-Lettres, whose presence to record the event is also noted by Saint-Simon.

The throne in fig. 99 is not the silver one described in the text, above; the latter had been melted down for silver bullion, along with other silver furniture, to help pay for the War of the League of Augsburg.

12. ". . . à l'entrée de la Gallerie, l'Ambassadeur pouvant estre veu du Roy, a pris la lettre du Roy de Perse, toujours Enveloppée dans l'étoffe d'or, et l'a portée sur ses deux mains; on a continué à marcher jusqu'au pied du Trosne, où l'Ambassadeur a salué le Roy d'un seul salut à sa manière. Le Roy le voyant entrer dans la Gallerie s'est levé et découvert. . . . L'Ambassadeur a fait son compliment qui a esté expliqué par l'Interprête, de mesme que la réponse du Roy, le compliment finy, l'Ambassadeur a présenté au Roy la lettre de Sa Ma^te . . . il a aussy présenté le coffret dans lequel estaient les présents, le Roy ne l'a point touché, l'Ambassadeur l'a remis au Marquis de Torcy, puis est descendu au bas des degréz de l'estrade, d'où il a salué le Roy s'inclinant en portant ses deux mains à sa tête, a fait quelques pas tourné du costé du Roy, qu'il a perdu de veüe dans le moment par la foule de courtisans qui ont fermé le passage" (Marie and Marie, 1976, 452).

See ibid., 450, figure 190, for a drawing that shows in plan the arrangement of the throne and platform for the 1715 reception. Figure 191, however, purporting to show the end of the Galerie in elevation, does not accord with the Galerie des Glaces in architectural articulation or in painted decoration.

13. Saint-Simon, 1967–68, II, 405–6.

14. On this provisional church (not to be confused with the old Église Saint-Julien in the Old Town), see Marie and Marie, 1972, I, 155ff. It was located on the present rue de la Paroisse, near the extant Église Notre-Dame.

15. The niche at the first landing was originally filled with a fountain of superposed basins; the antique sculptural group and new fountain shown in figures 34 and 37 replaced the original fountain in 1712 (see chapter IV, n. 105).

16. Cf. *Le Mercure galant,* 1682, 308: "Il y a quelquefois Symphonie, & l'endroit de tout Versailles où elle se fait entendre le plus agreablement, est le grand Escalier du Roy."

17. *Le Mercure galant,* June 1681, 4–11:

. . . [the procession] de Versailles estant preste à sortir de la Paroisse qui est dans la Ville neuve, Sa Majesté s'y rendit pour l'accompagner, suivie de toute la Cour, qui estoit nombreuse & magnifique. Tous les Pages de la Chambre, avec ceux de la Grande & Petite Ecurie, les Cent Suisses, & les Gardes du Corps, portoient chacun un Flambeau de cire blanche. On en compta pres de mille. Les Pages du Roy sont en si grand nombre, qu'on ne doit point s'étonner de celuy que je vous marque. Les Peres de la Mission, les Recolets, & les Aumôniers de toute la Maison Royale, assisterent à cette Procession, qui passa devant la Pompe, & s'y arresta. M^r Denys, Fontenier de Sa Majesté, avoit pris le soin d'y faire dresser un Reposoir d'une façon extraordinaire. C'estoit une Feüillée toute remplie de Cascades d'eau, & de Rocailles. La Procession passa de là dans l'Avantcour du Chasteau, & en suite dans la Court, toutes deux tenduës des plus belles Tapisseries de la Couronne. Tous les Balcons & toutes les Fenestres, jusqu'au comble du Chasteau, estoient parez de Tapis de Perse à fonds d'or & d'argent. On avoit placé le Reposoir au bas du grand & magnifique Escalier. . . . De grands Vases d'argent, remplis de Plantes de Fleurs, avoient esté mis sur les Piédestaux de marbre qui accompagnent les Balustres de bronze doré. On en avoit posé de semblables sur les Corniches & aux autres endroits où de pareils ornemens pouvoient convenir. L'Autel estoit sur la premiere hauteur du Degré, vis-à-vis de la Fontaine. Un Parement de Drap d'or, d'une beauté surprenante, faisoit admirer le devant de cet Autel, dont le Tabernacle qu'on avoit percé à jour, estoit orné de Rubis, d'Emeraudes, & de Diamans. Une Couronne de trois pieds de diametre en faisoit le Dôme. Elle estoit toute de Pierreries, & jettoit un feu si éblouïssant, qu'on avoit peine à en soûtenir l'éclat.

Les Cascades de la Fontaine paroissoient au travers du Tabernacle, & rien n'estoit plus agreable à la veuë que cette Eau & les Pierreries que les Lumieres faisoient briller. Il y avoit de grands Guéridons, avec de grandes Torcheres aux deux costez de l'Autel, ainsi que sur les extrémitez des marches de l'Escalier. La Musique de la Chapelle du Roy estoit placée sur le haut. Il seroit fort mal-aisé de trouver un lieu plus avantageux pour l'Harmonie. Aussi les Instrumens & les Voix y furent-ils entendus avec grand plaisir. Il n'y eut aucun desordre, & tout parut ce jour-là digne de la Cour d'un Roy Tres-Chrestien. La Procession estant sortie du Chasteau, passa devant les superbes Ecuries de Sa Majesté, qui estoient tenduës jusques à la Ville neuve de riches Tapisseries. Ce Prince la remena jusques à l'Eglise, ayant eu la teste nuë pendant trois heures, sans s'estre mesme servy de Parasol contre l'ardeur du Soleil. Il entendit la Grand'Messe à la Paroisse, où tous les soirs de l'Octave il est venu au Salut.

The procession is summarized in Marie and Marie, 1972, I, 156–57.

18. The space occupied today by the room containing the book counter and tourist services (ground floor) and the Salon d'Hercule (first floor).

19. Kimball, 1944, 317ff.; Marie and Marie, 1972, II, 505ff. This was the chapel that preceded the final, extant one.

20. On this broad topic, see Bertholot du Chesnay (1967, with bibliography).

21. On Le Pautre's projects for this altar, see Kimball, 1943, 79ff.; on the executed main altar of the Chapel, see Marie and Marie, 1976, 482 and pl. 202.

22. "Promitto vobis, & perdono, quòd unicuique de vobis, & Ecclesiis vobis commissis canonicum privilegium & debitam legem atque iustitiam servabo, & defensionem quantum potero, adiuvante Domino exhibebo, sicut Rex in suo Regno unicuique Episcopo, & Ecclesiae sibi commissae per rectum exhibere debet" (Godefroy, 1649, I, 59, 360, with French trans. on 360–61).

APPENDIX II

1. Colbert, v, 284–85, doc. 39 (Paris, Archives Nationales, K 899, no. 11 [new classification]).

2. On Carlo Vigarani see Hautecoeur, 1948, II, passim; *Enciclopedia dello spettacolo,* Rome, 1962, IX, cols. 1682–83. Carlo was one of the organizers of the *fête* of 1664 at Versailles (*Les plaisirs de l'isle enchantée*), along with the Duc de Saint-Aignan. He also helped organize the *fête* of 1668.

3. Colbert, v, 285, doc. 39.

4. On Gabriel see Hautecoeur, 1948, I, 644–46; Braham and Smith, 1973, I, 182–83.

5. Colbert, v, 286–87, doc. 39.

6. See chapter II, n. 16. On Claude Perrault see Herrmann, 1973, with bibliographical references to Claude's activity as a designer. A recent contribution is Petzet, 1982.

Charles Perrault, in his *Mémoires* of circa 1700, wrote: "*Dessein donné par mon frère d'un nouveau bâtiment pour Versailles.*—Mon frère eut ordre de faire un dessein de ce bâtiment-là; il en fit un plan et une élévation qui furent très-approuvés non-seulement du Roi, mais de son conseil, où il appella tous les princes, plusieurs ducs et maréchaux de France. Mais le Roi voulut toujours conserver le petit château" (Perrault, 1909, 112). This passage would seem to apply to the competition of 1669.

Bibliography

Abbreviations of Periodicals:
AB The Art Bulletin
BM The Burlington Magazine
BSHAF Bulletin de la société de l'histoire de l'art français
GBA Gazette des beaux-arts
JSAH Journal of the Society of Architectural Historians
RAAM La revue de l'art ancien et moderne
RHV Revue de l'histoire de Versailles et de Seine-et-Oise
ZfK Zeitschrift für Kunstgeschichte

Ackerman, J.S. "Sources of the Renaissance Villa." In
 The Renaissance and Mannerism. Studies in Western
 Art: Acts of the Twentieth International Congress of
 the History of Art. Princeton, 1963, II, 6–18.
Alberti, L.B. Ten Books on Architecture. Trans. J. Leoni.
 Ed. J. Rykwert. London, 1955. (Written ca.
 1450. 1st ed. Florence, 1485.)
Babelon, J.P. Demeures parisiennes sous Henri IV et Louis
 XIII. Paris. 1965.
Bacou, R. "Cartons et dessins de Le Brun pour
 l'Escalier des Ambassadeurs, au Musée du
 Louvre." In D. de Hoop Scheffer et al., eds.,
 Liber amicorum Karel G. Boon. Amsterdam, 1974,
 13–27.
Baillie, H.M. "Etiquette and the Planning of the State
 Apartments in Baroque Palaces." Archaeologia,
 CI, 1967, 169–99.
Batiffol, L. "L'origine du château de Versailles." La
 revue de Paris, XVI, 2, 1909, 841–69.
———. Le roi Louis XIII à vingt ans. Paris, [1910].

———. "Le château de Versailles de Louis XIII et son
 architecte Philibert Le Roy." GBA, ser. 4, X,
 1913, 341–71.
Battisti, E., et al. "Astronomy and Astrology." Encyclo-
 pedia of World Art. New York, Toronto, Lon-
 don, 1960, II, cols. 39–88.
Berger, R.W. Antoine Le Pautre: A French Architect of the
 Era of Louis XIV. New York, 1969.
———. "Charles Le Brun and the Louvre Colonnade."
 AB, LII, 1970, 394–403.
———. Review of W. Prinz, Die Entstehung der Galerie
 in Frankreich und Italien (Berlin, 1970), in AB, LV,
 1973, 459–60.
———. "Louis Le Vau's Château du Raincy." Architec-
 tura, VI, 1, 1976, 36–46.
———. "Rubens's 'Queen Tomyris with the Head of
 Cyrus.'" Bulletin of the Museum of Fine Arts,
 Boston, LXXVII, 1979, 4–35.
———. "The Chronology of the Enveloppe of Ver-
 sailles." Architectura, X, 2, 1980, 105–33.
———. "Versailles in Verse: Some Notes on Claude
 Denis' 'Explication.'" Journal of Garden History,
 IV, 1984, 127–38.
Berthelot du Chesnay, C. "Gallicanism." New Catholic
 Encyclopedia, New York etc., 1967, VI, 262–67.
Blondel, J.F. Architecture françoise. 4 vols. Paris, 1752–
 56.
Blunt, A. François Mansart and the Origins of French
 Classical Architecture. London, 1941.
———. Review of A. Laprade, François d'Orbay, archi-

tecte de Louis XIV (Paris, 1960), in *BM*, CIII, 1961, 190–91.

———. *Art and Architecture in France, 1500 to 1700*. 2nd ed. Baltimore, 1970.

Böhmker, R. "Spiegel-Räume im Zeitalter Ludwigs XIV: Ein Beitrag zur Entwicklung und Bedeutung des Spiegels in Barock." Ph.D. Diss., University of Vienna, 1946.

Bouret, B. "L'ambassade persane à Paris en 1715 et son image." *GBA*, ser. 6, C, 1983, 109–30.

Braham, A., and Smith, P. *François Mansart*. 2 vols. London, 1973.

Braham, A., and Whiteley, M. "Louis Le Vau's Projects for the Louvre and the Colonnade—II." *GBA*, ser. 6, LXIV, 1964, 347–62.

Brice, G. *Description nouvelle de la ville de Paris*. . . .3rd ed. 2 vols. Paris, 1698.

Briganti, G. *Il Palazzo del Quirinale*. Rome, 1962.

Brown, J., and Elliott, J.H. *A Palace for a King. The Buen Retiro and the Court of Philip IV*. New Haven and London, 1980.

Browne, E. *Journal of a Visit to Paris in the Year 1664*. Ed. G. Keynes. London, 1923.

Büttner, F. Review of W. Prinz, *Die Entstehung der Galerie in Frankreich und Italien* (Berlin, 1970), in *Architectura*, II, 1, 1972, 75–80.

Campbell, M. *Pietro da Cortona at the Pitti Palace*. Princeton, 1977.

Carducho, V. *Diálogos de la pintura*. Madrid, 1633.

Champigneulle, B. Review of A. Laprade, *François d'Orbay, architecte de Louis XIV* (Paris, 1960), in *GBA*, ser. 6, LVI, 1960, 244–45.

Chantelou, P. Fréart de. *Journal du voyage du Cavalier Bernin en France*. Ed. L. Lalanne. Paris, 1885 [1665].

Charles Le Brun, 1619–1690, peintre et dessinateur. Versailles, 1963.

Charpentier, F. *Explication des tableaux de la galerie de Versailles*. Paris, 1684.

Chastel, A. Review of A. Laprade, *François d'Orbay, architecte de Louis XIV* (Paris, 1960), in *Art de France*, I, 1961, 321.

Colbert, J. B. *Lettres, instructions et mémoires de Colbert*. Ed. P. Clément. 7 vols. Paris, 1861–70.

Collections de Louis XIV, dessins, albums, manuscrits. Paris, 1977.

Collins, P. *Concrete: The Vision of a New Architecture*. London, 1959.

Combes (le sieur). See Morellet, L.

Comptes des bâtiments du roi sous le règne de Louis XIV. Ed. J. Guiffrey. 5 vols. Paris, 1881–1901.

Constans, C. "Les tableaux du Grand Appartement du Roi." *La revue du Louvre et des musées de France*, XXVI, 1976, 157–73.

Cottard, P. *Recueil des oeuvres du Sieur Cottart*. Paris, n.d.

Coüard, E. "L'intérieur et le mobilier du château royal de Versailles à la date de la Journée des Dupes." *RHV*, VIII, 1906, 97–122, 198–216.

Courajod, L. *Jean Warin. Ses oeuvres de sculpture et le buste de Louis XIII du Musée du Louvre*. Paris, 1881.

Coural, J. "Documents inédits sur le premier château de Versailles (1623–1629)." *BSHAF*, 1959, 135–43.

Crelly, W. *The Painting of Simon Vouet*. New Haven and London, 1962.

Denis, C. *Explication de toutes les grottes, rochers et fontaines du chasteau royal de Versailles, maison du soleil, et de la Ménagerie. En vers héroïques*. (ca. 1675.) Paris, Bibliothèque Nationale, ms. fr. 2348. (See Raynal, M.)

Dreyer, J.L.E. *A History of Astronomy from Thales to Kepler*. 2nd ed. New York, 1953.

Dudley, D.R. *Urbs Roma*. New York, 1967.

Dumolin, M. "Notes sur quelques architectes du XVII^e siècle." *BSHAF*, 1930, 11–22.

Félibien, A. *Description de la grotte de Versailles*. Paris, 1672.

———. *Description sommaire du chasteau de Versailles*. Paris, 1674. [Printed on December 30, 1673.]

———. *Recueïl de descriptions de peintures et d'autres ouvrages faits pour le Roy*. Paris, 1689.

Fontaine, A., ed. *Conférences inédites de l'Académie royale de peinture et de sculpture*. Paris, n.d.

Forster, K.W. "Back to the Farm. Vernacular Architecture and the Development of the Renaissance Villa." *Architectura*, IV, 1, 1974, 1–12.

Frommel, C.L. *Die Farnesina und Peruzzis architektonisches Frühwerk*. Berlin, 1961.

———. *Der römische Palastbau der Hochrenaissance*. 3 vols. Tübingen, 1973.

Godefroy, T., ed. *Le ceremonial françois*. 2 vols. Paris, 1649.

Goldstein, C. "Studies in Seventeenth Century French Art Theory and Ceiling Painting." *AB*, XLVII, 1965, 231–56.

Grand Escalier. Versailles, Bibliothèque Municipale, ms. 138G, fols. 127r–134v.

Guiffrey, J., and Marcel, P. *Inventaire général des dessins du Musée du Louvre et du Musée de Versailles: École française*. 10 vols. Paris, 1907–28.

Hautecoeur, L. *Le Louvre et les Tuileries de Louis XIV*. Paris and Brussels, 1927.

———. *Histoire de l'architecture classique en France: I La formation de l'idéal classique*. 2 vols. Paris, 1943.

———. *Histoire de l'architecture classique en France: II Le règne de Louis XIV*. 2 vols. Paris, 1948.

———. "François d'Orbay." *Journal des savants*, April–June 1960, 59–66.

Herrmann, W. *The Theory of Claude Perrault*. London, 1973.

Hillairet, J. *Dictionnaire historique des rues de Paris*. 2nd ed. 2 vols. Paris, 1963.

Hoffmann, V. Review of W. Prinz, *Die Entstehung der Galerie in Frankreich und Italien* (Berlin, 1970), in *Architectura*, I, 1, 1971, 102–12.

Huygens, C. *Oeuvres complètes de Christiaan Huygens*. 22 vols. The Hague, 1888–1950.

Jal, A. *Dictionnaire critique de biographie et d'histoire*. 2nd ed. Paris, 1872.

Johnson, K.O. "Il n'y a plus de Pyrénées: The Iconography of the First Versailles of Louis XIV." *GBA*, ser. 6, XCVII, 1981, 29–40.

Josephson, R. "Quelques dessins de Claude Perrault pour le Louvre." *GBA*, ser. 5, XVI, 1927, 171–92.

Jouin, H. *Charles Le Brun et les arts sous Louis XIV*. Paris, 1889.

Kalnein, W. Graf. Review of A. Laprade, *François d'Orbay, architecte de Louis XIV* (Paris, 1960), in *ZfK*, XXV, 1962, 184–90.

Keller, A.G. "Perrault, Claude." In C.C. Gillispee, ed., *Dictionary of Scientific Biography*. New York, 1974, X, 519–21.

Keller-Dorian, G. *Antoine Coysevox (1640–1720)*. 2 vols. Paris, 1920.

Kimball, F. "Mansart and Le Brun in the Genesis of the Grande Galerie de Versailles." *AB*, XXII, 1940, 1–6.

———. *The Creation of the Rococo*. Philadelphia, 1943.

———. "The Chapels of the Château of Versailles." *GBA*, ser. 6, XXVI, 1944, 315–32.

———. "The Genesis of the Château Neuf at Versailles, 1668–1671—I The Initial Projects of Le Vau." *GBA* ser. 6, XXXV, 1949, 353–72.

———. "The Genesis of the Château Neuf at Versailles, 1668–1671—II The Grand Escalier." *GBA*, ser. 6, XL, 1952, 115–22.

Kuraszewski, G. "La cheminée du Salon de la Guerre au château de Versailles. Sa création et ses transformations successives." *BSHAF*, 1974, 63–69.

La Fontaine, J. de. *Les amours de Psyché et de Cupidon*. Paris, 1669. (*Privilège du roi*: May 2, 1668.)

———. *Oeuvres de J. de La Fontaine*. Ed. H. Regnier. 11 vols. Paris, 1883–92.

Langner, J. "Zum Entwurf der französischen Ordnung von Le Brun." In *Kunstgeschichtliche Studien für Kurt Bauch zum 70. Geburtstag von seinen Schülern*. Berlin, 1967, 233–40.

———. "Die Deckenbilder der Spiegelgalerie im Schloss von Versailles." *Kunstgeschichtliche Gesellschaft zu Berlin: Sitzungberichte*, n.s., XIX, 1970/71, 9–11.

Laprade, A. *François d'Orbay, architecte de Louis XIV*. Paris, 1960.

[Le Fevre, L.C.] *Grand escalier du château de Versailles, dit Escalier des Ambassadeurs*. Paris, 1725.

Le Guillou, J.C. "Remarques sur le corps central du château de Versailles." *GBA*, ser. 6, LXXXVII, 1976, 49–60.

———. "Aperçu sur un projet insolite (1668) pour le château de Versailles." *GBA*, ser. 6, XCV, 1980, 49–58.

———. "Le Château-Neuf ou Enveloppe de Versailles. Conception et évolution du premier projet." *GBA*, ser. 6, CII, 1983, 193–207.

Lehmann, K. "The Dome of Heaven." *AB*, XXVII, 1945, 1–27.

Lemonnier, H., ed. *Procès-verbaux de l'Académie royale d'architecture*. 10 vols. Paris, 1911–29.

Le Rouge, G.L. *Les curiositez de Paris, de Versailles, de Marly, de Vincennes, de S. Cloud, et des environs. . . .*Paris, 1716.

Lorne. "Explication de la galerie de Versailles." *Le Mercure galant*, December 1684, 3–85.

Lossky, B. Review of W. Prinz, *Die Entstehung der Galerie in Frankreich und Italien* (Berlin, 1970), in *GBA*, ser. 6, LXXVII, 1971, 26 ("La chronique des arts").

MacDonald, W.L. *The Architecture of the Roman Empire I: An Introductory Study*. New Haven and London, 1965.

Mâle, É. "La clef des allégories peintes et sculptées au XVII^e et au XVIII^e siècle—II En France." *Revue des deux mondes*, ser. 7, XXXIX, 1927, 375–94.

Margry, P. *Un fils de Colbert. Étude suivie de la correspondance du marquis d'Ormoy avec son père concernant les bâtiments du palais de Versailles et les travaux faits dans les environs (1663–1704)*. Paris, 1873.

Marie, A. "Le premier château de Versailles construit par Le Vau en 1664–1665." *BSHAF*, 1952, 50–55.

———. *Naissance de Versailles. Le château. Les jardins*. 2 vols. Paris, 1968.

Marie, A., and Marie, J. *Mansart à Versailles*. 2 vols. Paris, 1972.

———. *Versailles au temps de Louis XIV*. Paris, 1976.

Martin, J.R. *The Farnese Gallery*. Princeton, 1965.

Massé, J.B. *La Grande Galerie de Versailles. . . .*Paris, 1753.

Mauricheau-Beaupré, C. "Un document inconnu sur les premiers travaux de Louis XIV à Versailles. La 'basse cour' de 1662." *RHV*, XXXV, 1933, 31–40.

Mazerolle, F. *Jean Varin*. 2 vols. Paris, 1932.

Meeks, C.L.V. Review of A. Laprade, *François d'Orbay, architecte de Louis XIV* (Paris, 1960), in *JSAH*, XXI, 1962, 43.

Michon, E. "Centaure marin et Silène. Groupe antique du Musée du Louvre." *RAAM*, XIX, 1906, 389–96.

Moisy, P. "Note sur la Galerie des Glaces." *XVII^e siècle*, no. 53, 1961, 42–50.

Montagu, J. "The Early Ceiling Decorations of Charles Le Brun." *BM*, CV, 1963, 395–408.

Morellet, L. *Explication historique, de ce qu'il y a de plus remarquable dans la maison royale de Versailles, et en celle de Monsieur à Saint Cloud*. Paris, 1681. (*Privilège du roi*: November 7, 1680. Approved by the painters Noël Coypel and Antoine Paillette [Paillet] on October 30, 1680; approved by the sculptors Thomas Regnaudin and Antoine Coysevox on November 2, 1680.)

Nivelon, C. *Vie de Charles Le Brun & description détaillée de ses ouvrages*. Paris, Bibliothèque Nationale, ms. fr. 12987. [ca. 1700.]

Nolhac, P. de. "L'art de Versailles. L'Escalier des Ambassadeurs." *RAAM*, VIII, 1900, 54–68.

———. *La création de Versailles*. Versailles, 1901.

———. "L'art de Versailles. La Galerie des Glaces (premier article)." *RAAM*, XIII, 1903a, 177–91.

———. "L'art de Versailles. La Galerie des Glaces (deuxième article)." *RAAM*, XIII, 1903b, 279–90.

———. *Histoire du château de Versailles*. 2 vols. Paris, 1925.

Orso, S.N. "In the Presence of the 'Planet King': Studies in Art and Decoration at the Court of Philip IV of Spain." 2 vols. Ph.D. Diss., Princeton University, 1978.

Palladio, A. *The Four Books of Architecture.* Trans. I. Ware. Introduction by A.K. Placzek, New York, 1965. (1st ed. Venice, 1570.)

Panofsky, D., and Panofsky, E. *Pandora's Box. The Changing Aspects of a Mythical Symbol.* New ed. New York, 1965.

Pérate, A. "Les portraits de Louis XIV au Musée de Versailles." *Mémoires de la société des sciences morales, des lettres, et des arts de Seine-et-Oise,* xx, 1896, 1–16.

Pérouse de Montclos, J.M. "Le sixième ordre d'architecture, ou la pratique des ordres suivant les nations." *JSAH,* xxxvi, 1977, 223–40.

Perrault, Ch. *Parallèle des anciens et des modernes en ce qui regarde les arts et les sciences.* 4 vols. Paris, 1688–97.

———. *Mémoires de ma vie.* Ed. P. Bonnefon. Paris, 1909. (ca. 1700.)

Petzet, M. "Claude Perrault als Architekt des Pariser Observatoriums." *ZfK,* xxx, 1967, 1–54.

———. "Das Triumphbogenmonument für Ludwig XIV. auf der Place du Trône." *ZfK,* xLV, 1982, 145–94.

Piganiol de La Force, J.A. *Nouvelle description des chasteaux et parcs de Versailles et de Marly.* Paris, 1701. (*Privilège du roi:* December 22, 1700.)

Préaud, M. *Sébastien Leclerc* (Bibliothèque Nationale [Paris], Département des Estampes. Inventaire du fonds français. Graveurs du XVIIᵉ siècle, vols. 8, 9). 2 vols. Paris, 1980.

Prinz, W. *Die Entstehung der Galerie in Frankreich und Italien.* Berlin, 1970.

———. Reply to reviews by V. Hoffmann and F. Büttner of *Die Entstehung der Galerie in Frankreich und Italien* (Berlin, 1970), in *Architectura,* II, 2, 1972, 195–96.

Pühringer-Zwanowetz, L. "Ein Entwurf Berninis für Versailles." *Wiener Jahrbuch für Kunstgeschichte,* xxIx, 1976, 101–19.

Rainssant, P. *Explication des tableaux de la galerie de Versailles, et de ses deux sallons.* Versailles, 1687.

Raynal, M. "Le manuscrit de C. Denis, fontainier de Louis XIV, à Versailles." *Versailles,* nos. 36–44, 1969–71. (See Denis, C.)

Revel, J.F. "L'Escalier des Ambassadeurs." *Connaissance des arts,* no. 74, April 1958, 71–77.

Rose, H. *Spätbarock. Studien zur Geschichte des Profanbaues in den Jahren 1660–1760.* Munich, 1922.

Rosenberg, J. *Rembrandt, Life & Work.* Rev. ed. London, 1964.

Rubens, P.P. *I palazzi di Genova.* Antwerp, 1622.

Rule, J.C. "Louis XIV, Roi-Bureaucrate." In J.C. Rule ed., *Louis XIV and the Craft of Kingship.* Columbus, 1969, 3–101.

Saint-Aignan, Duc de. "Sur la beauté des apartemens du Roy à Versailles, & sur les divertissemens que Sa Majesté y donne à toute sa cour." *Le Mercure galant,* November 1682, 359–67.

Saint-Simon, Duc de. *Mémoires.* New ed. Ed. A. de Boislisle. 41 vols. Paris, 1879–1928.

———. *Historical Memoirs of the Duc de Saint-Simon. A Shortened Version.* Ed. and trans. L. Norton. 2 vols. London, 1967–68.

Sauval, H. *Histoire et recherches des antiquités de la ville de Paris.* 3 vols. Paris, 1724. [Mainly written ca. 1650–70.]

Schnapper, A. "Colonna et la 'quadratura' en France à l'époque de Louis XIV." *BSHAF,* 1966, 65–97.

———. *Jean Jouvenet 1644–1717 et la peinture d'histoire à Paris.* Paris, 1974.

Scoville, W.C. *Capitalism and French Glassmaking, 1640–1789.* University of California Publications in Economics. Vol. 15. Berkeley and Los Angeles, 1950.

Scudéry, M. de. *La promenade de Versailles.* Paris, 1669. (*Privilège du roi:* March 16, 1669. Republished as *Célanire.* Paris, 1671.)

———. *Conversations nouvelles sur divers sujets.* 2 vols. Paris, 1684.

Souchal, F. "Les statues aux façades du château de Versailles." *GBA,* ser. 6, LxxIx, 1972, 65–110.

———. *French Sculptors of the 17th and 18th Centuries. The Reign of Louis XIV.* 2 vols. published. Oxford, 1977–. Vol. 3 forthcoming.

Sources, Marquis de. *Mémoires du marquis de Sources.* Ed. le Comte de Cosnac, A. Bertrand, and E. Pontal. 13 vols. Paris, 1882–93.

Stimson, D. *The Gradual Acceptance of the Copernican Theory of the Universe.* Gloucester, Mass., 1972 (1st ed. New York, 1917.)

Tadgell, C. "Claude Perrault, François Le Vau and the Louvre Colonnade." *BM,* cxxII, 1980, 326–37.

Taton, R. "Cassini, Gian Domenico." In C.C. Gillispee, ed., *Dictionary of Scientific Biography.* New York, 1971, III, 100–104.

Tervarent, G. de. *Attributs et symboles dans l'art profane 1450–1600.* 2 vols. Geneva, 1958–64.

Tessin, N. "Relation de la visite de Nicodème Tessin à Marly, Versailles, Clagny, Rueil et Saint-Cloud en 1687." Ed. P. Francastel. *RHV,* xxvIII, 1926, 149–67, 274–88.

Teyssèdre, B. *L'art au siècle de Louis XIV.* Paris, 1967.

Thornton, P. *Seventeenth-Century Interior Decoration in England, France and Holland.* New Haven and London, 1978.

Thuillier, J. "Peinture et politique: Une théorie de la galerie royale sous Henri IV." In A. Châtelet and N. Reynaud, eds., *Études d'art français offertes à Charles Sterling.* Paris, 1975, 175–205.

Thuillier, J., and Foucart, J. *Rubens' Life of Marie de' Medici.* New York, [1970].

Tooth, F.C. "The Private Houses of Louis Le Vau." Ph.D. Diss., University of London, 1961.

Utz, H. "The *Labors of Hercules* and Other Works by Vincenzo de' Rossi." *AB,* LIII, 1971, 344–66.

Vacquier, J. *L'Hôtel Lambert*. 2nd ed. Paris, 1914. (F. Contet, *Les vieux hôtels de Paris,* ser. 9.)

Vasari, G. *Le vite de' più eccellenti pittori, scultori ed architettori*. . . . Ed. G. Milanesi. 9 vols. Florence, 1906. (1st ed. Florence, 1550; 2nd ed. Florence, 1568.)

Vaudoyer, J.L. *Les peintres provençaux de Nicolas Froment à Paul Cézanne*. Paris, 1947.

Verlet, P. *Versailles*. Paris, 1961.

Vertron, C.C.G. de. *Le nouveau Pantheon*. . . .Paris, 1686.

Vitruvius. *On Architecture*. Trans. F. Granger. 2 vols. Cambridge, Mass. and London, 1931. (Loeb Classical Library.)

Vitzthum, W. *Charles Le Brun e la sua scuola a Versailles*. Milan and Geneva, 1965.

Volk, M.C. "Rubens in Madrid and the Decoration of the Salon Nuevo in the Palace." *BM,* CXXII, 1980, 168–80.

Walton, G. " 'L'enveloppe' de Versailles: Réflexions nouvelles et dessins inédits." *BSHAF,* 1977, 127–44.

Weber, G. "Die Versailles-Konzepte von André Le Nôtre." *Münchner Jahrbuch der bildenden Kunst,* ser. 3, XX, 1969, 207–18.

Weigert, R.A., and Hernmarck, C., eds. *Les relations artistiques entre la France et la Suède 1693–1718: Nicodème Tessin le jeune et Daniel Cronström, correspondance (extraits)*. Stockholm, 1964.

Wildenstein, D. "Les oeuvres de Charles Le Brun d'après les gravures de son temps." *GBA,* ser. 6, LXVI, 1965, 1–58.

Wilkinson, C. "The Escorial and the Invention of the Imperial Staircase." *AB,* LVII, 1975, 65–90.

Wolf, J.B. *Louis XIV*. New York, 1968.

Index

Illustrations

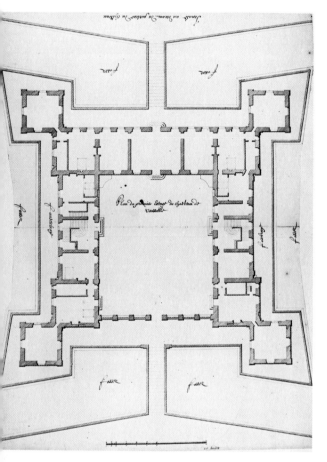

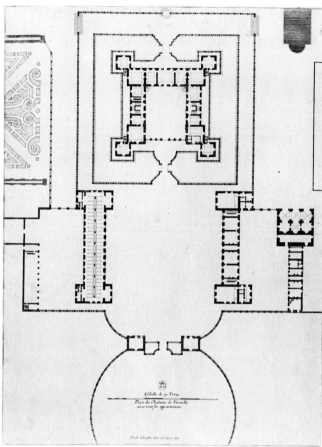

FIG. 1. Petit Château, Versailles, Plan, ca. 1662.
Bibliothèque Nationale, Paris, Cabinet des Estampes, Va
422

FIG. 2. Petit Château, Versailles, Plan. Engraving by
ISRAEL SILVESTRE, 1667

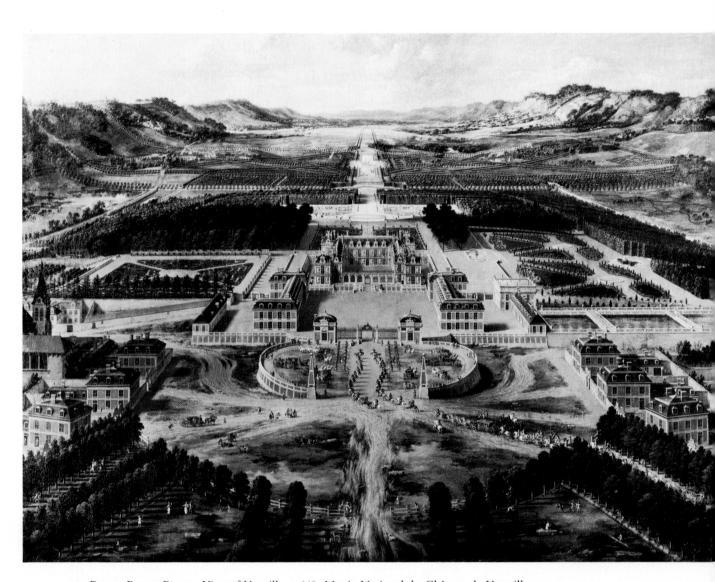

FIG. 3. PIERRE PATEL, *View of Versailles,* 1668. Musée National du Château de Versailles

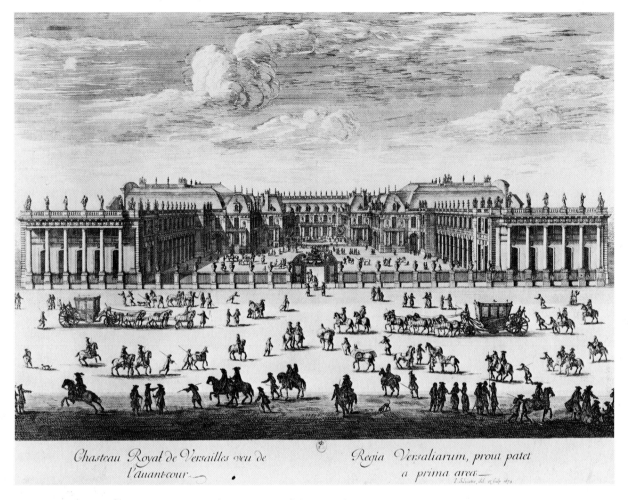

Fig. 4. Château, Versailles, Entrance Side. Engraving by Israel Silvestre, 1674

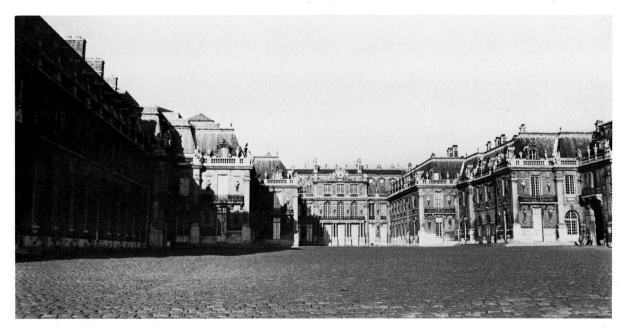

Fig. 5. Château, Versailles, Entrance Side

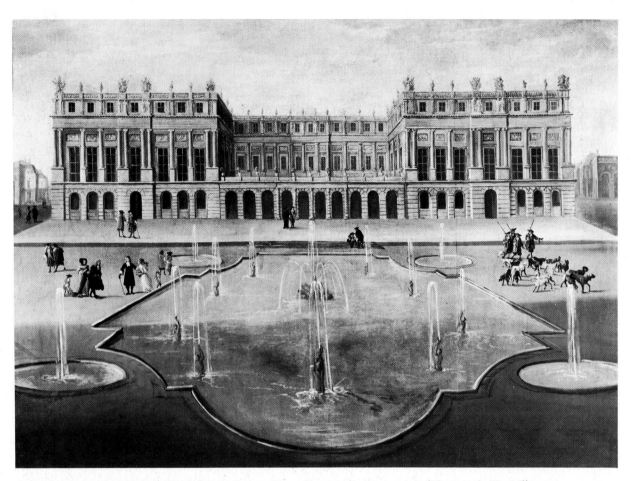

FIG. 6. ANONYMOUS, *Western Façade of Enveloppe of Versailles*. Musée National du Château de Versailles

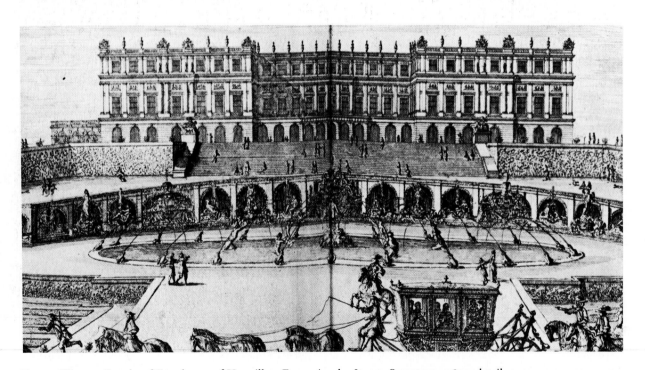

FIG. 7. Western Façade of Enveloppe of Versailles. Engraving by ISRAEL SILVESTRE, 1674, detail

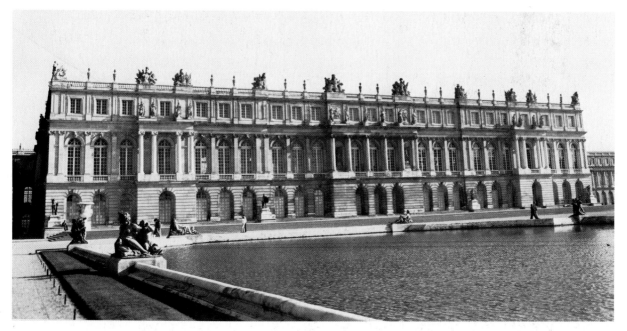

FIG. 8. Western Façade of Enveloppe of Versailles with Modifications by JULES HARDOUIN-MANSART

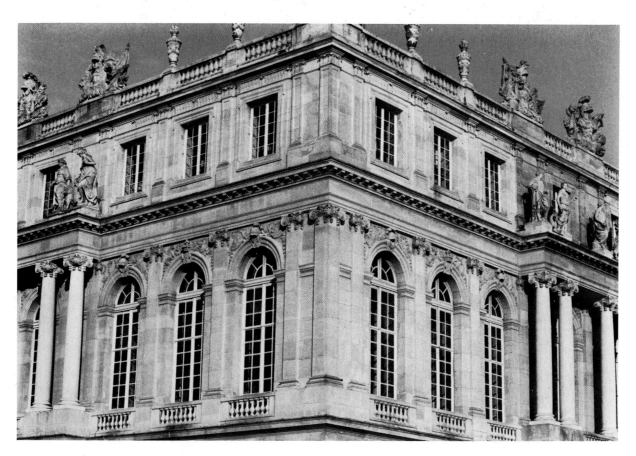

FIG. 9. Detail of fig. 8

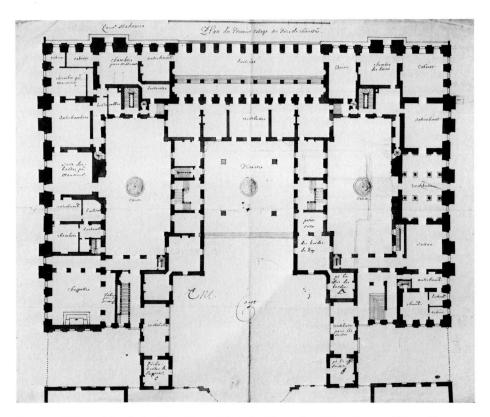

FIG. 10. Office of Louis Le Vau, Plan of Rez-de-Chaussée of Enveloppe of Versailles.
Louvre, Paris, Cabinet des Dessins, Inv. 30.278

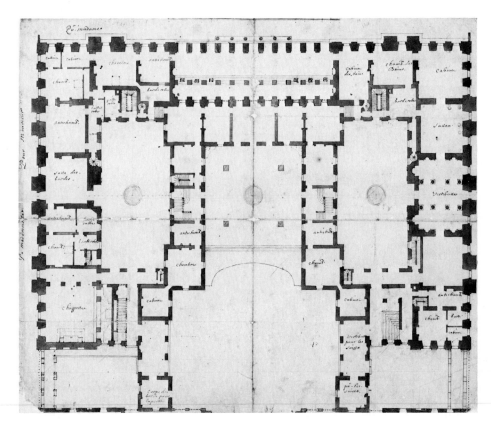

FIG. 11. Office of Louis Le Vau, Plan of Rez-de-Chaussée of Enveloppe of Versailles.
Archives Nationales, Paris, 0¹ 1766¹, no. 1

FIG. 12. Office of François d'Orbay, Plan of Premier Étage of Enveloppe.
Nationalmuseum, Stockholm, CC 74

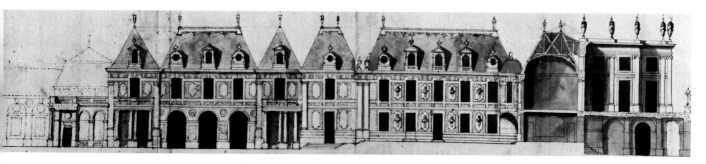

FIG. 13. Office of Louis Le Vau, Versailles, Elevation and Section, with Project for Enveloppe Elevation.
Nationalmuseum, Stockholm, CC 271

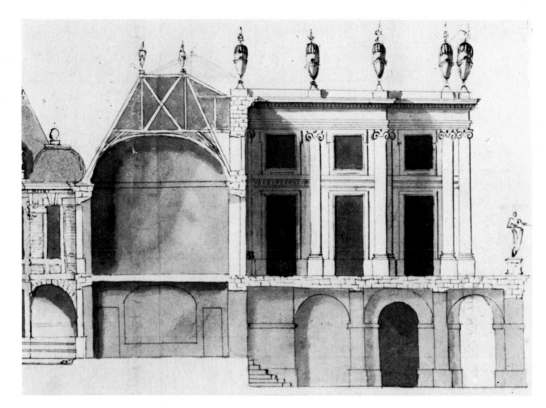

Fig. 14. Detail of fig. 13

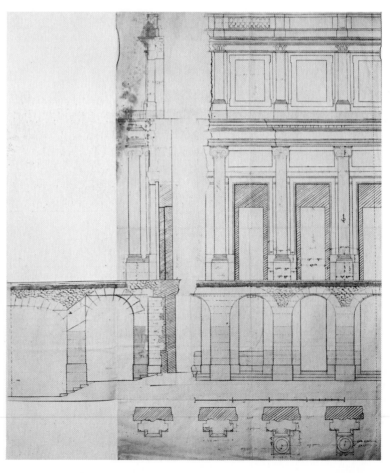

Fig. 15. Studies for Enveloppe Elevation. Nationalmuseum, Stockholm, CC 35

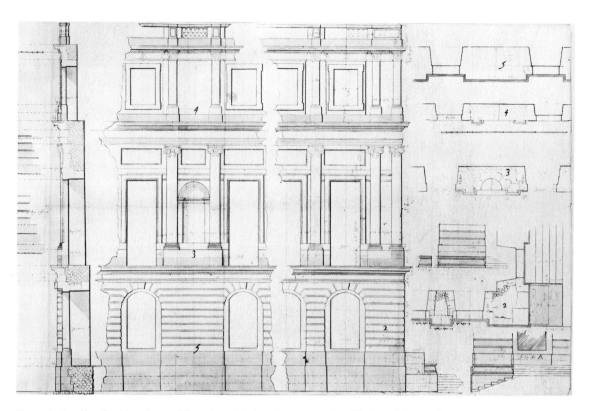

FIG. 16. Studies for Enveloppe Elevation. Nationalmuseum, Stockholm, CC 36, alternate version

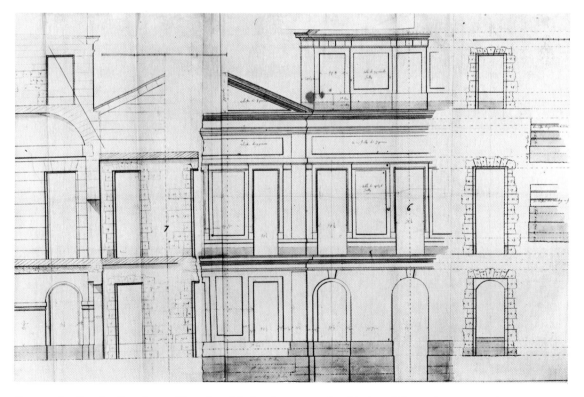

FIG. 17. Studies for Enveloppe Elevation. Nationalmuseum, Stockholm, CC 36, alternate version

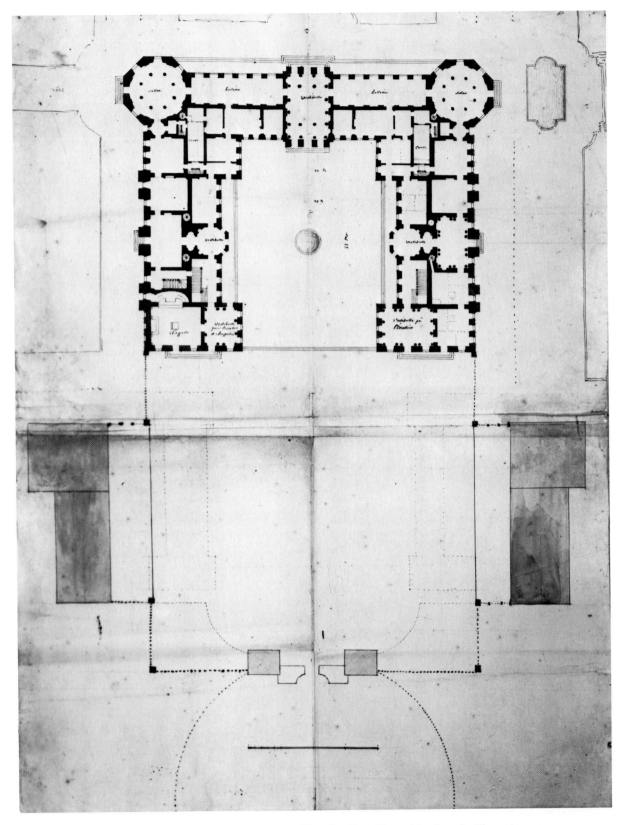

FIG. 18. Office of Louis Le Vau, Revised Competitive Plan for Versailles, 1669, Rez-de-Chaussée.
Nationalmuseum, Stockholm, THC 2392

FIG. 19. LOUIS LE VAU, Rotundas of Mars and Apollo, Louvre, Paris

FIG. 20. GIOVANNI VASANZIO, Villa Borghese, Rome

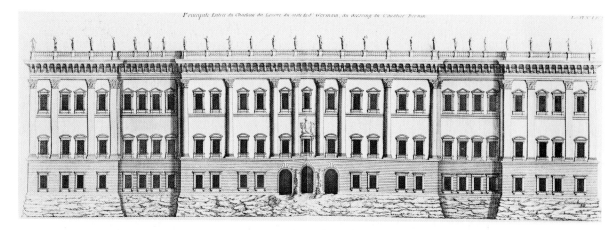

Fig. 21. Gianlorenzo Bernini, Third Project for the East Façade of the Louvre, Paris. Engraving by Jean Marot

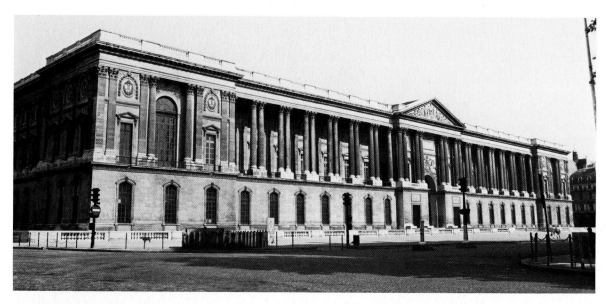

Fig. 22. Louvre Colonnade, Paris

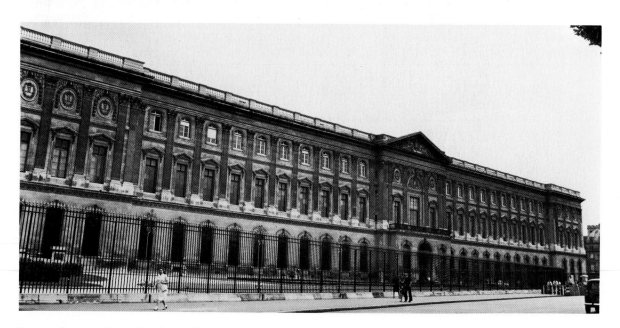

Fig. 23. Louvre, Paris, South Façade

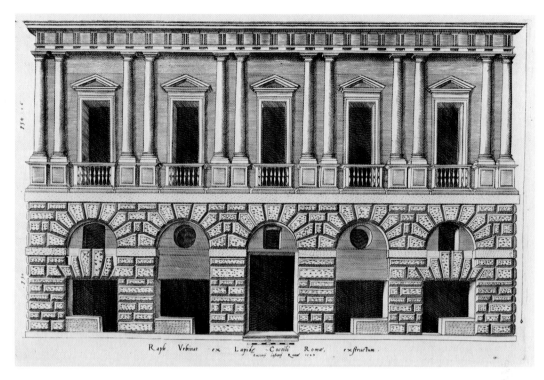

FIG. 24. DONATO BRAMANTE, Palazzo Caprini, Rome. Engraving by ANTONIO LAFRERI, 1549

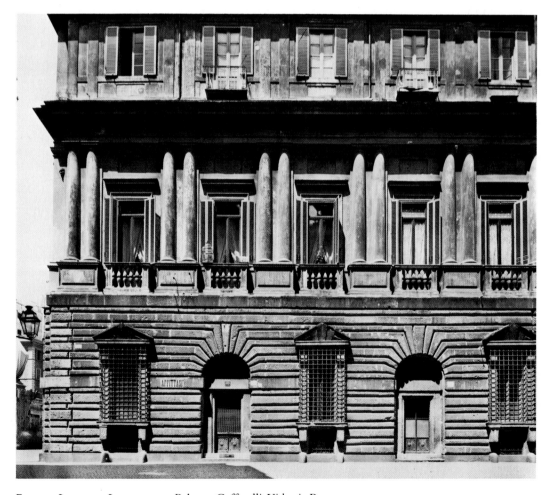

FIG. 25. LORENZO LORENZETTI, Palazzo Caffarelli-Vidoni, Rome

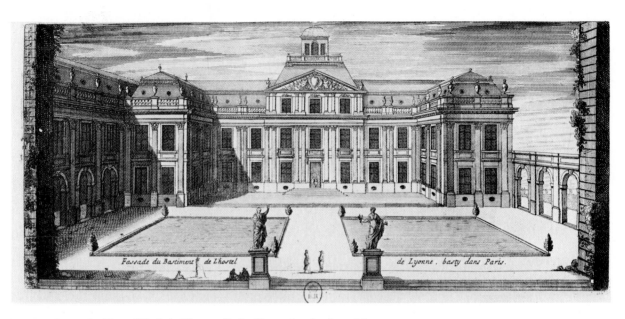

FIG. 26. LOUIS LE VAU, Hôtel de Lionne, Paris. Engraving by JEAN MAROT

FIG. 27. FRANÇOIS D'ORBAY, Project for a Stair, S. Trinità dei Monti, Rome.
Bibliothèque Nationale, Paris, Cabinet des Estampes, Réserve, B II

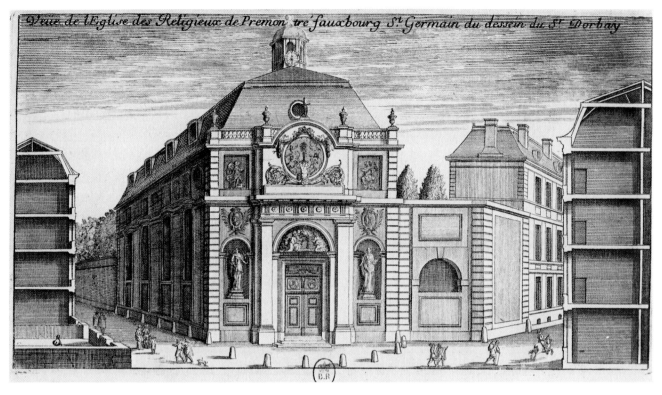

FIG. 28. FRANÇOIS D'ORBAY, Chapelle des Prémontrés, Paris. Engraving by JEAN MAROT

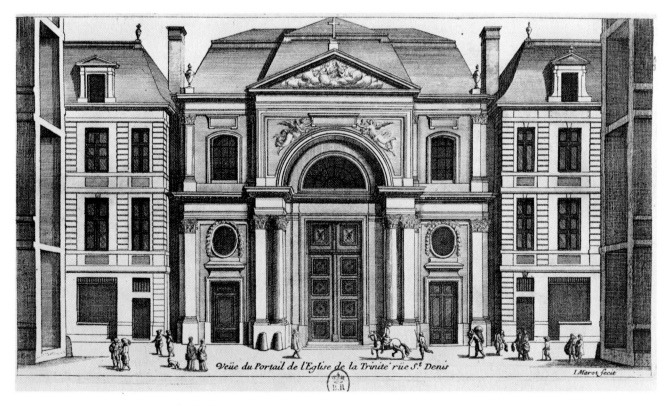

FIG. 29. FRANÇOIS D'ORBAY, Chapelle de la Trinité, Paris. Engraving by JEAN MAROT

FIG. 30. Office of François d'Orbay, Salon Project, Château, Versailles. Bibliothèque de l'Institut, Paris, ms. 1307

FIG. 31. Office of François d'Orbay, Project for the King's Stair, Château, Versailles. Bibliothèque de l'Institut, Paris, ms. 1307

FIG. 32. Office of François d'Orbay, Section of North Wing, Château, Versailles. Bibliothèque de l'Institut, Paris, ms. 1307

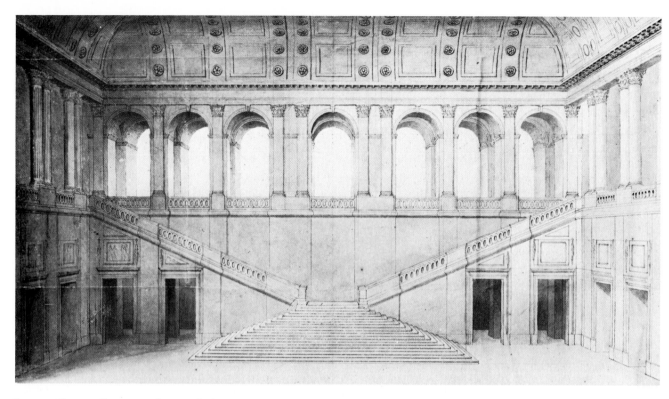

FIG. 33. CLAUDE PERRAULT, Louvre Stair Project. Nationalmuseum, Stockholm, THC 2203

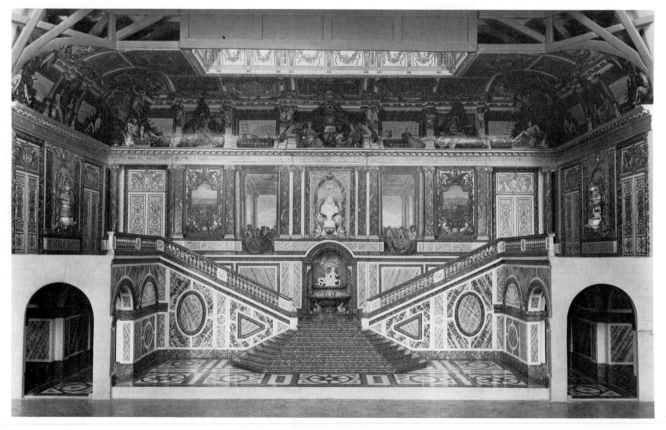

FIG. 34. Escalier des Ambassadeurs. Model by ARQUINET. Château de Versailles

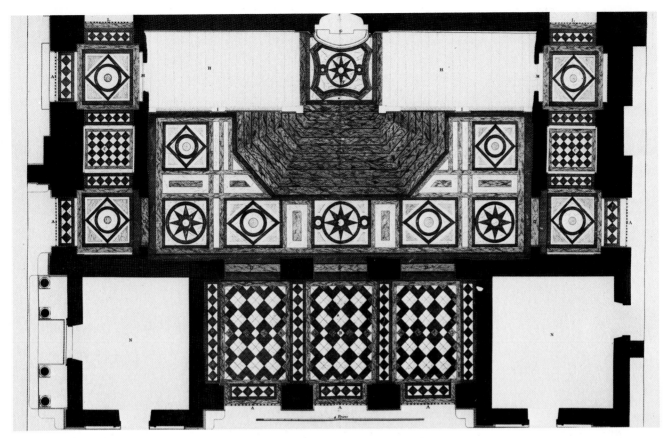

Fig. 35. Escalier des Ambassadeurs. Plan. Engraving by L. Surugue after J.M. Chevotet from [L.C. Le Fevre], *Grand escalier du château de Versailles, dit Escalier des Ambassadeurs,* Paris, 1725

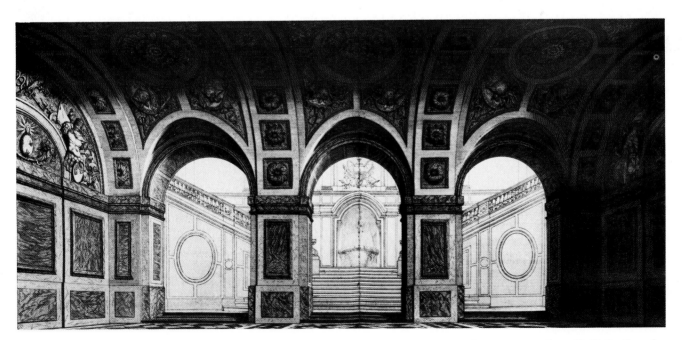

Fig. 36. Escalier des Ambassadeurs. Vestibule. Engraving by L. Surugue after J.M. Chevotet, 1723 from [L.C. Le Fevre], *Grand escalier du château de Versailles, dit Escalier des Ambassadeurs,* Paris, 1725

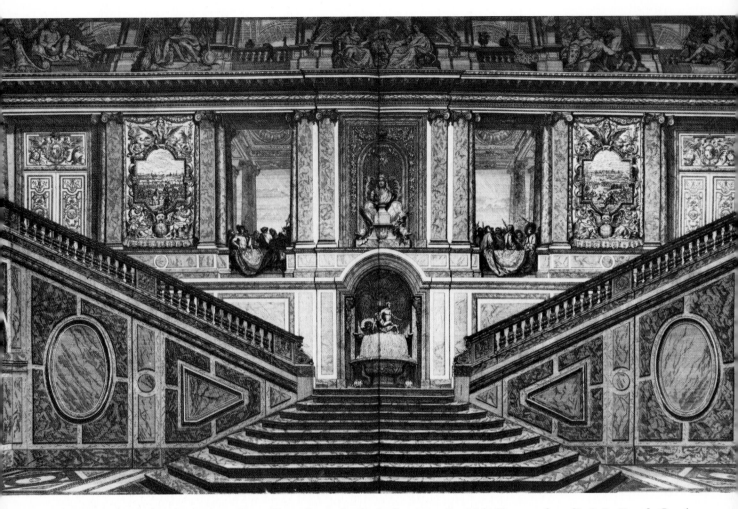

FIG. 37. Escalier des Ambassadeurs. View. Engraving by L. SURUGUE after J.M. Chevotet from [L.C. Le Fevre], *Grand escalier du château de Versailles, dit Escalier des Ambassadeurs,* Paris, 1725

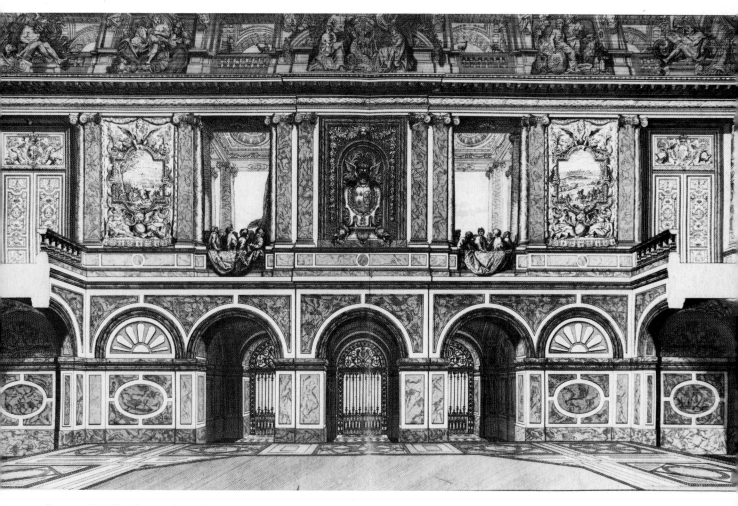

FIG. 38. Escalier des Ambassadeurs. View. Engraving by L. Surugue after J.M. Chevotet from [L.C. Le Fevre], *Grand escalier du château de Versailles, dit Escalier des Ambassadeurs*, Paris, 1725

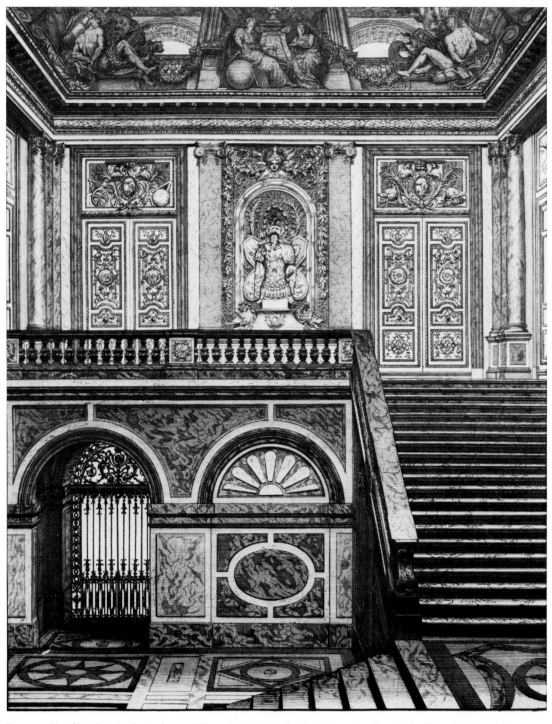

FIG. 39. Escalier des Ambassadeurs. View. Engraving by L. SURUGUE after J.M. Chevotet from [L.C. Le Fevre], *Grand escalier du château de Versailles, dit Escalier des Ambassadeurs*, Paris, 1725

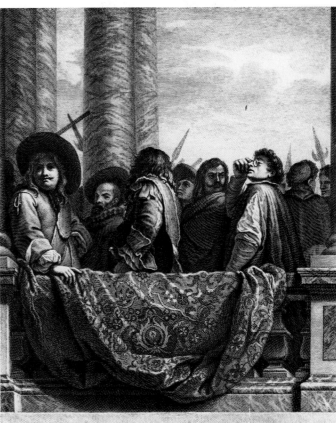

FIG. 40. Escalier des Ambassadeurs. *The Nations of America*. Engraving by L. SURUGUE, 1720 from [L.C. Le Fevre], *Grand escalier du château de Versailles, dit Escalier des Ambassadeurs*, Paris, 1725

FIG. 41. Escalier des Ambassadeurs. *The Nations of Europe*. Engraving by L. SURUGUE, 1720 from [L.C. Le Fevre], *Grand escalier du château de Versailles, dit Escalier des Ambassadeurs*, Paris, 1725

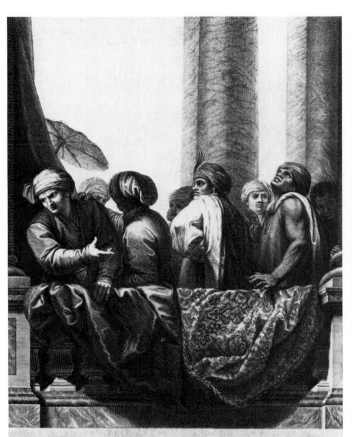

Fig. 42. Escalier des Ambassadeurs. *The Nations of Africa.*
Engraving by L. SURUGUE, 1720 from [L.C. Le Fevre],
*Grand escalier du château de Versailles, dit Escalier des
Ambassadeurs,* Paris, 1725

FIG. 43. Escalier des Ambassadeurs. *The Nations of Asia.*
Engraving by L. SURUGUE, 1720 from [L.C. Le Fevre],
*Grand escalier du château de Versailles, dit Escalier des
Ambassadeurs,* Paris, 1725

FIG. 44. Escalier des Ambassadeurs. *The Siege of Cambrai.* Engraving by L. SURUGUE, 1725 from [L.C. Le Fevre], *Grand escalier du château de Versailles, dit Escalier des Ambassadeurs,* Paris, 1725

FIG. 45. Escalier des Ambassadeurs. *The Siege of Valenciennes.* Engraving by L. SURUGUE, 1725 from [L.C. Le Fevre], *Grand escalier du château de Versailles, dit Escalier des Ambassadeurs,* Paris, 1725

Fig. 47. Escalier des Ambassadeurs. *The Siege of Saint-Omer.* Engraving by L. Surugue, 1725 from [L.C. Le Fevre], *Grand escalier du château de Versailles, dit Escalier des Ambassadeurs,* Paris, 1725

Fig. 46. Escalier des Ambassadeurs. *The Battle of Cassel.* Engraving by L. Surugue, 1725 from [L.C. Le Fevre], *Grand escalier du château de Versailles, dit Escalier des Ambassadeurs,* Paris, 1725

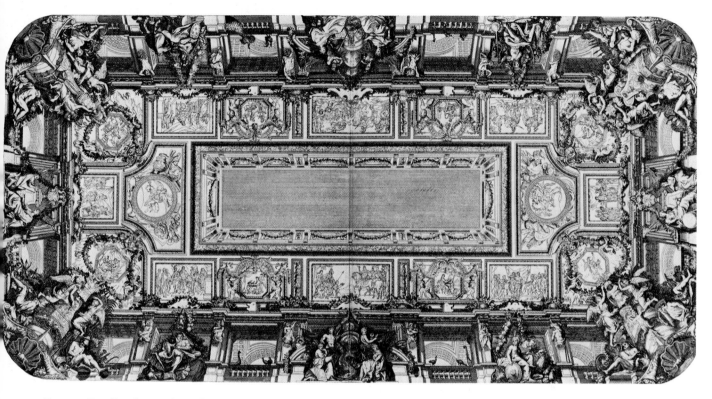

Fig. 48. Escalier des Ambassadeurs. Vault. Engraving by C. Simonneau from [L.C. Le Fevre], *Grand escalier du château de Versailles, dit Escalier des Ambassadeurs*, Paris, 1725

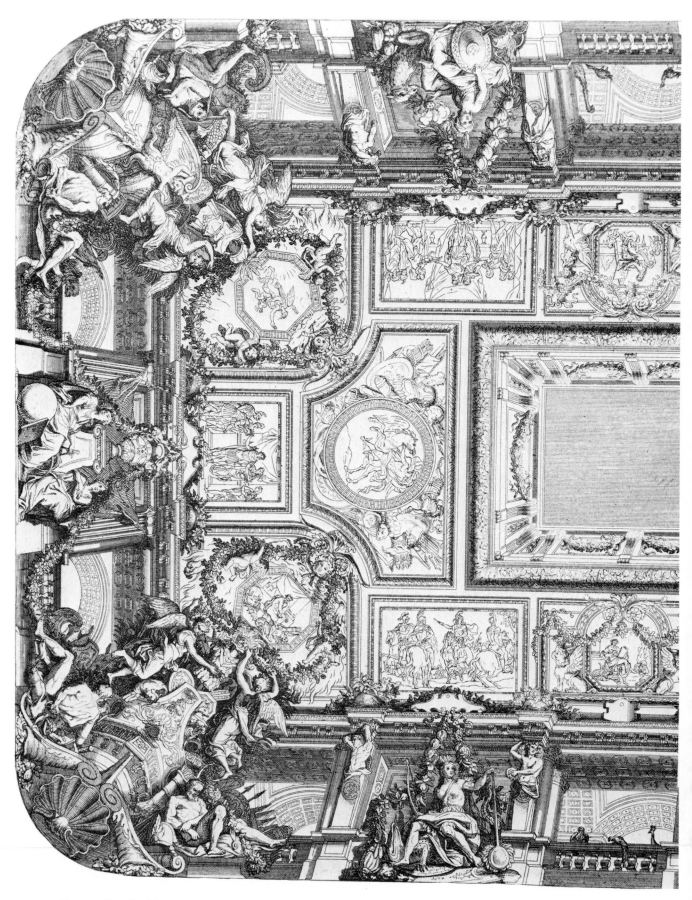

FIG. 49. Detail of fig. 48

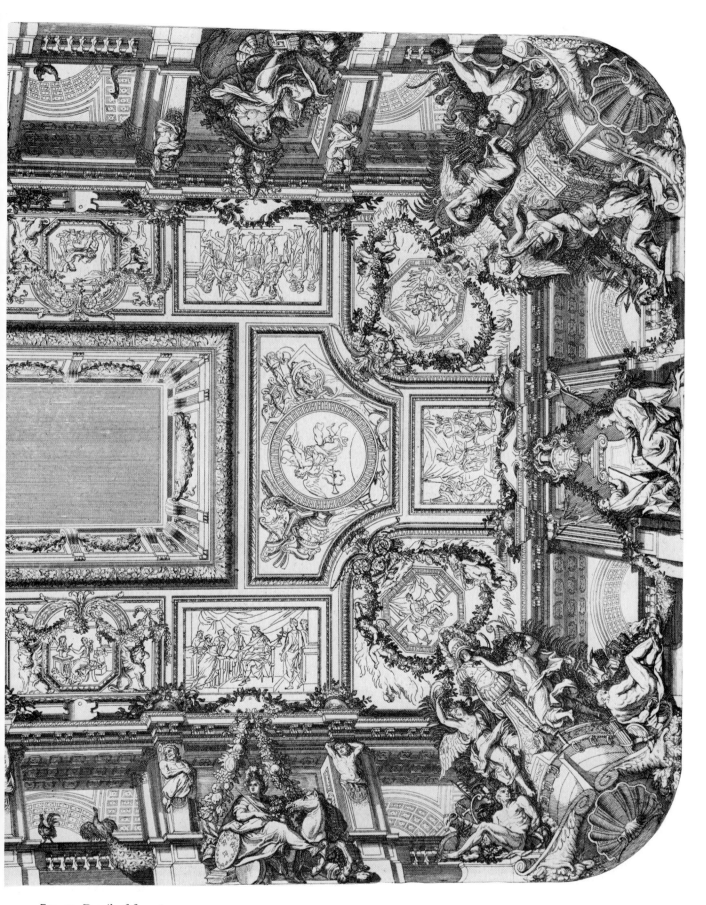

FIG. 50. Detail of fig. 48

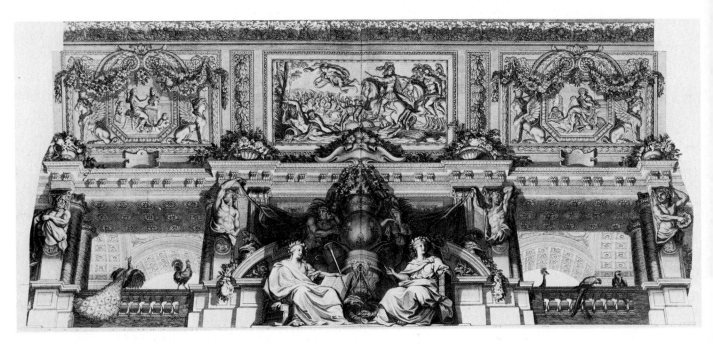

FIG. 51. Escalier des Ambassadeurs. Detail of Vault. Engraving by É. BAUDET from [L.C. Le Fevre], *Grand escalier du château de Versailles, dit Escalier des Ambassadeurs*, Paris, 1725

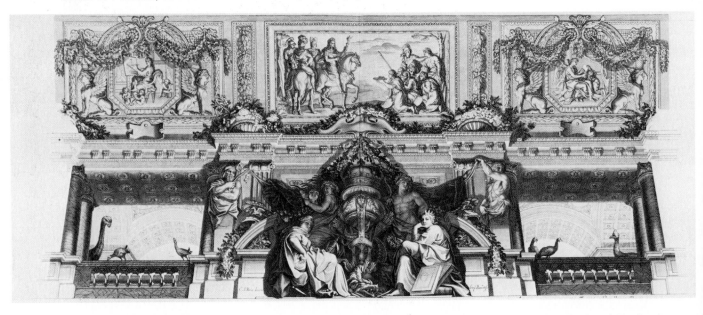

FIG. 52. Escalier des Ambassadeurs. Detail of Vault. Engraving by É. BAUDET from [L.C. Le Fevre], *Grand Escalier du château de Versailles, dit Escalier des Ambassadeurs*, Paris, 1725

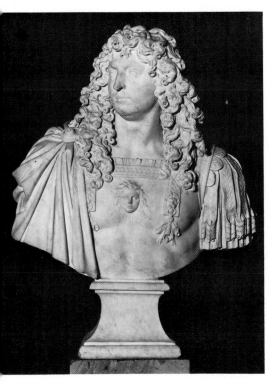

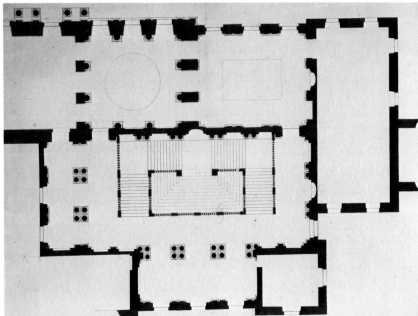

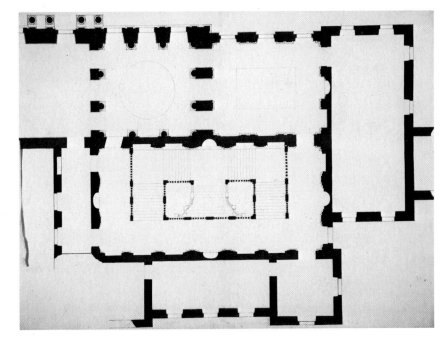

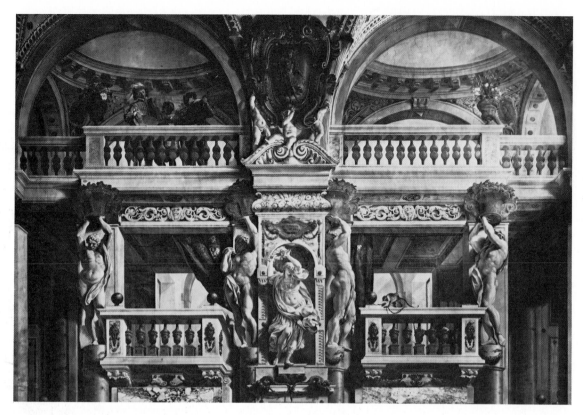

FIG. 56. Angelo Michele Colonna and Agostino Mitelli, *Third Room,* Museo degli Argenti, Palazzo Pitti, Florence

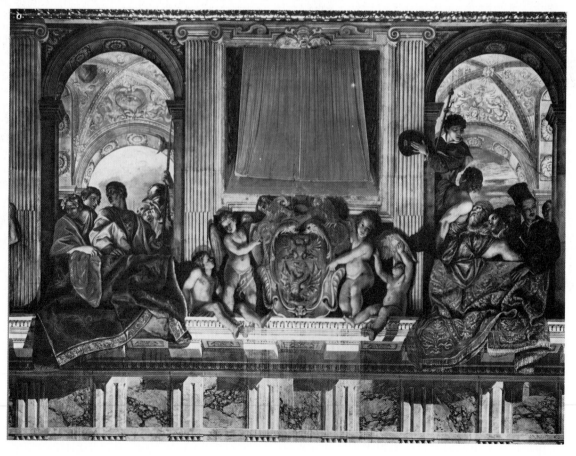

FIG. 57. Agostino Tassi, Giovanni Lanfranco, Carlo Saraceni, *Frieze,* Sala Regia (Sala dei Corazzieri), Palazzo Quirinale, Rome

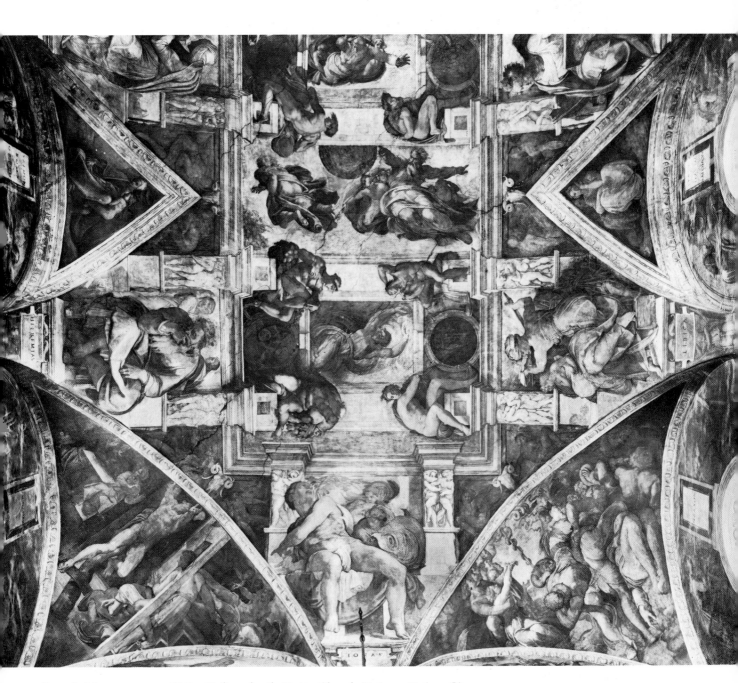

FIG. 58. MICHELANGELO, *Sistine Ceiling,* detail. Sistine Chapel, Vatican, Vatican City

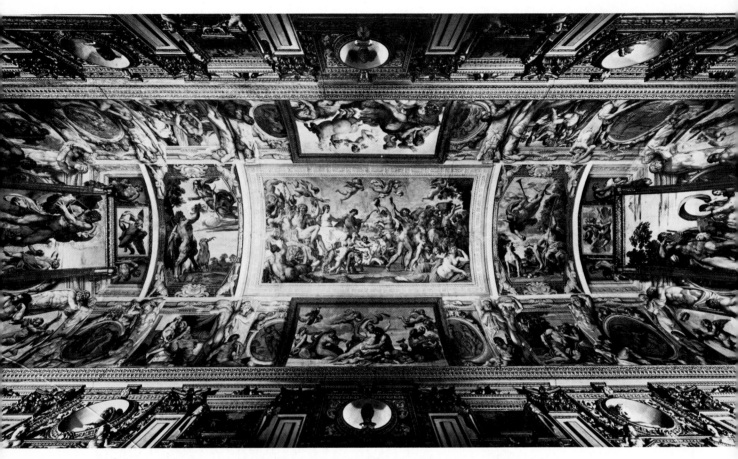

FIG. 59. ANNIBALE CARRACCI, *Farnese Gallery Vault*. Palazzo Farnese, Rome

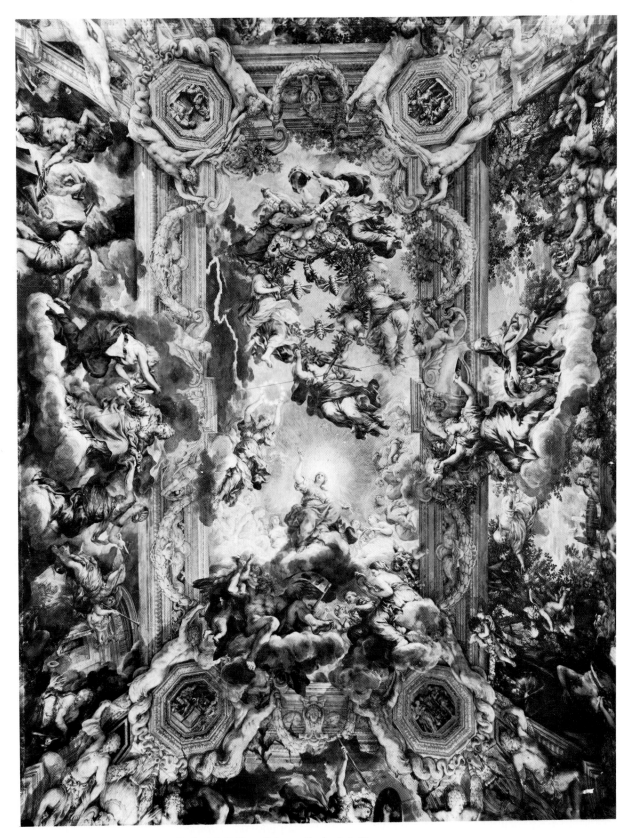

FIG. 60. PIETRO DA CORTONA, *Barberini Ceiling*. Palazzo Barberini, Rome

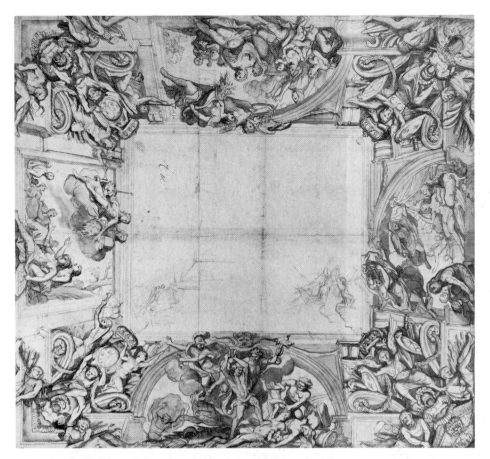

FIG. 61. CHARLES LE BRUN, *Study for the Chambre du Conseil, Louvre, Paris*. Louvre, Paris, Cabinet des Dessins, Inv. 27.653

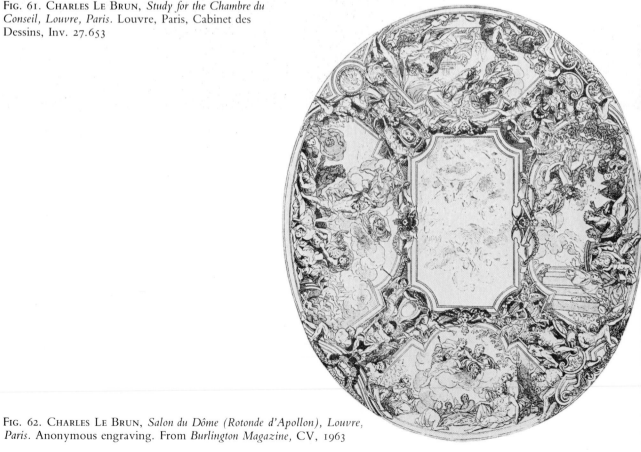

FIG. 62. CHARLES LE BRUN, *Salon du Dôme (Rotonde d'Apollon), Louvre, Paris*. Anonymous engraving. From *Burlington Magazine*, CV, 1963

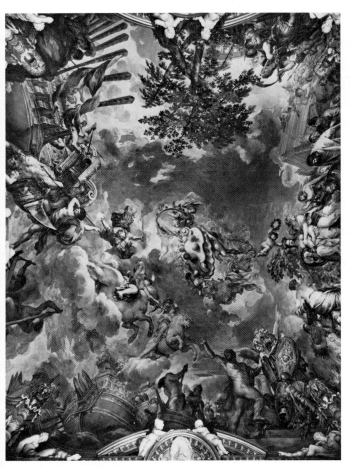

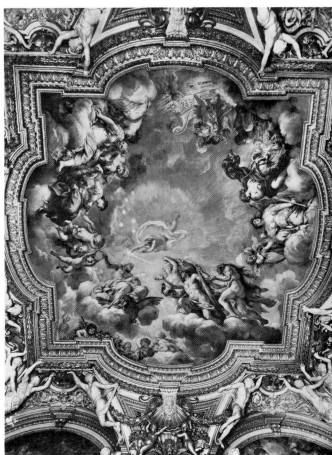

Fig. 63. Pietro da Cortona, *Sala di Marte,* Ceiling, Palazzo Pitti, Florence

Fig. 64. Pietro da Cortona, *Sala di Giove,* Ceiling. Palazzo Pitti, Florence

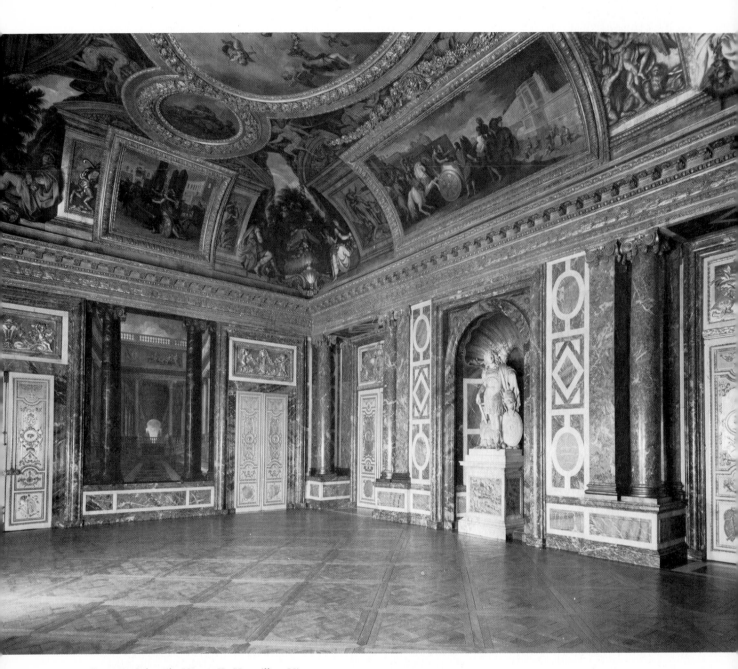

Fig. 65. Salon de Vénus II, Versailles. View

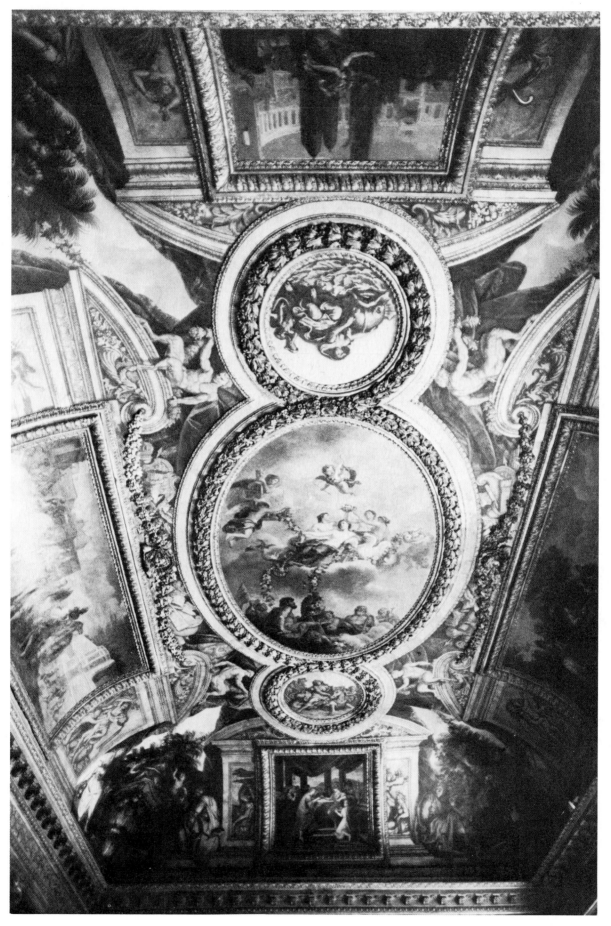

FIG. 66. Salon de Vénus II, Versailles. Ceiling

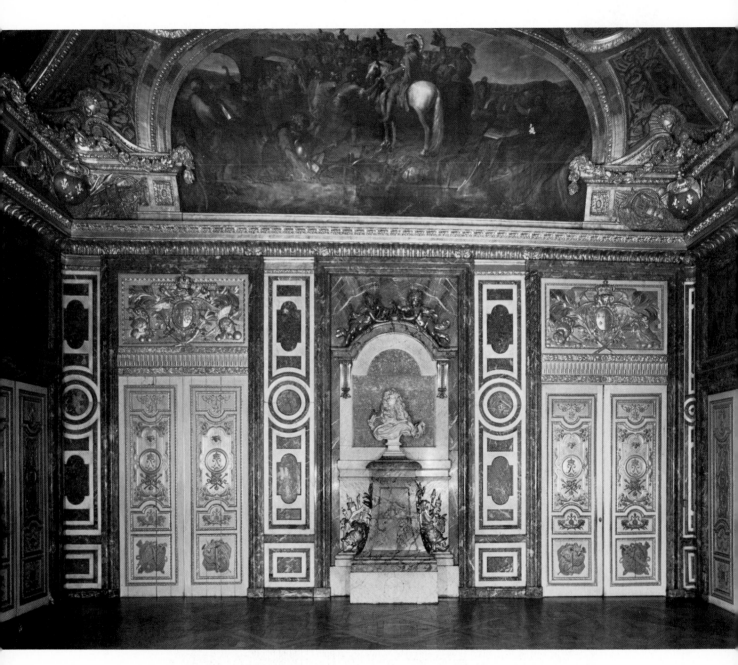

Fig. 67. Salon de Diane, Versailles. View

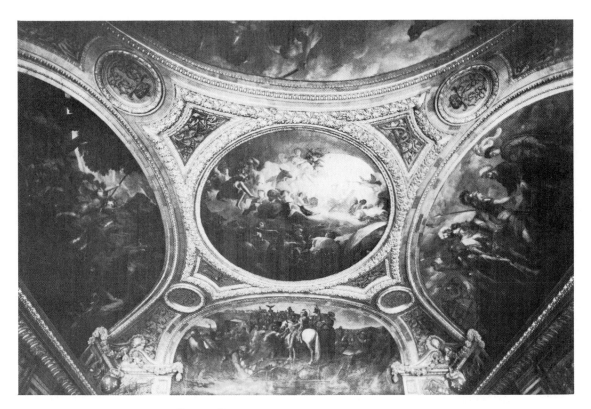

FIG. 68. Salon de Diane, Versailles. Ceiling

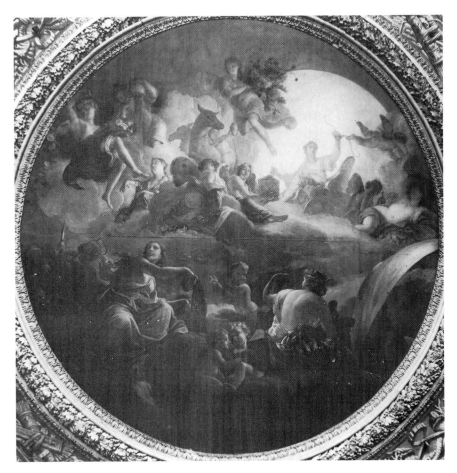

FIG. 69. GABRIEL BLANCHARD, *Diana in a Chariot Pulled by Hinds*. Salon de Diane, Versailles

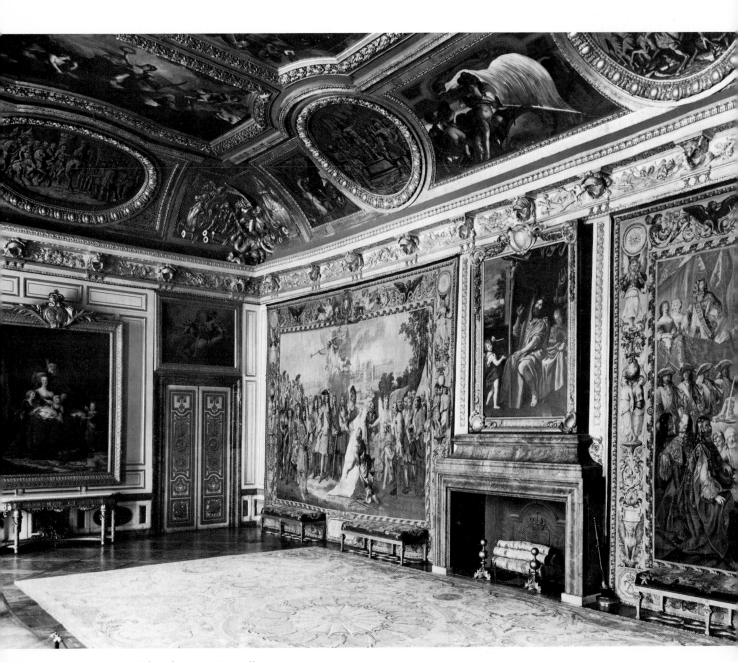

Fig. 70. Salon de Mars, Versailles. View.

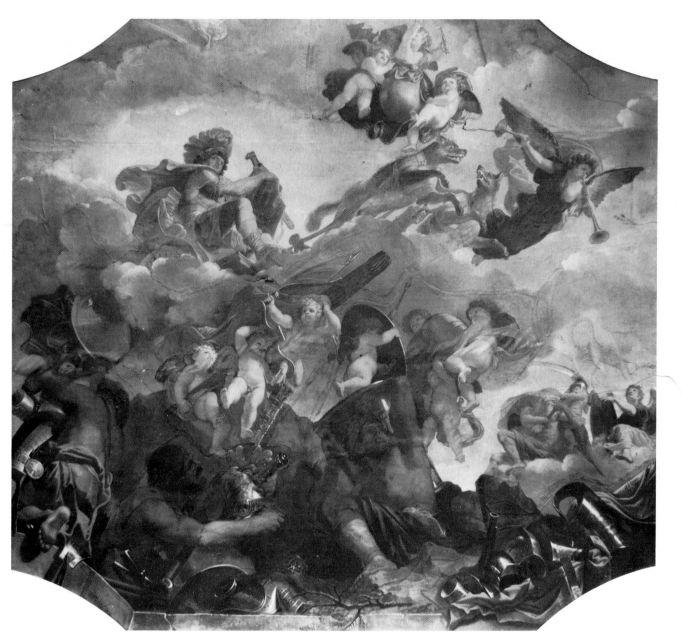

FIG. 71. CLAUDE II AUDRAN, *Mars in a Chariot Pulled by Wolves.* Salon de Mars,
Versailles

FIG. 72. Salon de Mercure, Versailles. View

FIG. 73. Salon de Mercure, Versailles. Ceiling

Fig. 74. Salon d'Apollon, Versailles. View

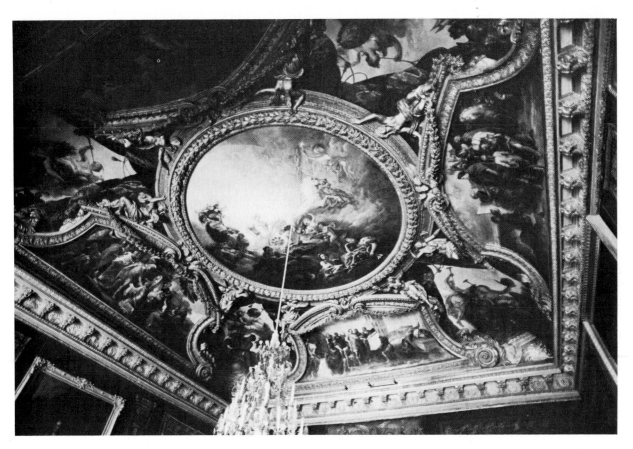

Fig. 75. Salon d'Apollon, Versailles. Ceiling

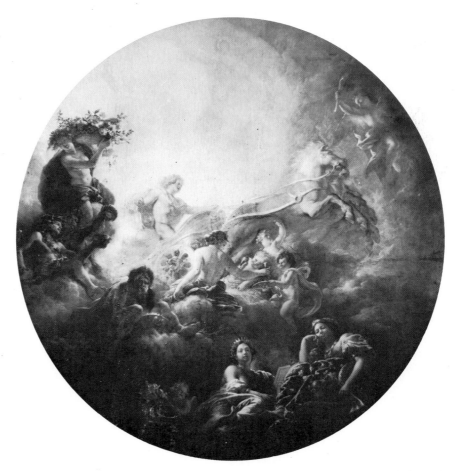

Fig. 76. Charles de La Fosse, *Apollo in a Chariot Pulled by Horses* (*Rising of the Sun*).
Salon d'Apollon, Versailles

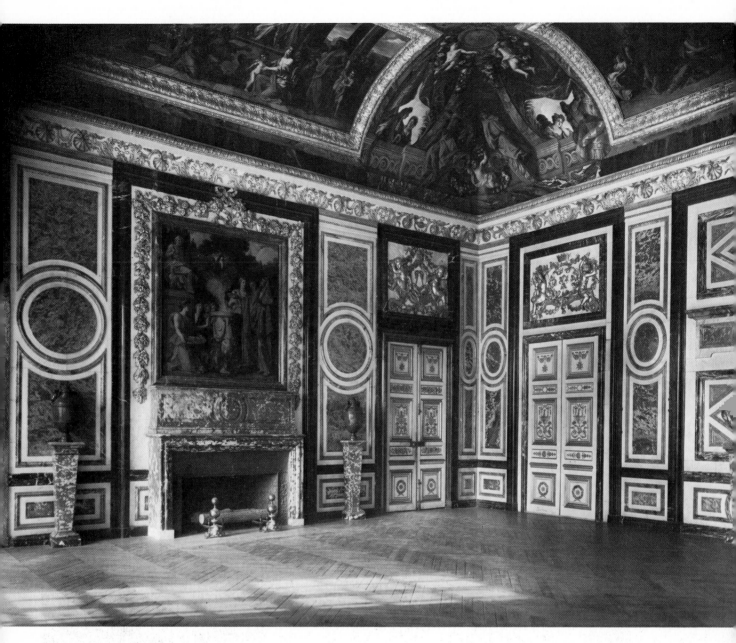

FIG. 77. Salle des Gardes de la Reine, Versailles. View

Fig. 78. Salle des Gardes de la Reine, Versailles. Ceiling

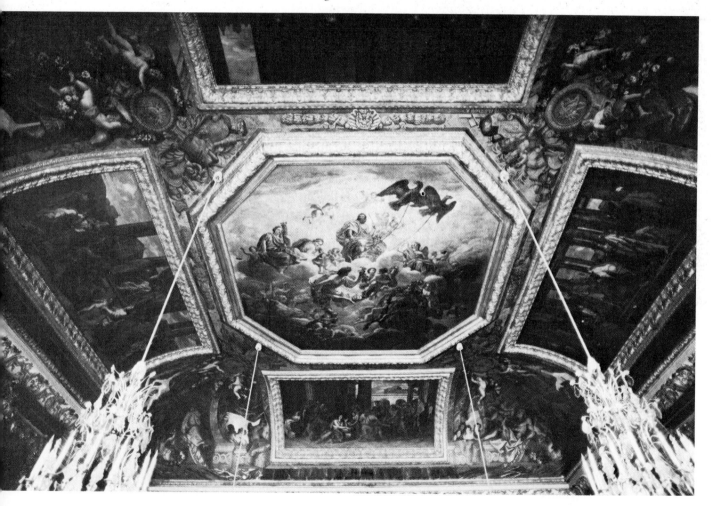

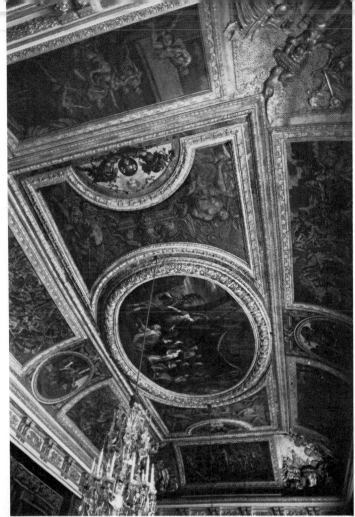

FIG. 79. Antichambre de la Reine, Versailles. Ceiling

FIG. 80. Salon de la Reine, Versailles. Ceiling

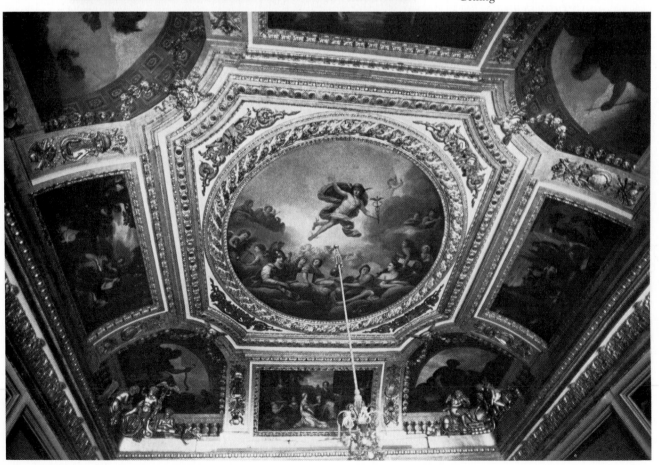

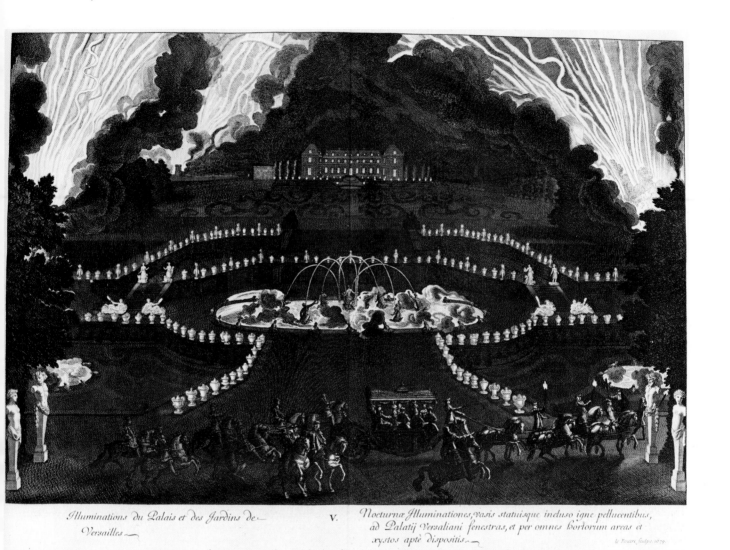

FIG. 81. View of Petit Château and Fer-à-Cheval. Nocturnal Illumination, *fête* of 1668. Engraving by JEAN LE PAUTRE, 1679 from A. Félibien, *Relation de la feste de Versailles du 18 juillet 1668*, Paris, 1679

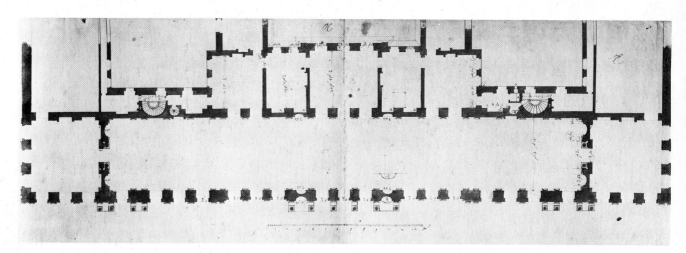

FIG. 82. Office of Jules Hardouin-Mansart, Plan of Galerie des Glaces. Louvre, Paris, Cabinet des Dessins, Inv. 30.227

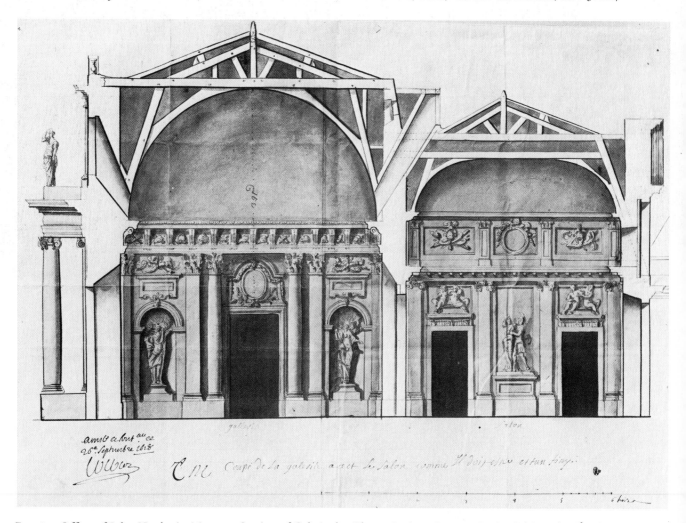

FIG. 83. Office of Jules Hardouin-Mansart, Section of Galerie des Glaces: Project. Louvre, Paris, Cabinet des Dessins, Inv. 30.282

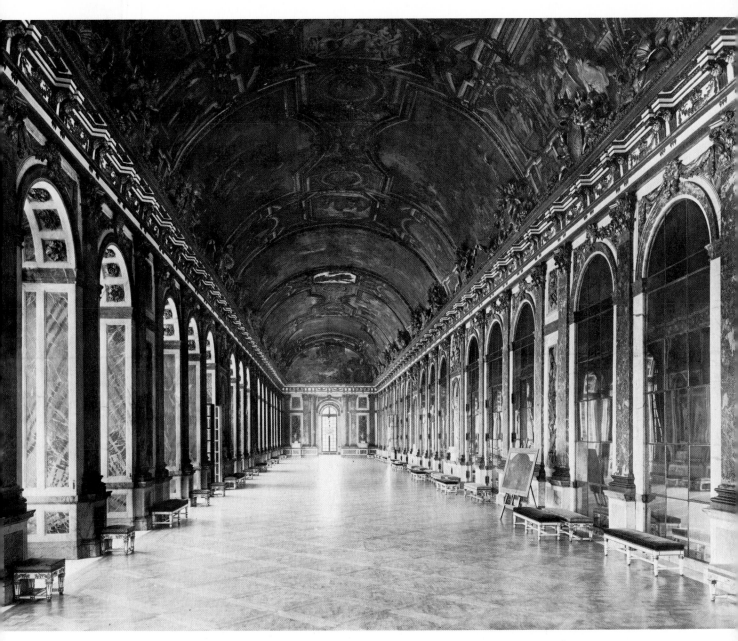

FIG. 84. Galerie des Glaces, Versailles. View

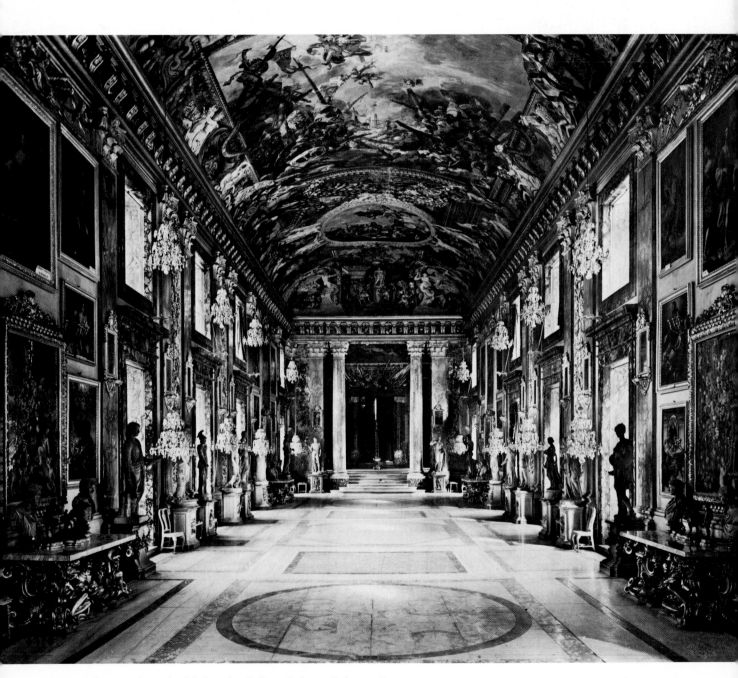

FIG. 85. Antonio del Grande, Gallery, Palazzo Colonna, Rome

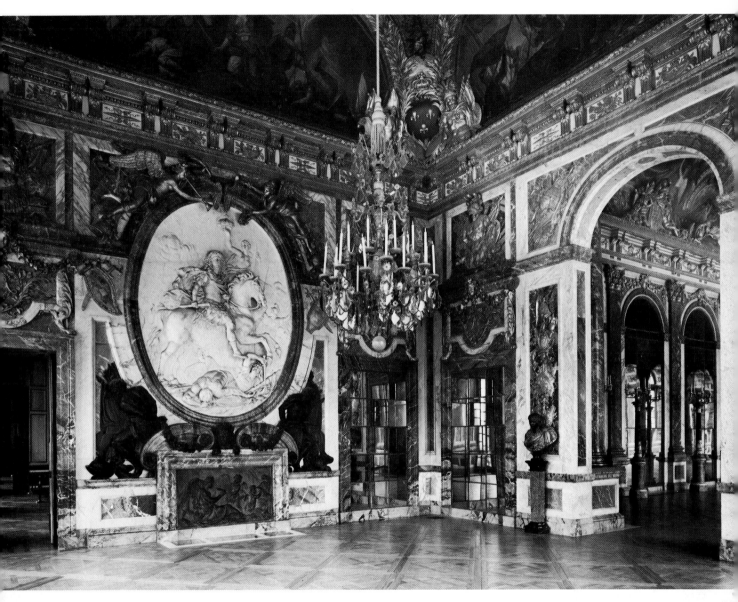

Fig. 86. Salon de la Guerre, Versailles

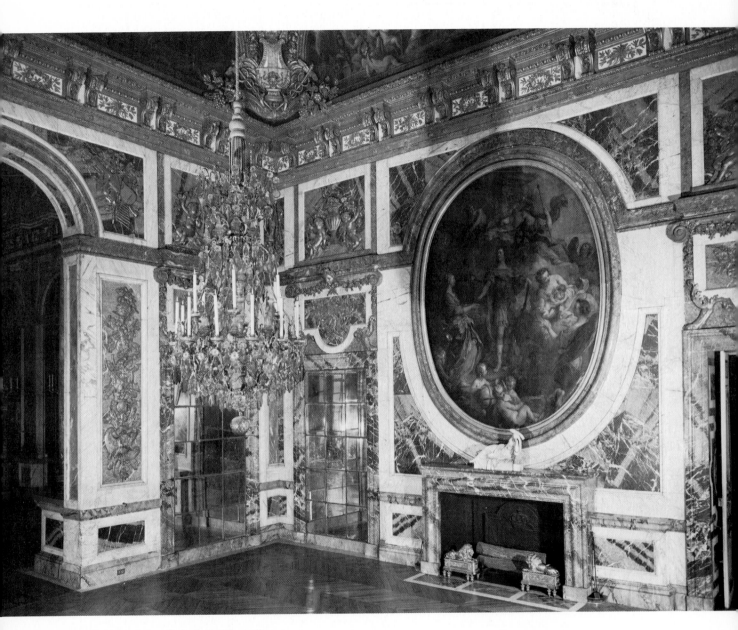

Fig. 87. Salon de la Paix, Versailles

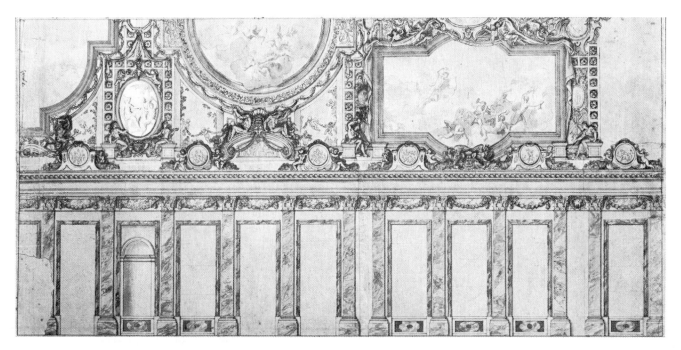

Fig. 88. Charles Le Brun and Office of Jules Hardouin-Mansart, Project for Galerie des Glaces. Louvre, Paris, Cabinet des Dessins, Inv. 27.642

Fig. 89. Charles Le Brun, Project for Galerie des Glaces. Louvre, Paris, Cabinet des Dessins, Inv. 29.639

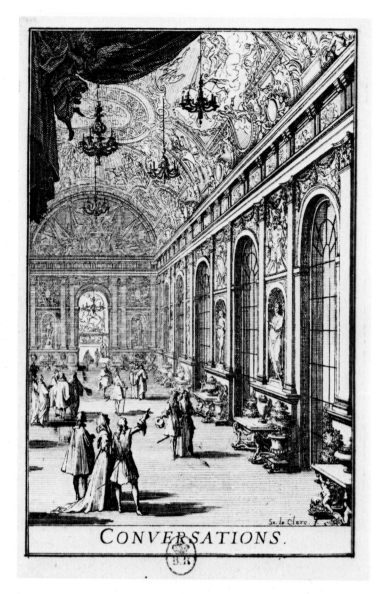

FIG. 90. Sébastien Le Clerc, View of Galerie des Glaces. Engraving from M. de Scudéry, *Conversations nouvelles sur divers sujets, dédiées au Roy,* Paris, 1684

FIG. 91. Charles Le Brun, Project for Galerie des Glaces. Louvre, Paris, Cabinet des Dessins, Inv. 27.067

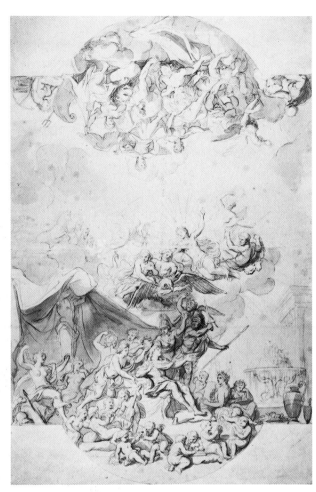

FIG. 92. CHARLES LE BRUN, Study for fig. 94. Louvre,
Paris, Cabinet des Dessins, Inv. 27.644

FIG. 93. CHARLES LE BRUN, Study for fig. 95. Louvre,
Paris, Cabinet des Dessins, Inv. 27.691

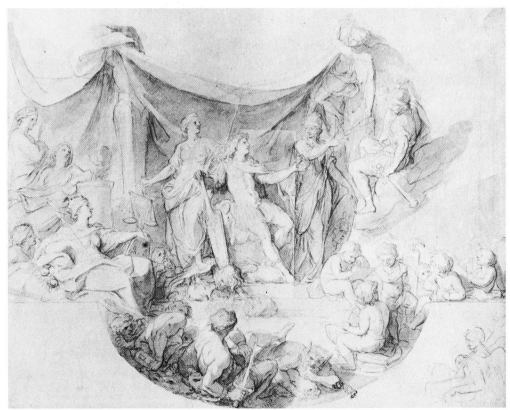

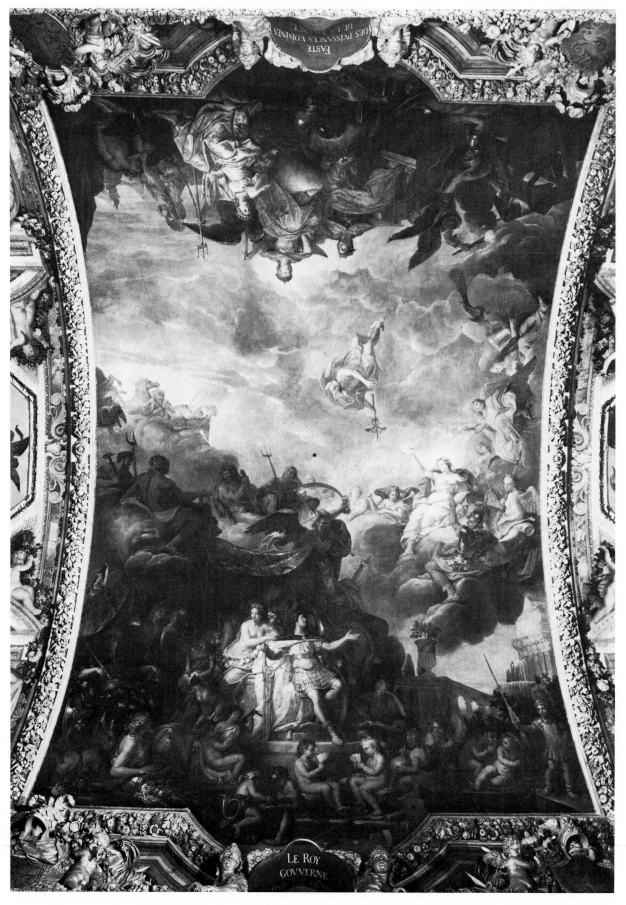

Fig. 94. Charles Le Brun, *The King Governs by Himself, 1661; Germany, Spain, Holland*. Galerie des Glaces, Versailles

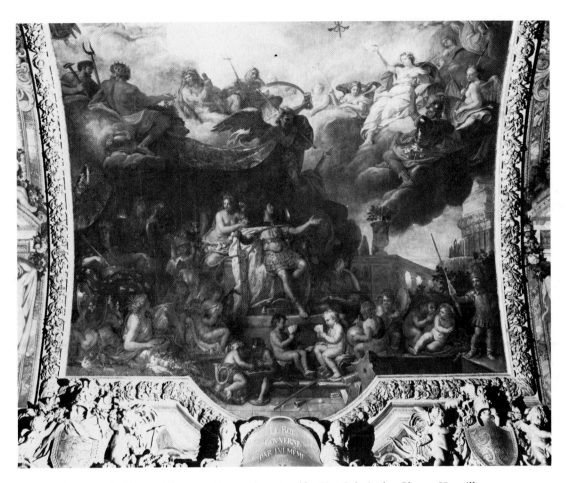

FIG. 95. CHARLES LE BRUN, *The King Governs by Himself, 1661*. Galerie des Glaces, Versailles

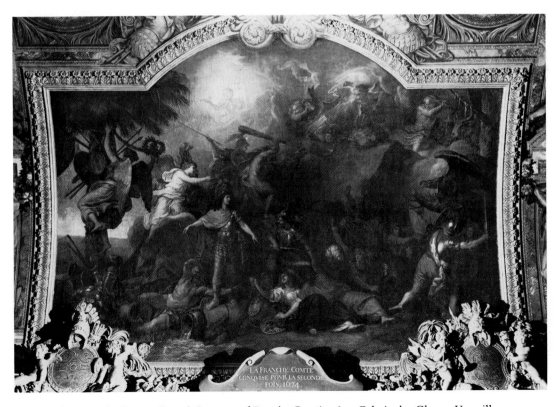

FIG. 96. CHARLES LE BRUN, *Second Conquest of Franche-Comté, 1674*. Galerie des Glaces, Versailles

FIG. 97. Galerie des Glaces, Versailles. Detail of French Order

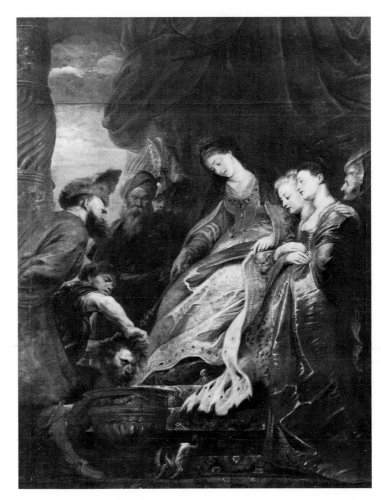

FIG. 98. PETER PAUL RUBENS, *Queen Tomyris with the Head of Cyrus*. Louvre, Paris

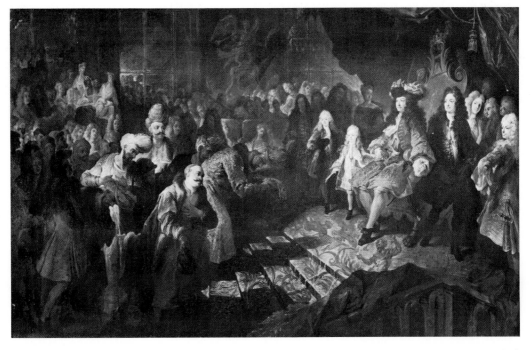

FIG. 99. ANTOINE COYPEL, *The Reception of the Persian Ambassador, February 19, 1715*. Musée National du Château de Versailles

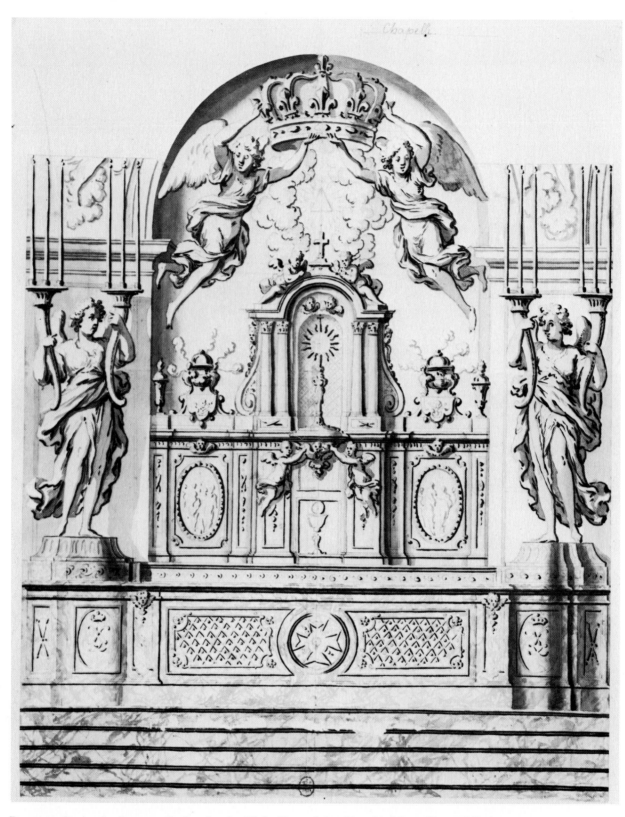

FIG. 100. PIERRE LE PAUTRE, Design for the High Altar of the Chapel of Versailles. Bibliothèque Nationale, Paris, Cabinet des Estampes, Va 78e VII